Painting the Spirit of Nature

"Nothing is less real than realism. It is only by selection,
by elimination, by emphasis, that we get at the real meaning of things."

—Georgia O'Keeffe

Painting the Spirit of Nature

by Maxine Masterfield

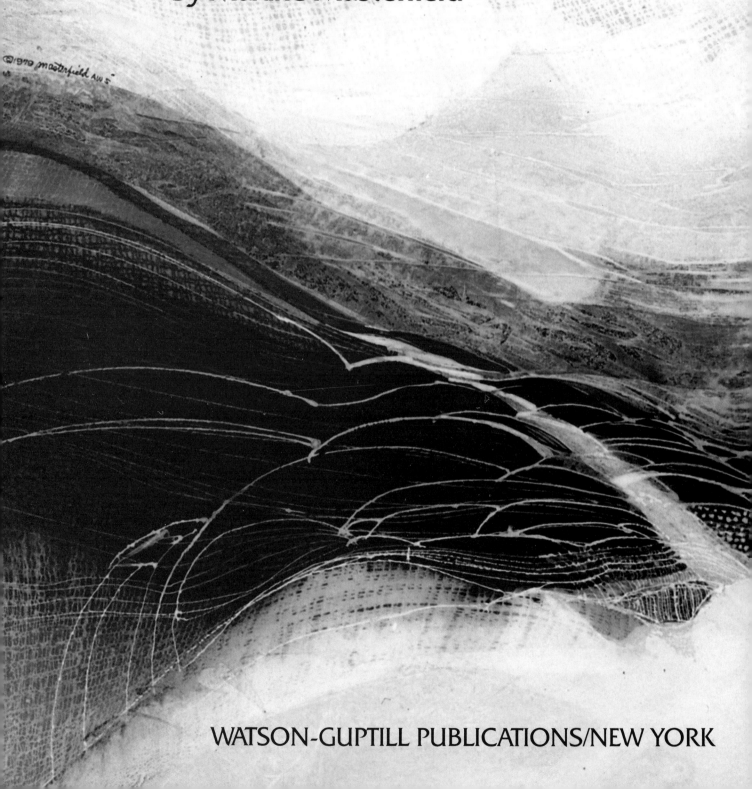

WATSON-GUPTILL PUBLICATIONS/NEW YORK

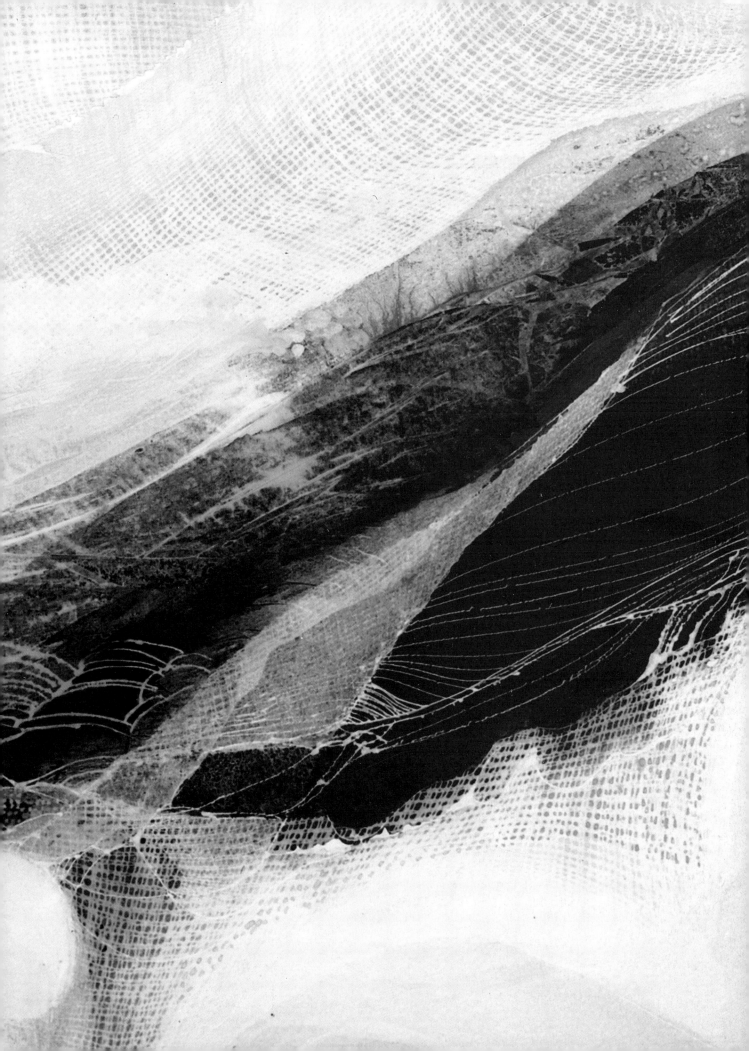

ACKNOWLEDGMENTS

I would like to express my deepest thanks and appreciation to the artists and photographers who have provided the wealth of material used in this book . . . to Mary Hudak and Bonnie Silverstein for helping me put my thoughts on paper . . . to George Hart who helped me get this book started and named us Abstract Naturalists . . . to Gerry Gable for his expert photographing of my work . . . and to his wife, Nancy Gable, for without her beside me through the years this book may not have been.

Thanks also to David Lewis, Editorial Director of Watson-Guptill, for his willingness to reach beyond the known . . . to Ed Betts and Lawrence Goldsmith for paving the way . . . and most of all, to my husband, George Smith, who helped keep the coffeepot—and me—going.

(Overleaf)
MAXINE MASTERFIELD, *THE BEGINNING AND END OF ALL THINGS*.
38" × 40" (96 × 102 cm), ink on Morilla paper.
Collection of C. G. Rein Galleries.

This painting embodies the concept of "free spirit." Its perspective is from a soaring vantage point, high above clouds and horizon. The feeling is spiritual in nature, and thus unencumbered by the usual restraints of mortal existence. This opportunity to experience boundless possibilities is the concept I want to carry into my painting method. Limits of creativity are imaginary, and my mind will recognize none. Once I am free of such restrictions, all things are not only possible, they are inevitable.

I began by pouring several colors into the center of the paper. While the inks were still wet, I stretched a piece of cheesecloth across the surface. Then I added white ink to the top and bottom portions and left it to dry. I also added white ink lines to integrate the fabric's delicate imprint with the forms, giving the work movement.

Except where otherwise mentioned, the photographs of the paintings in this book and all of the demonstrations were taken by Gerry Gable.

First published 1984 in New York by Watson-Guptill Publications, a division of Billboard Publications, Inc., 1515 Broadway, New York, N.Y. 10036

Library of Congress Cataloging in Publication Data
Masterfield, Maxine.
 Painting the spirit of nature.
 Includes index.
 1. Nature (Aesthetics). 2. Water-color painting, Abstract—Technique. 3. Water-color painting—Technique. I. Title.
 ND2237.M37 1984 751.42'245 83-26055
 ISBN 0-8230-3861-0

Distributed in the United Kingdom by Phaidon Press Ltd., Littlegate House, St. Ebbe's Street, Oxford.

Manufactured in Japan

9 10/94 93

Edited by Bonnie Silverstein
Designed by Jay Anning
Set in 10-point ITC Bookman Light

To George and Nancy

Contents

Introduction

I've never felt that any artist could improve on nature, but I've always felt compelled to interpret visually how nature has inspired and fascinated me with its beauty. Creating art on paper that reflects the beauty of nature, and the feelings it generates within you, is possible without years of study. My method of painting is for those who are not interested in drawing detailed pictures of what they see and can photograph. And my tools are whatever will create the image of a feeling or experience I can share.

PORTRAIT OF AN ABSTRACT NATURALIST PAINTER

It's hard to calculate the part my formal art education played in the way I work now. But I always felt resistant to the instructions that preached a strict adherence to traditional methods I did not feel comfortable with. My need to create preceded my formal training, and my determination to ally myself with nature to accomplish this survived the sophisticated bent of the educational system.

When I was very young, at about the age of five, I created miniature villages of sand piles and lucky stones. These were all-day projects, and I charged a tax stamp admission fee to viewers. I was not aware at the time that I was creating art—and getting paid for it, too. Then, in my first art class, I made a clay fish. I can still remember the difficulty I had in understanding a three-dimensional form. The teacher explained that gills were not flat, like paper, but had many sides. Her example had both form and depth; mine was a two-dimensional, decorative slab.

When I was in high school, an inspiring art teacher, Anthony Eterovich, brought in old master drawings for the class to copy, to integrate the eye and hand. But more importantly, each morning there was a question on the blackboard: "What color was the mail box you passed this morning?" or "What's across the street?" We were learning to not just see, but to be aware of what we saw—and to look for more. This teacher made me start a portfolio of my art, and try for a scholarship (which I received) to the Art Institute. At the institute, a watercolor instructor, Kae Dorn Cass, introduced me to a loose painting technique. I knew then that watermedia would be my medium. The pencil seemed too confining and oils were too complicated, but water-based colors flowed freely and naturally.

In 1975, I read Ed Betts' *Master Class in Watercolor*, and it was this book that gave me the courage to explore and experiment. Since then, I have found other watermedia materials more luminous and fluid than watercolor—inks. Inks dry to a gloss and are now lightfast. I also use unusual tools such as afro combs, rollers, squeeze bottles with needle-type points, and whatever else I can find to apply and disperse the colors. I use manmade and natural products to produce form: plastics, wax paper, tree bark, leaves, stones, shells, etc. During the creative process, I fuse natural elements with time and chemicals. Salt, alcohol, oil, and wax are used for texture and resist effects. Even now, I am constantly finding new and different materials that lead to discoveries of new techniques and add refinement to established methods.

Experimentation also plays an important part in introducing changes into my work. Experimenting encourages the unexpected and fosters new discoveries. The results may seem accidental, but with each "accident" I find a new idea to develop. It is only by being inventive and trying unusual tools that I survive as an artist. I react to what is happening on the paper in front of me as though nature, not the artist, is in control.

CONTENTS AND PURPOSE OF THE BOOK

Painting the Spirit of Nature describes how the abstract naturalist painter works out ideas and feelings about nature and translates them into personal, poetic, yet accurate, statements. By showing how I and artists like me work and think, you can translate these methods and ideas into your own paintings. To enable you to follow our working methods, I will begin with a series of demonstrations of basic techniques I use to create texture, form, color, or other unusual effects. In later chapters I will discuss theories on color, composition, form, texture, painting out, line, and collage. Throughout, there will be many examples of how these ideas have been translated into paintings by me and other watermedia artists who paint nature with a free spirit. A few of these artists have been in my workshops; some are people I have studied or worked with; and some are artists whose works I've been attracted to because of their experimental approach. In addition to showing you how we work and think, we will also suggest projects for you to practice at home or in your studio, to help you to

begin thinking in a freer, more abstract way. However, in the long run, you must find your own direction to explore. This book offers suggestions, but they are only that. There are many ways to paint the spirit of nature.

WHAT MAKES A PAINTING SUCCESSFUL?

The decision of whether a painting is successful, or if it shows "talent," is not just a matter of opinion or taste. It depends on whether you have realized your initial goal in creating the work. If your intent was to produce something that was self-pleasing, either as a process or finished product, then that is your priority. Many times it is harder to judge a work by your own standards than it is to please others who are less critical. I have often rejected paintings that my friends liked because they didn't meet my standards or suit my intent. In the final analysis, you alone can judge whether a work is successful.

I recently participated as a member of a watercolor critique panel. Beside me sat a famous and revered traditional watercolorist, a man whose talent I have greatly admired. But after a while I found myself defending the very works he voiced the strongest objections to. He was fighting to preserve the tight subjectivity that artists were taught for eons all over the world, while I was encouraging a free, intuitive approach to art that exceeded these conservative perimeters to reach out for a more sensuous and exciting reality.

Thus, even if a shared meaning or making a specific statement is your goal, it is not realistic to expect everyone to understand it, no matter how well you've painted it. In the past, the most successful paintings reproduced nature realistically or representationally. It was easy to appreciate them—by not straying too far from impressions others can relate to, a shared understanding is always more

possible. But I hope, through this book, to make you see that the abstract artist communicates the natural scene—and even more successfully.

THE BASIC TECHNIQUES

Before we study the paintings, I'd like to show you the major techniques of this experimental, free-spirited approach to painting nature. Although I have developed many of these techniques after years of experimentation, several other artists in this book also use one or more of them, either as former students of mine, or having arrived at them independently.

First there is a list of materials I recommend for this method of painting. Then there are eight demonstrations: on pouring color, on creating textures and shapes through plastic wraps and dropcloths, on texturing with waxed paper and with natural or man-made materials, on the layering process, on painting out with wax resists or an airgun, on adding line to a textured painting, and on collage. These demonstrations are deliberately arranged in the order I actually paint, though I rarely use more than a few of these techniques in a single painting, as you shall see. I also want to mention at this point that, though you can use any water-based paint for these techniques, after much experimentation, I have found that inks work best. Only inks maintain their consistency and hues during the pouring and layering processes. But of course, by all means, try other watermedia, too. Maybe you'll prefer a different look.

After each demonstration I have suggested a project for you to try. These projects will enable you to practice the techniques on your own—before you start an actual painting. They will also give you the opportunity to see how much fun it is to experiment with these free-spirited painting techniques.

Demonstrations of Basic Techniques

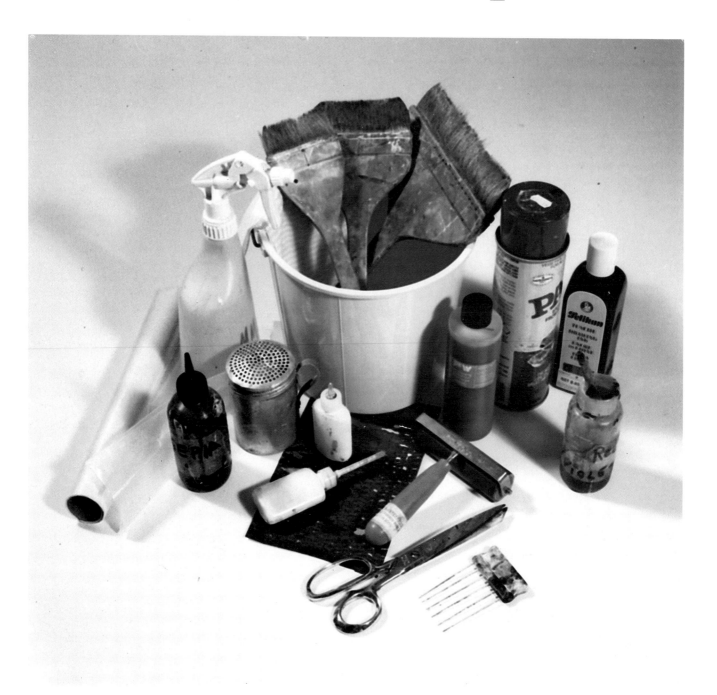

T he materials and equipment you use should be based on your own needs. However, I recommend the following items for the projects described in this book:

1. A table that tilts and spins, yet is firm enough to withstand the pressures of laying washes. I recently designed one (see illustration) that is screwed or bolted together (except for the metal strips, which were welded to the pulley). When the table is assembled, a watercolor board is placed on top of the pine board and attached to each metal strip with a small clamp, to keep the painting in place as it spins and tips.

2. A large wash bucket filled with clear, fresh water.

3. Watercolor paper: I prefer no. 1059 Morilla watercolor paper, which comes in a roll 48″ (122 cm) wide and 10 yards (9.1 m) long and can be cut to any size. Experiment with various papers until you find one you like. The amount of sizing on the paper affects your color: papers with less sizing absorb more color into the paper, so the colors look brighter. If you plan to collage your work, you will need a paper with enough thickness that, when it is torn into pieces, it will show about three or four layers.

4. Plywood boards of all sizes to fit various size papers. The boards should be 1/8″ (3 mm) thick and about an inch (25 mm) wider than the paper.

5. Gum tape or paper staples to hold the paper firmly to the board when stretching the paper.

6. A spray bottle for wetting the paper.

7. Waterproof inks. I prefer two brands: Steig FW Lightfast Colored Inks and Pelikan Drawing Inks. I use both the transparent and opaque types. You can buy them in an art supply store or order them by mail. The Pelikan ink can be purchased from Utrecht Linens, 33 35th Street, Brooklyn, N.Y. 11232 and the Steig ink from Steig Products, P.O. Box 19, Lakewood, N.J. 08701.

8. A drawing pen for applying the inks in a fine line. I purchase this handy drawing tool from Gaunt Industries, 6217 Northwest Highway, Chicago, Illinois 60631. It is generally used as a dispensor for solvents—grease, cement, oil—but I use it for opaque inks. There are six needle sizes available. I use the Hypo 200, a 25-gage needle, on a 1 1/4 oz. (37 cc) oval-shaped polyethylene bottle. More will be said about this pen later, on page 26.

9. Plastic bottles with applicator tips (generally found in beauty supply houses) for pouring inks.

10. Rollers of all sizes for spreading the paint.

11. Large Japanese-style hake brushes for spreading broad washes.

12. An assortment of objects for texturing the washes: waxed papers, plastic dropcloths, thin food wrap (such as Saran Wrap), Pam (a cooking oil spray found in supermarkets).

13. Plastic dropcloths for covering the work till dry.

14. A wiping cloth (I use Handiwipes) to absorb the excess ink, and to apply the ink with as well. I also use it to texture the wet ink.

15. Canning salt (a coarse salt, also called "kosher salt") in a large salt shaker for adding texture to the wet colors.

16. Afro combs and other implements that produce texture and line. Other products are suggested later in this section (see "Texturing with Natural and Manmade Materials").

17. Acid-free foam core boards for backing finished paintings. I use a board 1/2″ (13 mm) thick. It is available at art supply stores, or you can order it from Wayne Buffington at the All-Seasons Paper Company, 6346 Eastland Road, Brookpark, Ohio 44142.

18. UF3 Plexiglas acrylic sheet, 1/8″ (3 mm) thick, to cover the finished painting in its frame. The plastic protects the painting from ultraviolet light, which can fade some watermedia inks and paints. You can find this product in plastics stores or picture-framing sections of art supply stores.

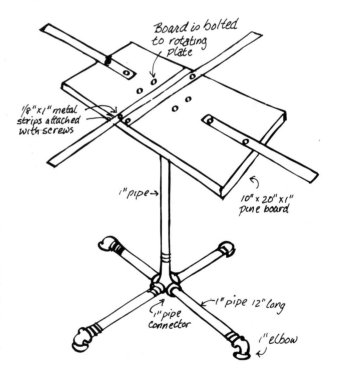

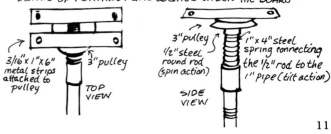

DETAIL OF ROTATING PLATE LOCATED UNDER THE BOARD

Pouring Colored Inks

Before you can paint, you must stretch the watercolor paper so it doesn't buckle when you wet it. Soak the paper in clear water until it is thoroughly drenched, stretch it onto a plywood board, then tape or staple the paper and let it dry thoroughly. Now you are ready to pour color.

You can either rewet the paper and work wet-in-wet, as I often do, or work on the dry paper, depending on the effect you want. Wet areas create softer edges and blended areas; dry paper results in harder edges. I will be working with inks. You can use any liquid watermedia, such as acrylics and watercolors, but this works best with ink.

I begin by squirting on color with a plastic squeeze bottle and applicator tip, then tilt the board to make it run where I wish it to go. You can work one color at a time, or pour several colors at once onto your paper and let them blend, directing their flow and adding more color to an area whenever needed. You can also direct the color to a particular section of the painting by first spraying that area with water to clear a path for the colors to run or you can direct it with a large Japanese-style wash brush. Incidentally, since gravity plays such an important role in moving color, be sure your table is level or the colors will run without your control.

With experience, you will begin to anticipate how much ink or paint you'll need; but in the beginning, less is better. The excess ink will only run off the board and be wasted, and areas with too many colors or too thick with paint can become muddy.

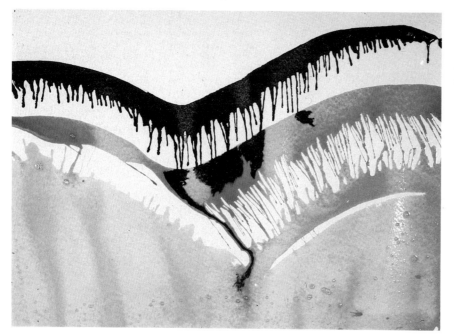

First Pour. *Three basic colors—blue, orange, and yellow—are poured onto the dry watercolor paper with a plastic squeeze bottle. When the paper is tilted, broad, sweeping lines of vertical color and diagonal drips are formed. The thinner lines occur when the ink is squirted out of the bottle.*

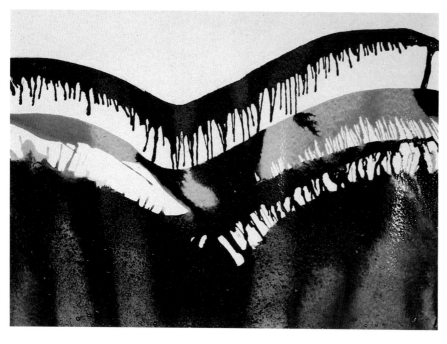

Second Pour. *I add more blue to the yellow area at the bottom of the paper and tip the board, forcing the colors to flow into one another.*

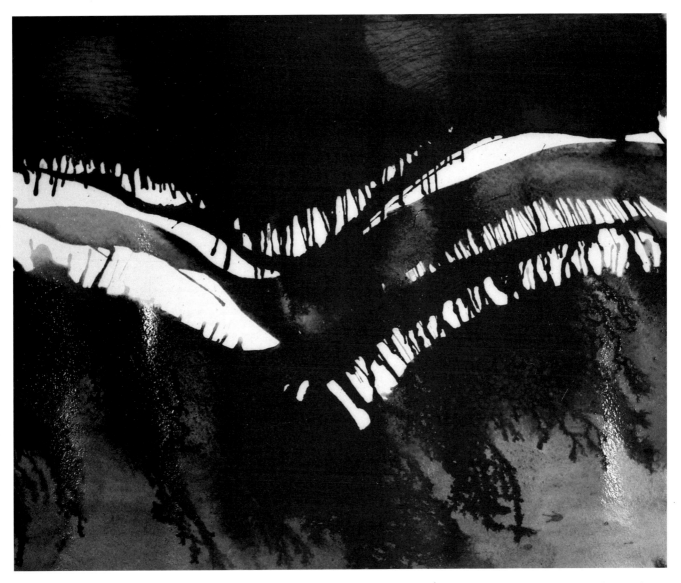

Third Pour. *I add more blue to the upper portion, which represents the sky area, and pour magenta into the area below. Since the colors are wet, they blend together. This is particularly evident in the lower right, where a ragged, slightly blurred edge is formed as the colors meet, causing a treelike effect.*

Project

To help you learn how your colors will mix together in a pouring, and to give you experience in pouring and controlling colors, I recommend the following project. Take a piece of watercolor paper large enough to hold two different colors—say, orange and green—and pour each color on opposite sides of the paper. Lift the ends slightly, to allow the colors to run into each other. Control the amount of color in various areas of the paper with a brush. Notice how the hues change when a different color dominates. If you test all your new colors like this, you will have fewer disappointments later, when you're in the midst of a painting.

Creating Form and Texture with Plastic Film

The key element in producing a successful, textured painting with the method I use is *time*. Nothing in nature is instantaneous, and natural painting isn't either. In the first stage, colors were poured and guided by tilting them into a basic composition. In this second stage, the work is furthered by the placing of various materials such as plastic, acetate, vinyl, cellophane, and wax paper, to produce textures and patterns.

Wherever the material makes contact with the wet, poured ink and paper, more ink is trapped and held there than where it touches, stains the paper, and moves on. This ink build-up follows the shape of the material it touches and when dry, reveals that form permanently. Most of the colors used are transparent, so build-ups of color are darker and richer when more ink is used in the area. The inks I use dry to a gloss in build-up areas, so besides the richness, there is a texture of gloss and flat contrasts. When salt granules are sprinkled on the ink, they attract the ink and, though the salt dissolves, the darkened areas of ink contrast with the unsalted areas, leaving another textured effect. The wax from the waxed paper and oil from lubricants such as Pam cause the inks to bead up in small puddles, making the watercolor surface resist the next layer of color.

As you will see in the demonstration, the shaping materials can be placed on the wet color after each color is poured, one at a time, or at the every end, when the entire pouring process is completed. Even after the texturing materials are down, further tilting of the board will cause new flowing ink to get trapped and change some of the previous mixtures. Don't be afraid to turn your paper around. You are not wedded to any edge of your painting being the top or bottom. If something happens to change your original plan, go with what looks good.

You can also slip more ink or paint under the plastic coverings. And you can spread the ink or paint with rollers, brushes, or your hands either before or after the work is covered by a sheet of plastic to dry. Just remember that wherever there is contact, a line or form will be evident, and if the painting is not kept level, the ink will keep moving downward while it is wet.

Leave the color to dry under the texturing materials for at least three or four days. To help the drying process, keep the humidity in your studio to fifty percent or below. A description of some texturing materials follows.

USING PLASTIC FILM

Paint can be shaped and textured with both thin and thick plastic films for various effects. I like to cover the wet paint with a rather stiff plastic dropcloth. One of its special qualities is that wherever the plastic touches the ink, because of the film's hard, smooth, nonporous surface, it causes the color to dry with a high, enamel-like sheen. By causing the film to touch the wet ink in some places and not in others, I can play glossy areas against flat ones.

I also use plastic food wrap—Saran Wrap is one brand. It is thinner and more flexible than the dropcloth. The ink under the food wrap still dries with a shine, though it is not as high a sheen as it has under the dropcloth. However, the thin food wrap provides a good way to direct the flow of the inks. The wet paint follows the folds, often leaving a tree-like effect. You can also push the paint around with a roller after the entire painting is covered with plastic if you want more contact areas, or you can let the plastic settle by itself. Many times a painting is complete at this stage, without further work.

Step 1. *Indigo ink is poured across the top of the page and pieces of plastic are placed into the wet ink.*

Step 2. *A blue ink is added to the top of the painting and burnt sienna is poured into the middle section. Again more pieces of plastic are placed in the burnt sienna ink.*

Step 3. *The wet ink and plastic pieces are covered with a plastic dropcloth and left to dry.*

Step 4. *When the painting is dry, the dropcloth and plastic pieces are removed. Then opaque white ink is washed over the bottom of the painting and white lines are added with my special drawing pen.*

Texturing with Waxed Paper

Waxed paper is another texturing material. It comes in two thicknesses: the ordinary kind found in supermarkets and the heavier weight used by butchers. You can apply waxed paper as cutout shapes or spread it full length across a painting. You can also crumple, fold, or tear it before placing it on the wet paint, then cover the entire work with a plastic sheet to dry.

When the painting is dry, wherever the ink has come in contact with the waxed paper, it is now coated with wax and has become smooth and glossy. It is now as shiny and as tough as a waxed floor, and you can rub it until it glows. Sometimes, if you find the effect pleasing, you can leave the waxed paper on the painting in places, as a sort of collage, but be sure to use acrylic gel medium under the waxed paper to adhere it.

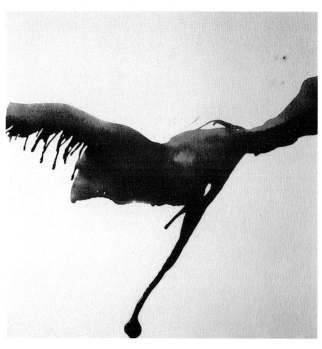

First Pour. *Burnt sienna ink is poured over the water-color paper in an unusual shape.*

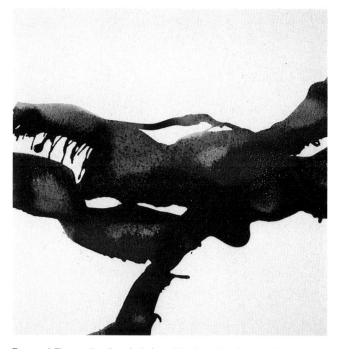

Second Pour. *Indigo ink is added to the burnt sienna, modifying its shape and color.*

Project

Pour several colors over your watercolor paper in planes or layers. Then add waxed paper to different areas. Some pieces should be crumbled, some twisted, some pinched, and others laid flat. Then cover the papers and paint with a plastic sheet and let it dry. When dry, choose two opaque paints or inks and decide where you're going to place them. Then pour the colors over the areas you want to modify. Notice the different textures left by the various wax paper sections. The wax of the paper repels the ink wherever they touch. The colors you choose can be as subtle or bold as you wish it. Remember, if you want to texture the new (second) pour, cover the area with plastic as it dries.

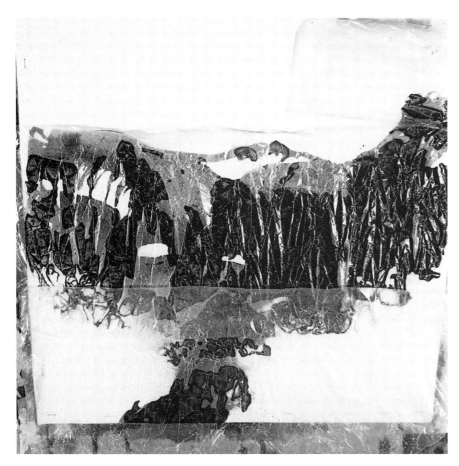

Third Pour. *Magenta is poured across the bottom. Then layers of crumpled wax paper are placed over the entire surface and the painting is left to dry.*

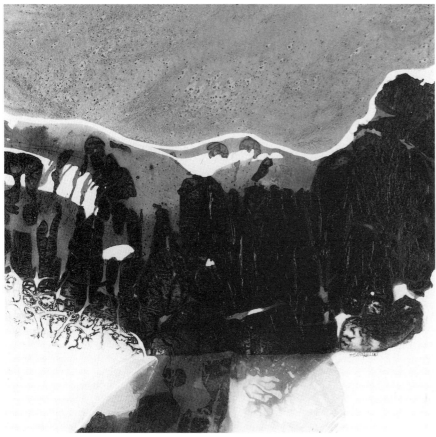

Final Stage. *When the paint is dry, the wax paper is removed. A burnt sienna sky area is added, and a bit of canning salt thrown into the wet wash for texture. Then opaque white is poured across the bottom and white lines are drawn in with a pen or poured on delicately in the upper area. The small areas accidentally left white and not wanted can be carefully filled in with colored markers when the painting is dry.*

Texturing with Found Objects

Begin looking for and collecting materials that can be used for forms and textures. During visits to the country, collect bits of tree bark, branches, dried leaves, grass, ferns, flower petals, seed pods—any sort of natural materials that have a flat, decorative surface. Avoid three-dimensional items without a flat surface, such as most shells because they are hard to work with. The materials you collect should be slightly absorbent, like feathers or leaves. Studying natural objects will lead you to discover recognizable shapes and textures in manmade materials, too.

Now, also look for various plastic materials, such as shower curtains with embossed patterns, plastic package wraps (in some cases, printed designs will transfer onto a paint surface), bubble plastic, different weights of cellophanes, commercial plastic lettering (found in art supply stores), and waxed papers. These objects produce interesting patterns when placed under the plastic film.

With the bulkier of the natural and man-made materials, you'll have to use weights to keep the contact constant during the drying process. Corners of the plastic, for example, can curl up and away from the ink surface. This may be an effect that you may want at times, but experiments can decide that. When weighting your materials, you must consider how much weight is necessary and where to place it, for it can change the effect if it creates its own contact areas or flattens the plastic dropcloth between shapes.

Always be alert for unusual textures. For example, on a recent visit to my dentist, I noticed an interesting embossed plastic bib he placed on patients. He gave me a dozen or so and I applied them in one of my paintings. It left an interesting grid texture. Some linear textures can resemble crystal formations, frost patterns, mushroom gills, and sheaves of grain. Look for such patterns all around you. Awareness is an artist's most valuable asset.

Natural materials like these make excellent textures in a painting.

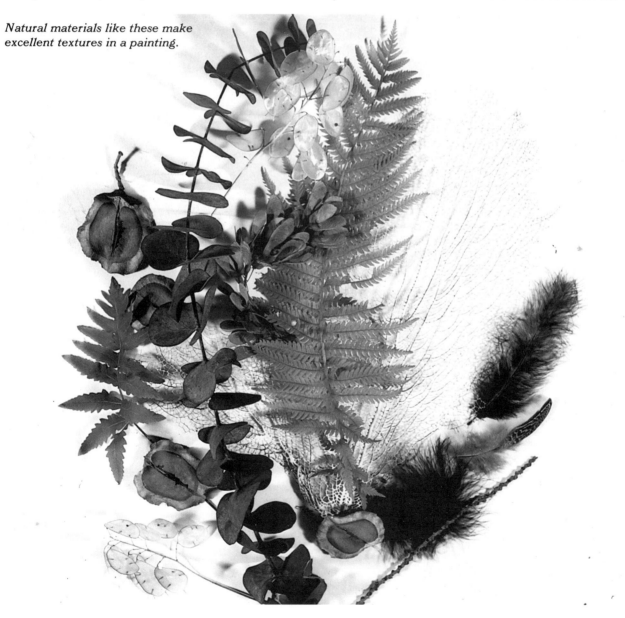

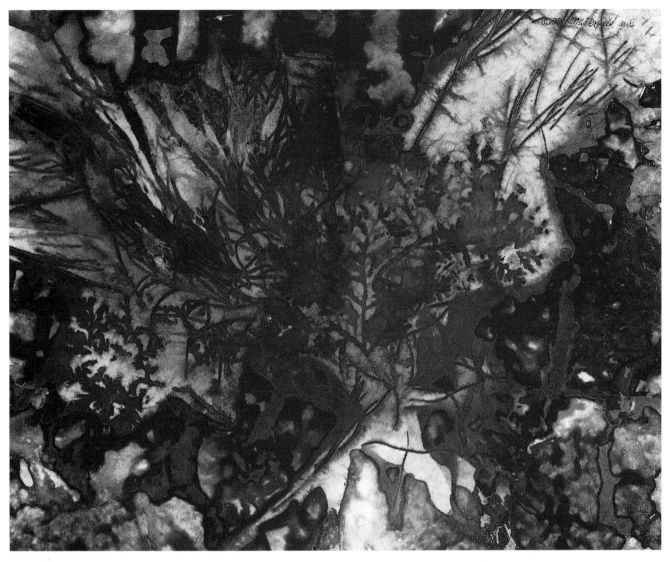

MAXINE MASTERFIELD, *LEAVES.* 20″ × 25″ (51 × 64 cm).
Courtesy of C. G. Rein Galleries.

While walking along a beach, I gathered flat leafy shapes from fir trees and shrubs. Back at my studio, I arranged them on a stretched paper, and freely poured color (ochre, spring green, and burnt sienna) over the branches and leaves. Then I covered the piece with a plastic film and weighted the surface to establish contact with the ink while it dried. This took a week. When the film was removed, the shapes remained.

Project

Begin with a small piece of stretched watercolor paper (around 12 inches—30.5 cm—square). Pour several colors across the surface, making sure each color is separate from the rest, or maybe just slightly touching. Use enough ink to form puddles, but not so much that it runs off the board. Don't worry about the composition. This is just a test piece to see how the plastic works. You can let the plastic fall and make random contact on its own, or attempt to guide it. You can also pre-crinkle or gather and twist areas before you set it down. And you may even push or squeeze the ink around once the plastic is down to get the color to cover a dry section or have one color invade another. Some interesting results also occur when you tilt the board after the plastic is down.

Choose a section of your painting and sprinkle canning salt on it for a contrasting texture, before lowering the plastic onto it. Try other variations and change to a larger paper. The plastic can be folded or tie-dyed before laying on the ink, too. Remember to let the work dry thoroughly before you uncover it.

Layering Colors

After the first layer of paint is dry, and the plastic cover and wax paper or other materials are carefully removed from the painting, you may feel that the expression is not yet complete. It may still require more shapes and emphasis, depth, or clearer definition of what subject or overall feeling is being communicated. You may also feel a need to alter the composition or colors.

Layering refers to the addition of other layers of ink. This cannot be done on ink that is still wet, for instead of a new layer, the second layer of inks would combine with the first layer. In addition, colors still wet will blur and smear, and may become muddied. The original shapes will also be undefined, if not lost entirely, if new shapes are added while the paint is still wet.

The layering process usually consists of using shapes cut out of some nonporous material such as waxed paper, film, or plastic. A porous material would soak up the ink, and since the dry ink underneath is permanent and impermeable, the new color needs to be kept suspended and intact until dry.

After the shapes have been cut out and it is decided where they will go, color is carefully poured over the area and the cutout shape laid in place over it. The ink then spreads out and takes the same form as the cutout. The forms should touch, but if they overlap, the inks won't mix. For example, if you place a round form on red ink next to a square one on green ink, where these two forms meet, the two colored inks will blend. But if you have overlapped these two forms instead of butting against each other, no such mixing will occur.

If you want to keep the exact outline of your cutouts, be sure that all its edges contact the ink and paper, and that there's enough paint there to do it. Of course, you can also layer colors without using cutout shapes—by pouring or brushing colors in desired areas and allowing them to dry.

A cover of plastic is placed over the painting during the drying process. The plastic cover makes it possible to spread the ink or make contact shapes in the new color areas by applying pressure. It also holds cutout edges down. Finally, the cover slows down the drying process and keeps the ink and paper contact constant. Remember, weights can be used when needed during all the drying processes.

Unless you have applied paint over some areas that were unpainted, the drying time will vary according to how much new color was added. The first layer of ink seals the surface, and takes longer to dry because it soaks into the paper.

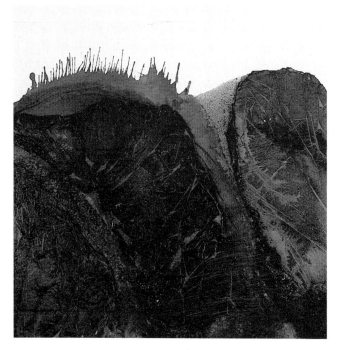

First Layer. *The original pour of blue was left to dry with a lightweight food wrap over it.*

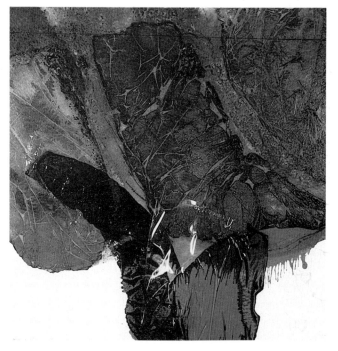

Second Layer. *I began to build the layered shapes of color after the first pour was dry. After removing the plastic wrap, I poured fresh color (magenta) over the dry paint. Then I put clean plastic food wrap over these newly painted areas to create another layer of textures. As you can see, I decided that the painting looked better upside down, and so reversed it.*

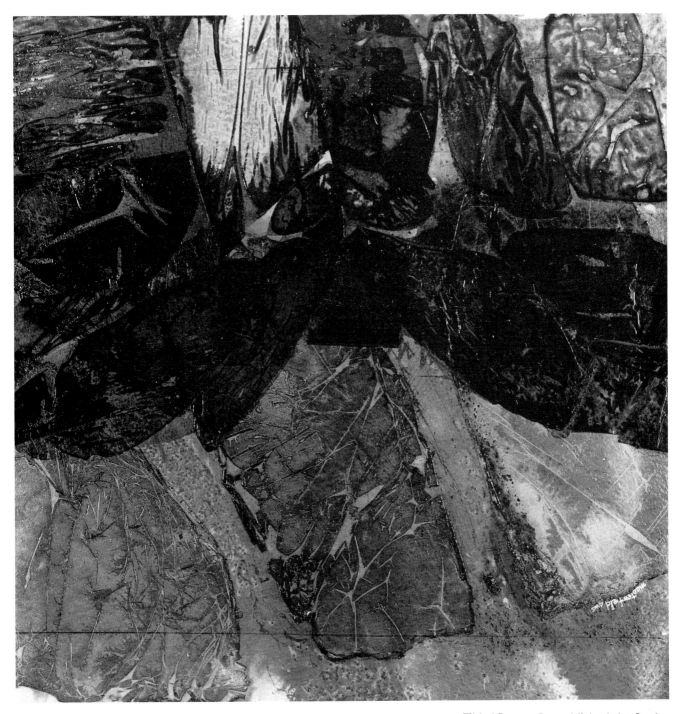

Project

Try to find as many similar shapes in a dry, single layer painting as possible. Develop a layering using a similar form repeatedly, sometimes giving it soft and sometimes letting it leave hard edges. Cluster some shapes, and isolate others. By repeating these basic shapes, you can create an underlying rhythm that will unify the expression. This method will result in a stronger statement.

Third Layer. *I established the final layer, particularly in the middle ground, with washes of dark blues and lavender. Then I placed the crinkled plastic wrap in the wet paint and left it. When it dried, I removed the plastic and I was done.*

Painting Out with Resists

Once you decide to paint out an area of a painting, you must determine how you want that area to look. Washes can be white, deep-colored, or tinted; they can also be transparent or opaque. Your choice of a wash should match the problem to be solved. If you want the shapes or colors to be veiled or subdued by the overwash, but still visible (like the effect of fog or water spray), than transparent washes should be used. If you want to obliterate the underpainting completely, then obviously opaque or dark paint should be your choice.

During the painting-out process, you can spray water on certain areas to diffuse and thin the ink or to modify the degree of its opacity. You can also use a resist to prevent the paint from adhering to the paper. One such resist is Pam, a vegetable oil spray used in cooking. The areas sprayed with Pam will resist the next layer of ink, adding texture to your painting.

You can also use waxed paper as a resist to create texture. Wherever the waxed paper has touched the ink, the next layer will be repelled. Therefore, for this second layer, I use opaque Pelikan ink. You can vary the patterns by crinkling, folding, or laying the waxed paper across the paper. As before, when you're finished, you can leave the painting to dry uncovered, or cover it with a plastic dropcloth. The plastic will also add its own texture and shapes to the drying ink.

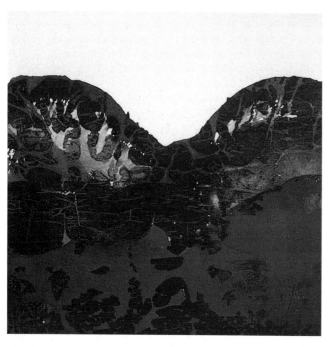

First Layer. *The painting began as a three-color pour of magenta, blue, and ochre. Then waxed paper was placed over it, forming the shapes you see here, and the ink was left to dry. During the drying process, wherever the wax had touched the ink, it was transferred onto the paper.*

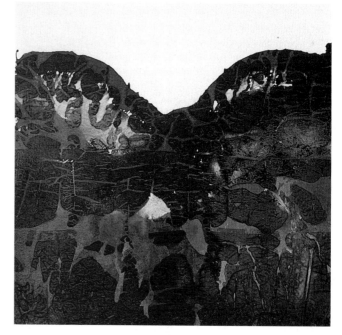

Second Layer. *After the first layers dried and the waxed paper was removed, a bright red opaque ink was washed across the foreground over the magenta ink. The dark areas represent places where the wax caused the wash to bead and resist the ink.*

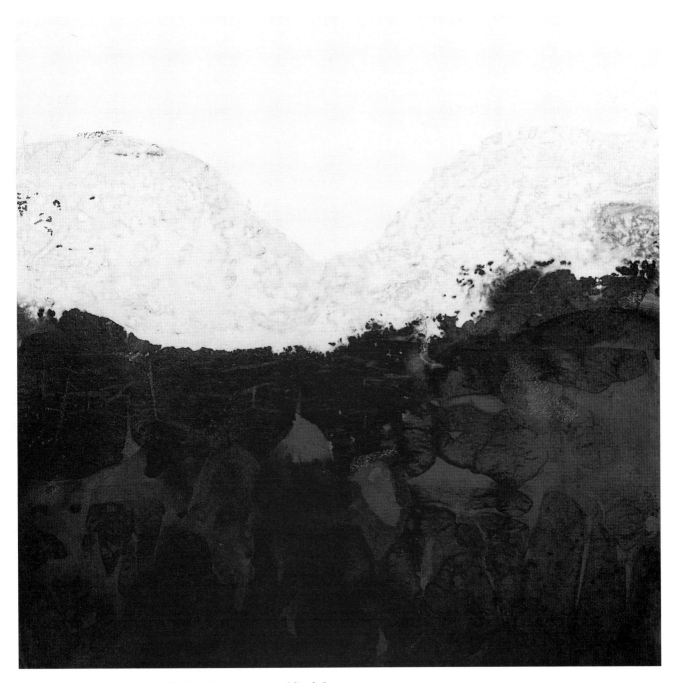

Third Layer. *When the red ink dried, opaque white ink was washed over the upper area of the painting and water was immediately sprayed into the white ink to soften the lower edge. Notice the texture of the red wash achieved by the preceding step.*

Painting Out with an Airgun

Many natural materials, such as the Brazilian agate geode shown on page 87, contain soft edges and milky areas. Among the sharp and colorful spreading forms and strata of the rock, there are also expanses of solid color of graded opacity. You can duplicate these natural effects of soft edges and an even coverage of color by applying inks and water paints with a powered airgun or aerosol spray.

The airgun is a versatile and convenient tool, but there are also small aerosol spray heads on the market that fit the plastic ink containers precisely, so inks can be sprayed directly from their original bottles.

Painting out is useful under certain circumstances. Often, certain small areas of a painting ("trouble spots") are completely unacceptable, even for textures. So I mask off the surrounding areas I want to keep and eliminate these problem areas by spraying them out. I also spray ink into areas that are wet for interesting effects. And in a painting that has too many hard edges and textured surfaces, sprayed ink can bring just the subtle difference in handling the painting needs.

You can also use the airgun to transfer a shape onto your paper by spraying over the object, using it as a type of reverse stencil. In the demonstration, I used a piece of coral to get this effect. Later, dissatisfied with the outcome, I re-used the coral and added a folding fan repeating their intricate designs in the composition. Spraying *through* lacy and carved objects is often the only way to achieve a particular effect.

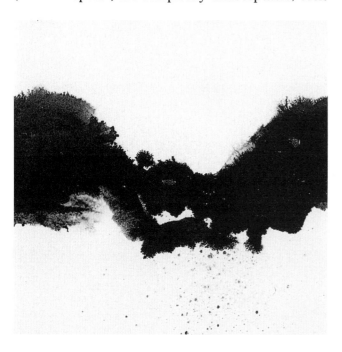

First Stage. *Indigo blue and raw sienna ink is poured over the paper.*

Second Stage. *Pieces of coral are pressed into the ink before it dries.*

Third Stage. *A plastic sheet is placed over the painting and it is left to dry.*

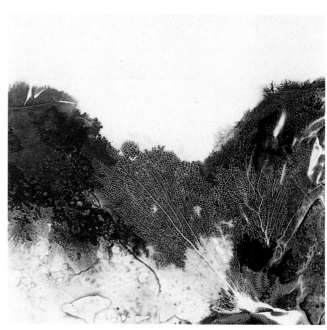

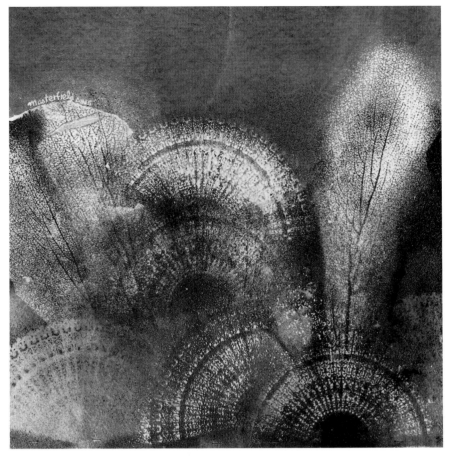

Final Stage. *This is a good example of how drastically a painting can change from beginning to end. I decided to ignore the original forms and textures and began to play with the coral. I also added a fan. I placed them in various areas of the painting and sprayed combinations of pastel blue and then white over them. Some of the earlier shapes and colors bled through the airgunned layers and caused subtle shapes to appear.*

Project:

Pour two or three colors onto a piece of watercolor paper, but this time put a natural object into the wet ink. Try spraying various colors around and through the objects, then let the ink dry. Continue alternately spraying and drying the ink until your design pleases you. You can select various shapes, such as circular, square, or rectangular objects, and combine soft edges with hard for variety and interest.

Sometimes a different color will form the division between forms, and sometimes the division between forms will just be a deeper area of the same color. You will soon find many shapes within other shapes, the lines will become more profuse, and you will have built up a texture. By using smaller quantities of paint in the initial pour and working in terms of smaller planes, you will get a more intricate finished line project. You can use brighter colors that mingle and create new hues and tones to unite the basic areas. You also may wish to experiment with several small paintings in which you alternate the base and line colors, or where you drop or spatter the inks instead of pouring them. Continue to experiment. See what happens when you let the inks dry without a plastic cover, or when you don't put any shapes into the ink.

Adding Line to a Textured Painting

Like many painting decisions—on what colors to choose or how to texture an area—the decision to add line is a purely optional one. I may want to use just a touch of line or add an extravagant network of lines, or leave it out altogether. It all depends on the needs of my painting. The color and placement of the line is also dictated by the needs of the specific work.

Selecting the right tool to apply the line, one that would give the line the right viscosity and flow, is also important. In my constant search for new implements, I came upon a most wonderful drawing tool. It is a plastic bottle with a fine hypodermic-like needle attached, used by commercial plastic fabri-cators to apply glue. There are various size openings available, but I prefer their finest needle. This "drawing pen" is inexpensive and can hold over an ounce of ink. The color flows freely and seldom clogs if you cover its tip between use and run water through it afterward. But you must clean it immediately; once the ink dries in the needle it is impossible to remove. (The pen is available from Gaunt Industries, 6217 Northwest Highway, Chicago, Illinois 60631. Ask for their list of hypodermic oilers used for oiling, greasing, and cementing. I buy their 1 1/4 ounce oval-shaped polyethelene bottles with a "hypo-200" 25-gage needle.)

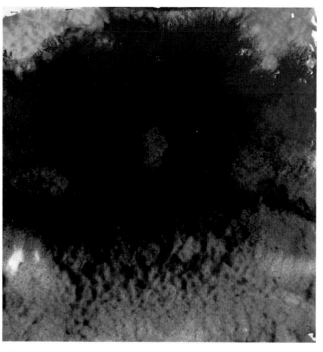

First Pour. *A mixture of gold, blues, magenta, and reds is poured over the paper, covering the entire surface.*

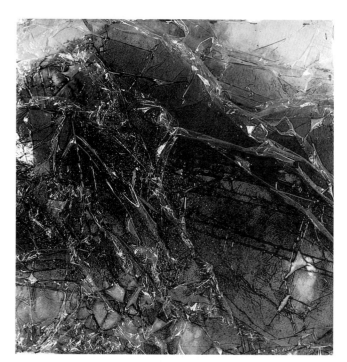

Adding Texture. *While the colors are still flowing, a large sheet of cellophane is placed over the wet surface. Allow the painting to dry like this for at least three or four days.*

Project

Pour small amounts of ink or paint on a sheet of prepared watercolor paper and tilt, spray, or disperse it in any method you wish. Cover some areas with small strips of cellophane or plastic, then put a plastic sheet over everything. When the painting is dry, remove the coverings and see what is suggested—perhaps a particular scene in nature. (Of course, you may just leave it abstract.)

Begin outlining first the larger shapes you see, then the smaller ones. Use black or any color you think would look good. As you work, you'll discover even more shapes, subtler and smaller than those you first saw.

my "drawing pen"

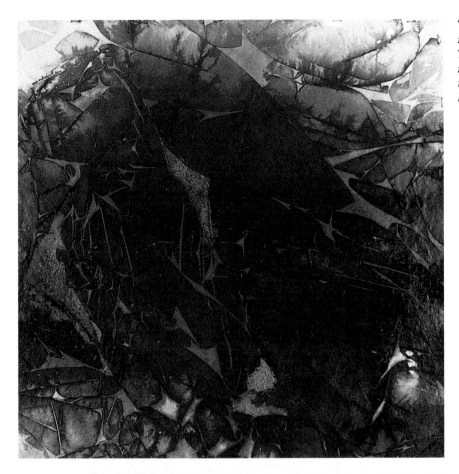

The Textured Surface. *When the ink is dry, the cellophane is removed. The colors now follow the forms made by the folds of the film. This is the way a typical painting looks before line is added.*

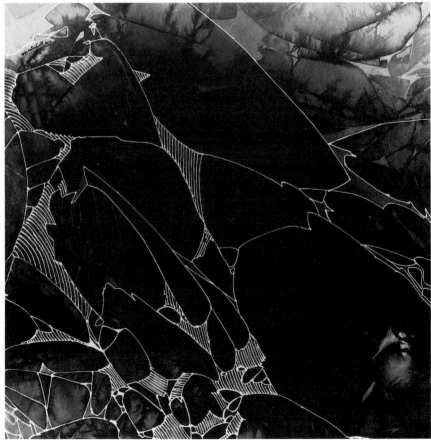

Adding Line. *The various forms are accented by delicate opaque white lines, drawn with a drawing pen.*

27

Restructuring an Image with Collage

Often, in the process of experimenting and painting, I feel there are works that cannot be resolved through layering, washes, or line. Yet parts of these paintings are too beautiful to dismiss. Sometimes it may only be a particular shape—or sometimes a texture is the real prize. I have been able to use these exceptional parts of an otherwise failed painting by carefully cutting them free. The sample paintings shown in the collage demonstration shows how I was able to combine sections I liked very much from two different paintings into a finished whole.

Obviously, such solutions don't come easily. I often leave unresolved paintings around the studio and glance at them now and then as I think of new experiments to make on them. When I collage paintings together, I use an acrylic gloss medium or white glue (like Elmer's) that dries clear and observe the precautions on permanency by backing them with an acid-free paper-covered foam core board (see list of materials).

THE MONOPRINT COLLAGE METHOD
Although the most successful areas of my paintings are collaged, I also save the rest of the rejected painting for use in monoprint collages. I tear these unsuccessful pieces of previous paintings into shapes and drop them into containers of different-colored inks. I often add salt to the ink to thicken it, and let the papers soak in ink for several days. As usual, time is an important element.

After a few days, I remove one saturated piece of torn paper from the ink at a time and place it on my prepared paper or unfinished painting. Then I run a roller over the piece to press the ink into the surface. When I lift the piece of watercolor paper, its shape, color, and texture are left behind. This is called a monoprint because it is a one-of-a-kind image. You could probably never transfer exactly the same image to another painting. You can, however, repeat the procedure with the same paper and get similar results in differing strengths of color and textures with the same shape of paper.

When you have finished making monoprint images, you can place the paper where it will look best, and collage it onto the surface of a painting. You can collage waxed paper, too. But you don't have to soak it in ink. When the wax paper is placed over the poured ink to create a shape, it usually emerges permeated with color and quite beautiful. I have always been rather successful in collaging it onto a painting.

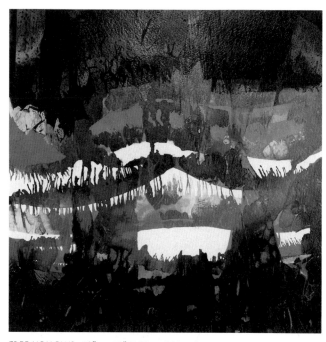

SUMMITS I, 40″ × 40″ (102 × 102 cm).

While there were sections in this painting I liked, I felt that the foreground and sky were too similar and not well enough integrated. I had used the wax paper method for texturing the shapes, and had layered additional washes of color and texture later.

TREE HOLLOWS, 40″ × 40″ (102 × 102 cm).

This painting also disappointed me, though I liked certain sections of it, particularly the top background plane. The background had a rich mixture of colors and effects. I had used a squirting method to apply the ink and had textured the inks with waxed paper and film. Although the outcome was interesting in part, it was not suitable as a whole painting.

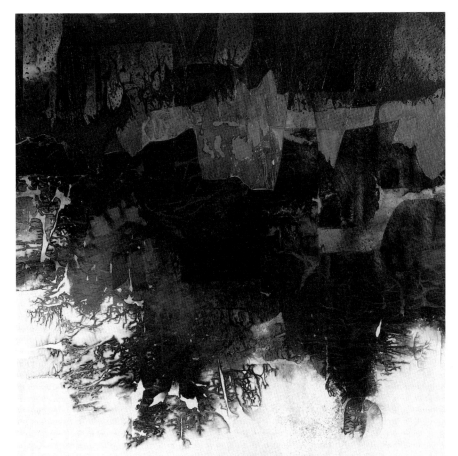

SUMMITS II, 40″ × 40″ (102 × 102 cm). Collection of the Avon Lake Library, Ohio.

I cut what was to be a horizon line to free the lower half of Summits I *(the cut is noted by the dark line) and placed it over* Tree Hollows *so just the portion I liked showed. The combined painting now had the right color and composition, just the right balance. The middle ground shapes no longer appeared too bold and unattached, as they did in* Summits I. *The background, which was now* Tree Hollows, *served in this painting as a dramatic sky area, as a backdrop that now echoed the lively forms and colors of the middle ground. Though this sounds easily resolved, that really wasn't true. Both* Summits I *and* Tree Hollows *hung around the studio for some time in their unresolved states before I thought of this solution.*

Project

Look through paintings you're not satisfied with and pick out areas with good textures and shapes. (Unsuccessful portions of paintings will always remain unsuccessful, even when re-used.) Begin with a plain sheet of watercolor paper and lay the collaged pieces onto it. Move them around until you see a configuration you like.

You can also try placing the collaged watercolor on an experimental painting you're not satisfied with and see if the collage possesses any of the colors, shapes, or textures your painting needs. That's what creates solutions—trying different avenues. There are no set rules on the number of pieces needed to complete a painting; add as many as you need.

You can experiment by monoprinting an interesting shape many times before you permanently adhere it to a painting. However, in your first collage experiments, you may want to use a shape exclusively as a monoprint—without adhering it—until you're more experienced. Save your preferred sections for collaging when you have more confidence.

For practice in composing planes, collect some sample horizontal shapes and try different arrangements by varying the amount of each plane that is exposed. Then tilt the planes and see which compositions seem more natural and which ones create tension. By working with small pieces of paintings, you can collage many different plane samples for reference compositions.

Abstract
Naturalism

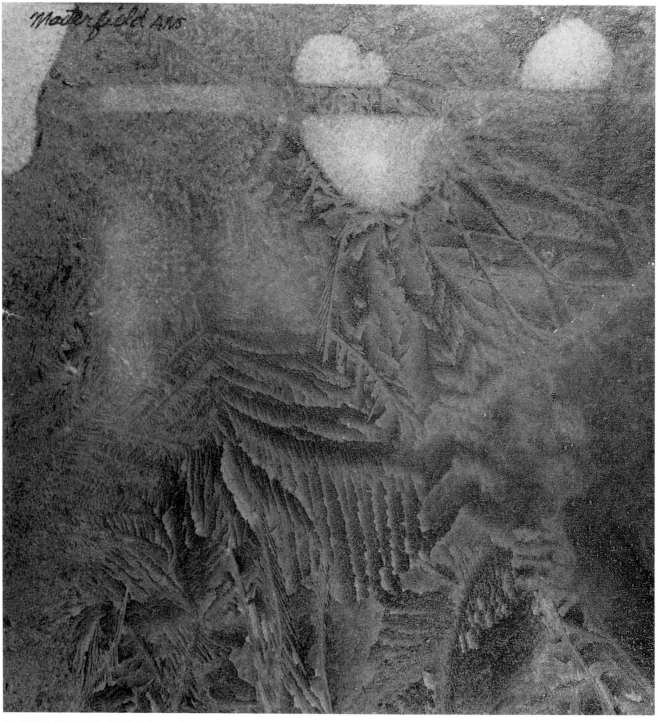

MAXINE MASTERFIELD, FROST. 30″ × 30″ (76 × 76 cm), ink on Morilla paper.
Collection of the artist.

The difference between abstraction and realism is based on philosophy as well as perceptions. Both types of artists are painting the same subjects and, in a way, both are trying to communicate their impressions and are working in a visual mode. But the representational artist is convinced that what is seen through the eyes is the reality, while the abstract naturalist senses that the reality lies less in the surface appearance than in how nature is experienced.

The abstract naturalist artist knows that no one scene can capture the essential reality because nature is always in a state of flux. Also, even among artists, no two people see the same things. Each artist has a unique personal response to express that varies with the subject, point of view, and mood of the moment.

Yet if the problem were merely to capture a moment in time, you may wonder why a photograph couldn't serve equally as well. In fact, on some level, you will see that photographers have seen the same truths about nature as the abstract naturalist. But a photograph, however excellent, is not a painting; the artist is freer to express his or her deepest responses and most subtle personal moods. Furthermore, there are many kinds of photographers—as there are many kinds of artists. Some photographers are content to merely press the camera shutter and think that they are capturing nature with a snapshot. The illustrator that paints a scene exactly as it appears does the same thing. Both think they are communicating by showing visual facts alone.

But there are as many types of photographers as there are artists. The photographer who creates a personal mood or sensation by distorting, cropping, or using filters or macro or telephoto lenses is the type that most closely resembles the abstract naturalist artist. Both are after that greater reality and are willing to distort the "facts" to achieve it—because both know that, in the end, it is the mind, not the eye, that controls our vision.

POINT OF VIEW

Abstraction is often a matter of perspective and composition, and our point of view or vantage point affects the way we see nature. Take, for example, a mountain range. You can paint it as a broad expanse of rock, seen from a distance; you can focus on just one small area within it; or you can even let a single jagged rock serve as a model for the entire range. The point is that natural forms are basic and repeat themselves continually on many different levels. You can see the universe in a drop of water, or view it from a satellite in orbit. The painting you choose to make depends on your point of view—your scale and perspective. As an artist, you are free to interpret nature, shaping or distorting whatever is necessary to communicate your meaning to the viewer.

The paintings in *Painting the Spirit of Nature* provide a wide range of viewpoints, from closeup abstractions that resemble photographs taken with a macro lens, to distant bird's eye views that perceive Earth from a plane or some orbiting satellite. As an artist you can create a greater reality—but only if you respond to nature with an open mind and a free spirit.

NATURE AS INSPIRATION

How can we use nature as a model for abstractions? In my studio I surround myself with favorite rocks, agates, geodes, minerals, and fossils. During my visits to the country I collect bits of tree bark, withered apples, seed pots, or any intricately designed bit of nature I can carry back with me. Often before I begin to paint, I sit in front of my collection and study the various shapes and inner forms. By studying the details and focusing on them, I train my eyes to seek out the more abstract images in nature. They are everywhere—in clouds, water reflections, microscopic forms, cracks in walls.

Look at the sky, earth, and life cycles of organic matter. These are the elements of our environment. Explore the infinite variations of patterns. Experience the landscape by feeling it as well as seeing it. If your techniques are not accompanied by a concept, your work will lack direction. Invent new textures and become more aware of familiar ones, and think of new ways to produce them.

Throughout this book you will see comparisons of photographic studies of nature and abstract naturalist watercolor paintings. For the most part, each artist was inspired by different sources in nature. But nature and art are allied. Sometimes the loosest, most expressive painting can surprisingly turn out to be an imitation of nature.

Sometimes the elements become my tools. For example, a series of paintings developed accidentally in temperatures below 0° fahrenheit (−18° celsius). I had just returned from giving a lecture-demonstration on collage painting. Because of the late hour and freezing temperatures, I decided to leave my paintings and materials in the car overnight. When I returned the following morning, I discovered that my small paintings had been sitting in containers of ink about an inch deep, and the ink had frozen on them in the most beautiful patterns of frost, like the kind found on windows. I carefully removed them from the containers and let them set for a few days. When they dried, I discovered that the crystal forms had become trapped—I had captured them. A new technique had been added to my repertoire, entirely by chance!

Using Nature for Abstract Compositions

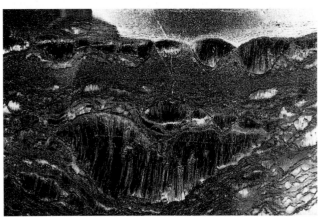 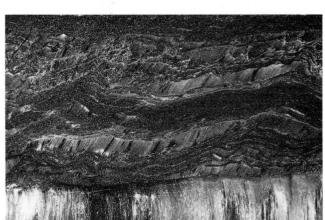

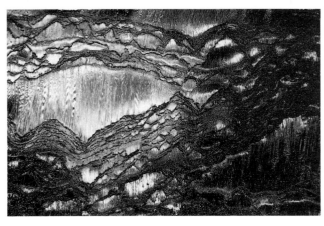

AUSTRALIAN TIGER EYE, photographed by William Horschke.

These are photographs of a tiger eye specimen from my collection. The first photo shows almost the entire surface of the sample. The other pictures gradually focus in closer, featuring different sections of the stone. Some views resemble mountains, some ocean waves, others a night sky. The last one, in its macro graininess, looks more like an abstract painting than a particle of nature.

Art is under the control of the artist, but nature is more random in its designs, with some sections better "designed" than others. Yet the eye of the photographer composes too, framing the focused area. There is nothing new in nature, but its countless ingredients are eternally being shuffled into different combinations. There is a lesson in this for the artist, too.

Compare the first photo with the painting opposite. Like the painting the forms in the stone are so suggestive of night and ocean waves that they impart an almost eerie existence to the "scene." The colors in the stone appear to emanate from within the "waves" and aren't just reflections. In both painting and stone the sections of white seem to be forms catching the moonlight punctuating the wave crests. The colors in the painting are suppressed; those in the stone are more daring. Yet the drama is evident in both.

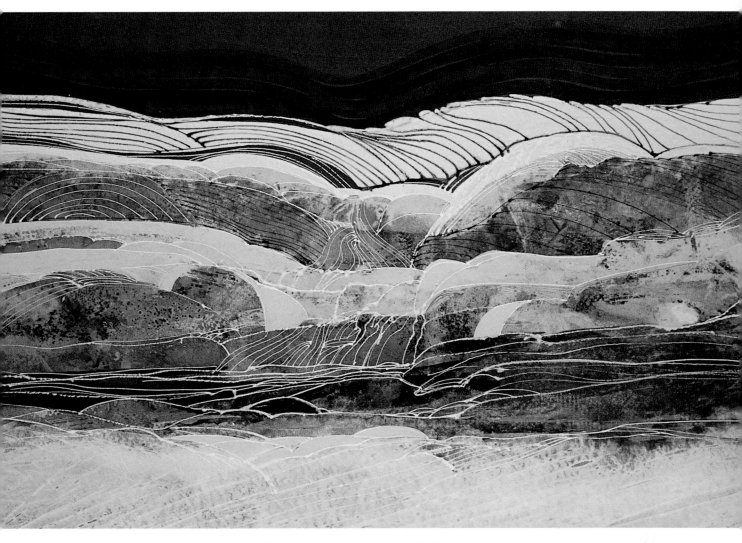

MAXINE MASTERFIED, *AFTER A LONG NIGHT.* 38" × 40" (97 × 101 cm), watermedia on Morilla paper.
Collection of the National Watercolor Society, 1978.

In this painting I used line to create the effect of water motion. After I poured several colors and they began to dry, there was barely a suggestion of water. So I put on a tape of Japanese music, and this, together with my past studies of Oriental art, triggered the Far Eastern influence. There was soon life and movement in the water and the swelling and crashing of successive waves suggested a mixture of froth and crystal. The moody darkness of the sky suggests the almost other-worldly feeling of being in the overpowering presence of energy forces.

Recreating the Textures of Nature

MARY BEAM, *THE LAST SONG.* 20" × 24" (51 × 61 cm), acrylic on no. 100 Crescent board.
Courtesy of Windon Gallery, Columbus, Ohio.

There is an amazing resemblance between Stirn's photograph and Mary Beam's painting The Last Song. *Both are dramatic in color, texture, and composition. The wall, though never seen by the artist, duplicates the aging process and texture through lichen, moss, and silt deposits. The high-key band in both painting and photo adds contrast and a sense of perspective rather than a feeling of separation. Both nature and the artist integrate basic forms into a design.*

Project

Cover a hard surface, such as a Crescent watercolor board, with a large acrylic wash and try texturing the wet wash with alcohol or salt.

Mary Beam explains that her painting "was inspired by a memory of the colors and textures of the bark of an old sycamore. I wanted to show the aging process and convey a feeling of timelessness. I wasn't trying for a literal rendition of something specific, but for an interpretation of this theme. The results grew out of the process of painting.

"When I paint, I strive for richness of imagination. I don't plan a specific range of colors or techniques, but just let the painting happen. I choose a process from my repertoire of techniques that would say it best, and let the things that are happening in the painting suggest the end product. In experimental painting, anything can happen; it is always out of control until the end.

"My favorite techniques vary widely and, since I experiment, they change frequently. I usually start with a large (4"/10 cm) brushes and a spray bottle of water, spraying my paints to keep them fluid. I also vary the size of my paintings. Since this painting was to suggest a concise idea, I wanted it to be small. Starting with an overall acrylic wash of burnt sienna, yellow ochre, and violet, mixed right on the paper, I flattened the planes

of the picture. As I worked, shapes and suggestions of objects started to emerge, a form and mood started to develop, and certain textures began to suggest a theme. As each layer dried, I painted lighter, transparent layers of paint over the darker ones, building up layers of color and letting the darks show through. This layering and glazing of colors permitted me to retain control over values. I also flicked alcohol on the wet surfaces to age them and reveal some of the color and design of the adjacent layer.

"In this painting, I stopped the action of the fluid paint with pieces of plastic cut into different shapes. The moon and bird shapes were cut out, laid over the paint, and removed after the paint had set.

"It is always difficult to tell when a painting is finished, but I usually have an inner sense that tells me that I've accomplished my goals. Here, I wanted to lead the eye through the painting by urging it to follow subtle changes of texture instead of hard and soft edges. My finishing touches were geometric lines that stopped the action of the eye and prevented it from moving too rapidly through the painting."

Painting Vast Perspectives from Closeups

MAXINE MASTERFIELD, *TEEMING MOUNTAINS.*
38″ × 40″ (97 × 102 cm), watermedia on
Morilla paper.
Collection of the Eaton Corporation.

*I can almost feel the chill of the
melting mountain snow rushing
down the lake. The mirrored surface
of the water, blurring and magnify-
ing the colors, is seemingy awesome
in scope. This painting began as a
demonstration of my spinning table,
in the days before I had discovered
the white line or drying techniques
with film and wax paper. The pieces
in the center of the painting were
added last in a collage process, to
give the work a touch more color. I
began the base painting with sepia
and gray ink, pouring the white ink
last. Wherever salt was added, the
white ink receded, texturing the
mountains with snowy crags on the
horizon. The larger shapes in the
foreground were added with a brush
before the rest of the painting was
dry.*

STREAM SHALE (Gros Ventre, Wy., July, 1979),
photographed by Howard Stirn.

*Maybe because I, too, was once
inspired by Gros Ventre, I am taken
by the resemblance of color and
form between these two visions, the
painting and the photo. The con-
trasty texture of this large shale
section echoes the veined and traced
early spring mountains of my
painting. The earthy-colored shale is
paralleled in the reflection of the
lake's edge. The intricate edges of
shale chips in the left foreground are
represented in the many-lined
surface of the lower corners of the
painting. The strength and solidity of
my painting is felt in each of these
views.*

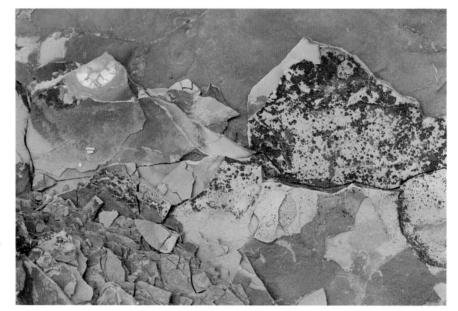

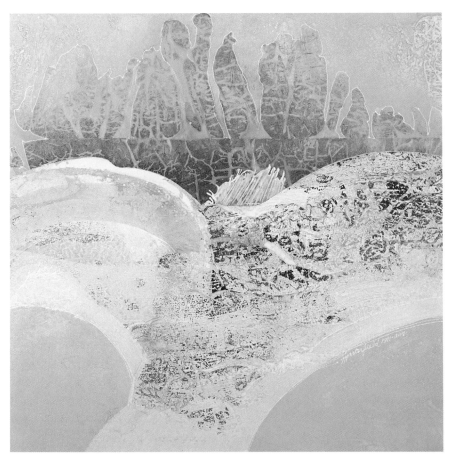

MAXINE MASTERFIELD, *WHITE DOVE OF THE DESERT.* 36" × 40" (91 × 102 cm), ink on Morilla paper.
Collection of Mrs. Pat Shimrak.

This painting's title came from my first encounter with desert blooms in Arizona. They were so delicate. I had also just purchased the Mexican lace agate specimen. The frosted lacy fingers reaching up from richer colored strata in the agate are easily recognizable in the painting. Both blooms and agate were formed by the forces of gravity and time, with color seeping and seeking the most opportune paths.

I began pouring raw sienna, burnt sienna, and sepia inks over the paper, then added waxed paper to the bottom half and an oil cloth to the top half. After the painting dried and all covering was removed from the paint, I brushed a mixture of white ink and lavender across the entire surface. Wherever the wash encountered a waxed surface, it resisted the wax and beaded up. This allowed the underpainting colors to emerge and produced a webbed and textured pattern. I drew the lines in the center after I decided that the subject looked like a desert bloom.

MEXICAN LACE AGATE, photographed by William Horschke.

This is the specimen of Mexican lace agate that inspired my painting.

Finding a Pattern in Floating Leaves

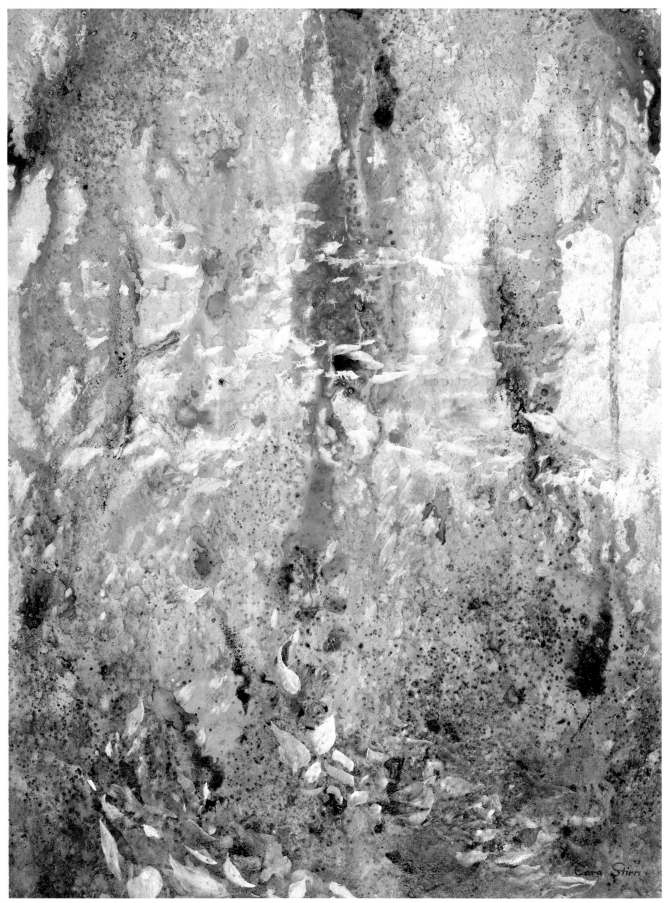

CARA STIRN, *JOURNEY.* 28" × 21" (71 × 53 cm), inks on Morilla board.
Collection of Petro-Lewis Corporation, Midland, Texas.

Cara Stirn says, "As a child, I loved to play in the wooded streams, pulling out small fallen branches and rearranging the stones to make the stream more interesting. I decided my painting would become this particular stream, and that I would tell the story of the leaves (myself and others) traveling through the flow (water) of life, not knowing when or where the end would be.

"I began by stretching the board, and let it dry completely. Then I chose five different Pelikan inks and poured them into separate plastic bottles with screw-on, narrow-opening tops. Then I squeezed cobalt and Prussian blue inks, one at a time, at the top of the painting, to portray the coolness of the water. To show the movement of the water and its lyrical S-curve, I sprayed the inks with water and tipped the board from side to side to get a swinging motion of blended colors. Then I turned the board around and applied the warm colors of the autumn trees reflected in the water. As I worked, I felt as though I were actually in the water, moving around in it. I could feel the coolness at its depth and the warmth of its reflections. While the paper was still wet, I added leaves with drops of vermilion, carmine, and yellow. I controlled the values by salting the wet color with both coarse (kosher) salt and rock salt. The salt constricts the color and darkens it. To lighten the color, I sprayed water over it to dilute it. I worked from dark to light using bright, pure colors mixed on the painting to convey drama and excitement. The weight of the paper also added to their brightness; its nonabsorbent surface kept the colors from sinking in and losing their brilliance. Adding the salt solidified the ink in some places so it didn't move as fast as in other areas. The salt made small areas that looked like leaves and created dots or staccato points for the babbling water.

"When the painting was nearly completed, I referred to my husband's photograph to add more leaves to the foreground and sprinkle sunlight throughout. I mixed cel-vinyl white with a small amount of violet or vermilion or yellow ink. Then I painted the leaves with a sable brush, blotting them with a tissue in order to get the "fade-in, fade-out" look. Some of the leaves were grayed to give the look of old leaves below the surface, while others were painted light to look like newly fallen leaves on the water. The brushstrokes that represented the light were put in the foreground and background to show the wind's movement on the surface."

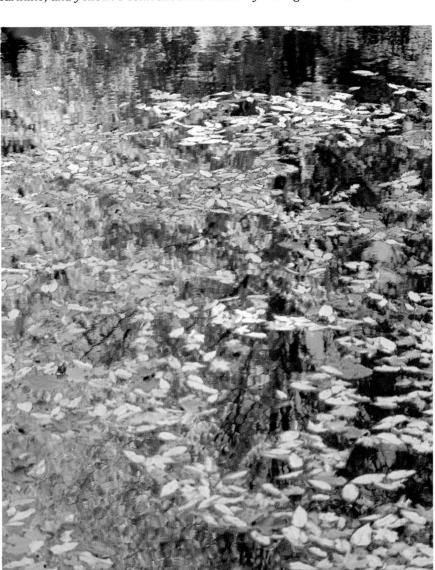

FLOATING FALL LEAVES (Reflections in a Vermont stream, 1978), photographed by Howard Stirn.

This remembered scene was shared by Howard and Cara Stirn, and the rhythm and feeling is undeniably the same. The dividing currents herd the floating leaves into groups, provide areas of open water for mirrored glimpses of the shore trees, and use the same tranquil S-shaped flow. But the colors in the painting are brighter—with greener greens and more red-rusts, and there is a suggestion of what lies below the water's surface.

Capturing the Rhythm of Rippling Water

"*All of us can identify with art that simulates nature*", *Phyllis Lloyd writes.* "*My inspiration has always come from the natural environment. My husband is an avid hunter and fisherman and I have spent many years as a participant observing the woodlands and streams.* October Stream *is a special sanctuary, a crystal clear trout stream that, in fall, reflects the brilliant foliage on its banks in its swirling currents and perhaps conceals a trout hidden in its depths.*

"*My aim in this painting was to capture the quiet tranquility and mood of this special place, the gentle flow and rhythmic currents of the stream, and the shimmering light filtered by the unseen trees on its banks.*

"*A design concept emerged from the swirling currents. To me they were circular, egg-shaped patterns. I decided to create the rhythm of the stream's flow by repeating these shapes. (Harmony is created through repetition!) I varied the size and position of the egg-shaped patterns, making some hard and some soft-edged, some clustered and some barely visible at the bottom of the stream. The colors reflected the sky, foliage, and undercurrents below.*

"*I planned the painting to be long and narrow, like narrowness of the stream itself. I began at the top on damp paper, layering the watercolors in transparent washes, saving some of the white of the paper. I used the Winsor-Newton Antwerp blue for the sky color reflection and made the stream bottom a very dilute gray-blue. When the washes were dry, the overlying shapes of the current were developed with thin plastic wrap. Pelikan inks—light green, deep green, scarlet, and a touch of yellow—were poured gently under the plastic wrap and pulled into the egg-like designs. Each horizontal strip was placed separately. I added acrylic gloss medium to some of the inks to give the water sheen and reflective quality.*

"*Originally the edge of the stream bank was painted to show at the top of the painting. But after trying various trial mats on the painting, I decided to omit the bank and let only the stream portion show. The impact is in the painting's brilliant colors and the current radiates horizontally.*"

PHYLLIS LLOYD, OCTOBER STREAM.
11" × 16½" (28 × 42 cm),
140-lb Fabriano.
Collection of the artist.

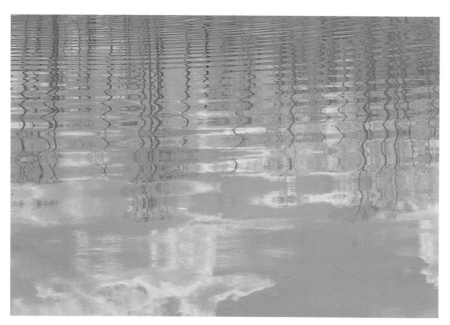

WATER REFLECTIONS (aspen trees at Jackson Hole), photographed by Howard Stirn.

Although the ripple construction in this photograph denotes calm waters, the painted version is more energetic. In nature, the trees reflect off the ripples, but in Lloyd's painting, the colors of the landscapes seem to permeate the waters.

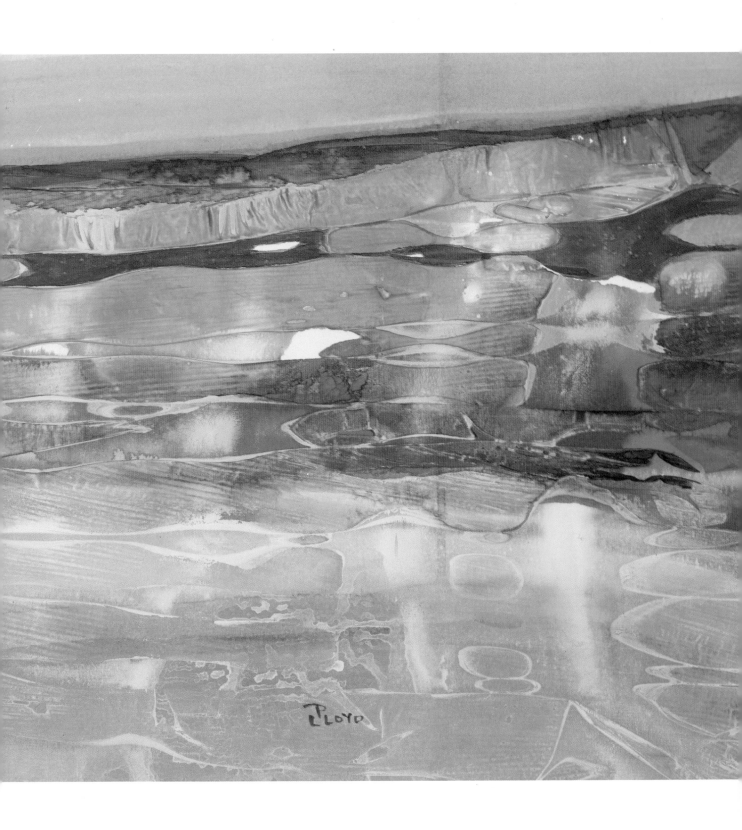

Painting the Rhythms in an Ancient Fossil

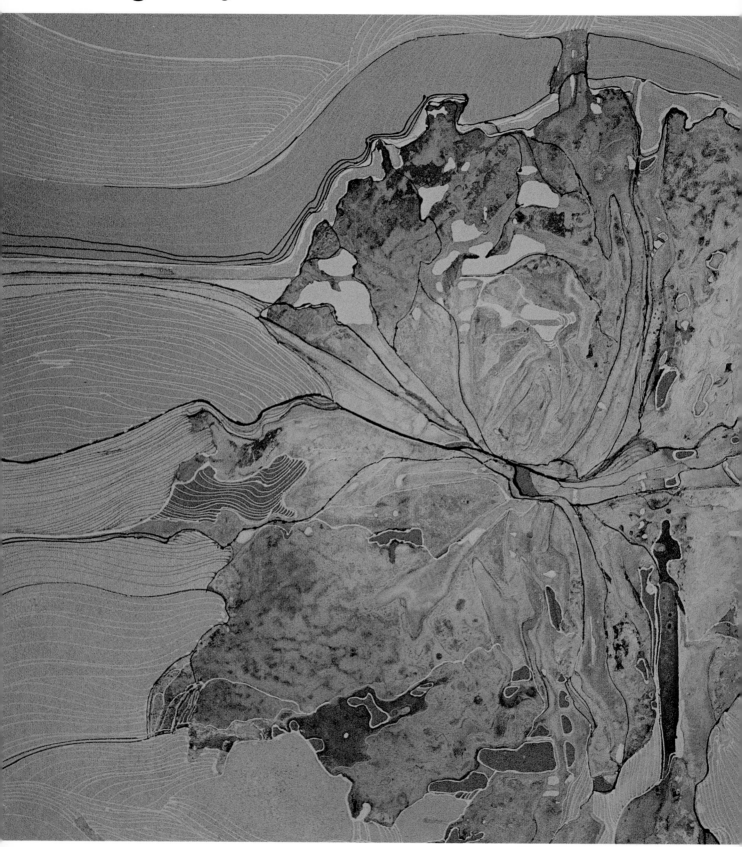

MAXINE MASTERFIELD, *FOSSIL.* 40" × 42" (102 × 107 cm), ink on Morilla paper.
Collection of Mr. and Mrs. Steven Shore.

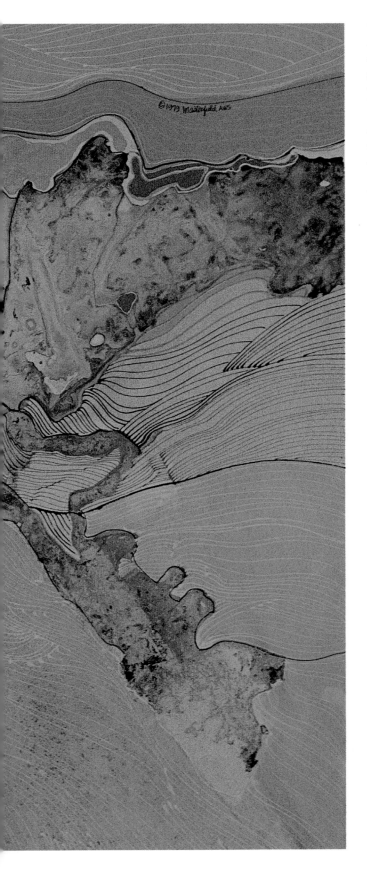

This painting should have been named Fossil Dig, because it was the result of an inspiring fossil hunt my husband and I took in Sarasota, Florida. Within large pits that are dug for road materials, are ocean fossils, millions of years old. After getting permission, several of us went to the pits with our baskets and crawled down the not-too-steep sides and began to hunt. I found a shallow stream and sat in it. All along the edges of the stream there were beautiful shells of all sizes, but you had to work hard to dig them free. I became so involved that only the setting sun forced me to leave. I brought home many beautiful specimens and memories. As I began to paint, I found myself seeing the fossils all over again, and it was some time before the images faded.

Three colors were used—gray, blue, and raw sienna. After the colors were poured across the surface, a large, heavy oil cloth was placed over the entire surface and all was left to dry. I found that, after removing the cloth, much drawing was needed to add definition. It was only at this stage that the concept of the fossil was revealed.

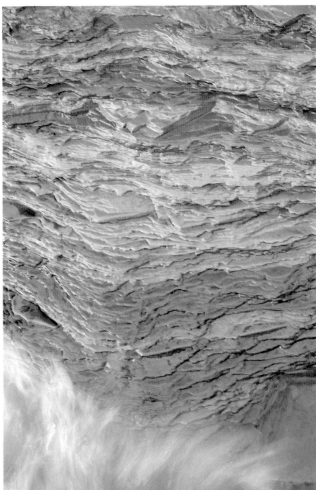

SHALE CLIFF (Lake Erie shore in Bay Village), photographed by William Horschke.

Like the painting, this photograph shows an extensive repetition of line and an uneven pattern of edges. In both pieces, the cool blues find relief in earthy touches of color. But more than anything else, the textures of both seem to describe many small hidden fissures harboring secret residues of evolution.

45

Conveying the Effects of Heat as Energy

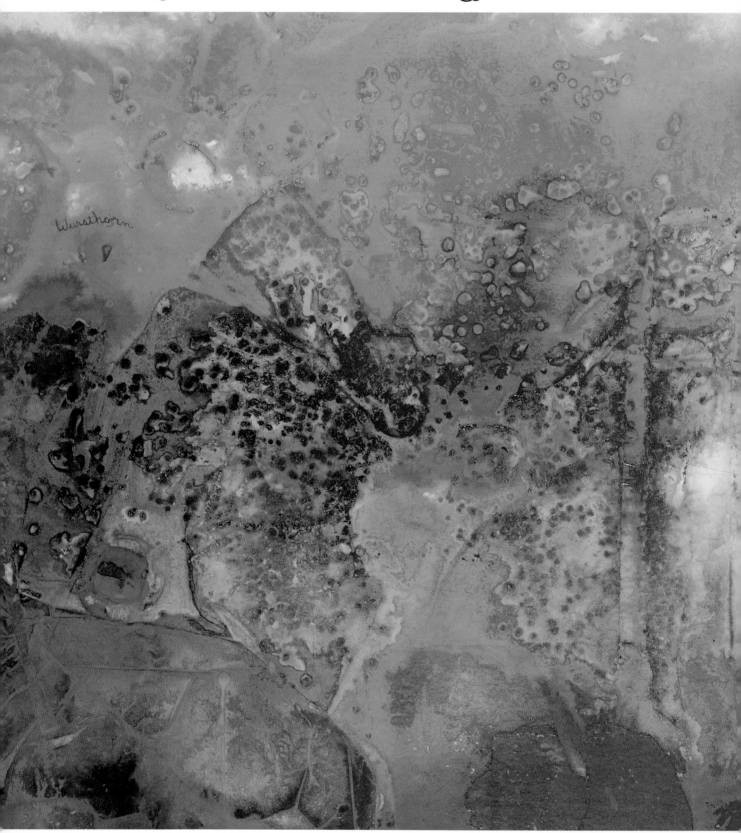

MABEL WURSTHORN, COSMOS, 28″ × 32″ (71 × 81 cm).
Collection of the artist.

Inspired by the extremity of the elements during a heatwave, the artist projected the blazing sun and vibrant red heat against cool grass, shadows, and earth colors. The mottled texture of darks created with the use of salt forms vague shapes and gives atmospheric clues to the humidity and existing temperature. The vivid primary colors and amorphic forms typify the smoldering dog days of summer, but give it the teeming energy of a solar explosion. In this sense, the title *Cosmos* relates the inclusive spectrum of colors to the refraction of sunlight, and the never-ending rebirth of energy in changing forms.

Mabel Wursthorn explains that the painting began with no specific concepts in mind, but was done simply for the joy of experimentation using several methods to obtain a variety of textures, shapes, and color intensities and sheen without using opaque paint. She says, "I used all inks with this, Steig and Pelikan, water, kosher salt, and plastics. I used stretched Morilla watercolor paper and I started at the top, spraying with water and pouring the warm colors progressively across, starting with yellows, sienna, orange, and red. I used the kosher salt in areas to coagulate the paint and placed some plastic rings from a six-pack that were stretched into different shapes. The board was tilted to spread and mix colors and to enlarge areas where salt was applied (the salt moves as you tilt the board when there's enough paint and moisture on it). Then various shapes, cut from acetate, and waxed papers were used both for design and for forms that also produced soft sheens and brilliant glazes. As the painting progressed, the separations and chemical reaction from the salt and the ink produced an organic quality that needed to be further described by the shapes used in the paint. When this was finished, the entire painting was covered with a plastic wrap. I hadn't planned the entire composition but worked with the unexpected developments at each stage, taking advantage of the happenings and going with the flow of the paint. I worked from light to bright colors down to cool and dark colors, starting from the top and working down. The entire painting was experimental. There were no problem areas. After it dried, only a few finishing touches were needed, namely strengthening some of the outlines of center forms. I use assorted sizes and boards, but actually prefer the freedom of working on a larger size board than this was done on."

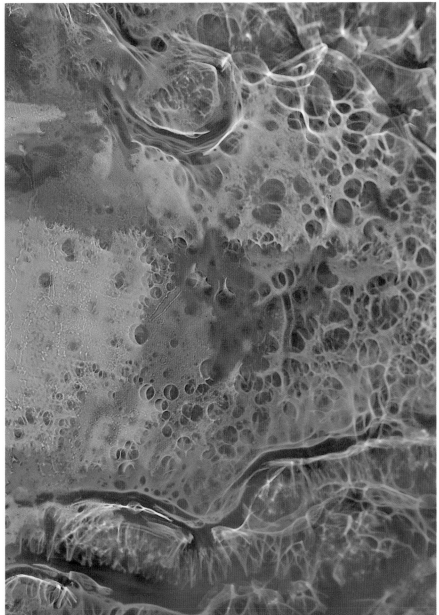

REFLECTIONS THROUGH GLASS, photographed by William Horschke.

This photo is of Christmas tree lights shot through a knubby-textured glass. The lights were refracted and the colors appear in the same amorphic crawling forms that create the texture in the painting Cosmos. *The shapes and colors seem as alive and teeming with energy as living organisms.*

Describing the Erosive Effects of Water

At the time I created this painting I was very concerned with the insidious crumbling and erosion of the earth, which threatened to change the scenes I loved. Somehow I felt that mankind, including myself, was responsible, and that we could stop the process. The passionate colors in my painting reflect both my ardor, and in some way the earth's lifeblood flowing away with the tides of time. The use of a solid sky contrasted well with the textured rock (which I used crumpled wax paper to achieve). The white sections and lines were added after the other colors were dry, to suggest moving water.

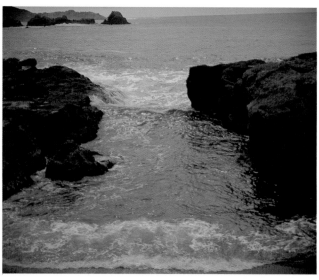

SURF (Point Lobos seashore), photographed by Howard Stirn.

The direct relationship between erosion and water is obvious in this photograph. The path worn through the rocks by the surf shows the power of persistence and the tenacity of time. The contrast between the sunset blaze of color and shadowed rock masses dramatizes the moment. I know now that I cannot stop the pounding waves or dam all the streams, and that these are the forces that created the beauty I want to preserve.

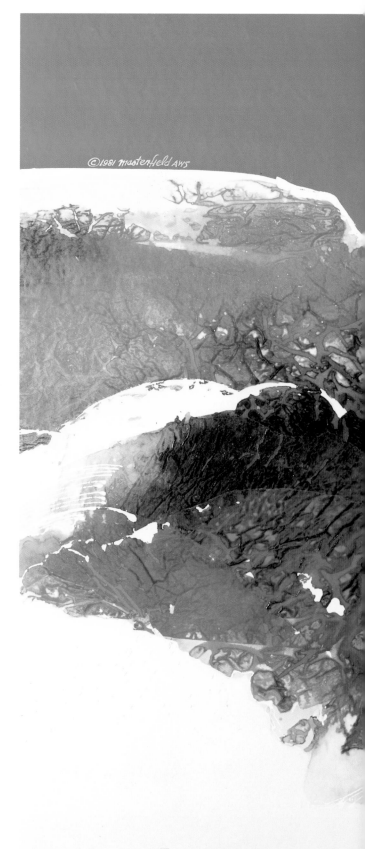

MAXINE MASTERFIELD, *SILENCE OF EROSION*.
36″ × 42″ (91 × 107 cm).
Collection of the C. G. Rein Galleries.

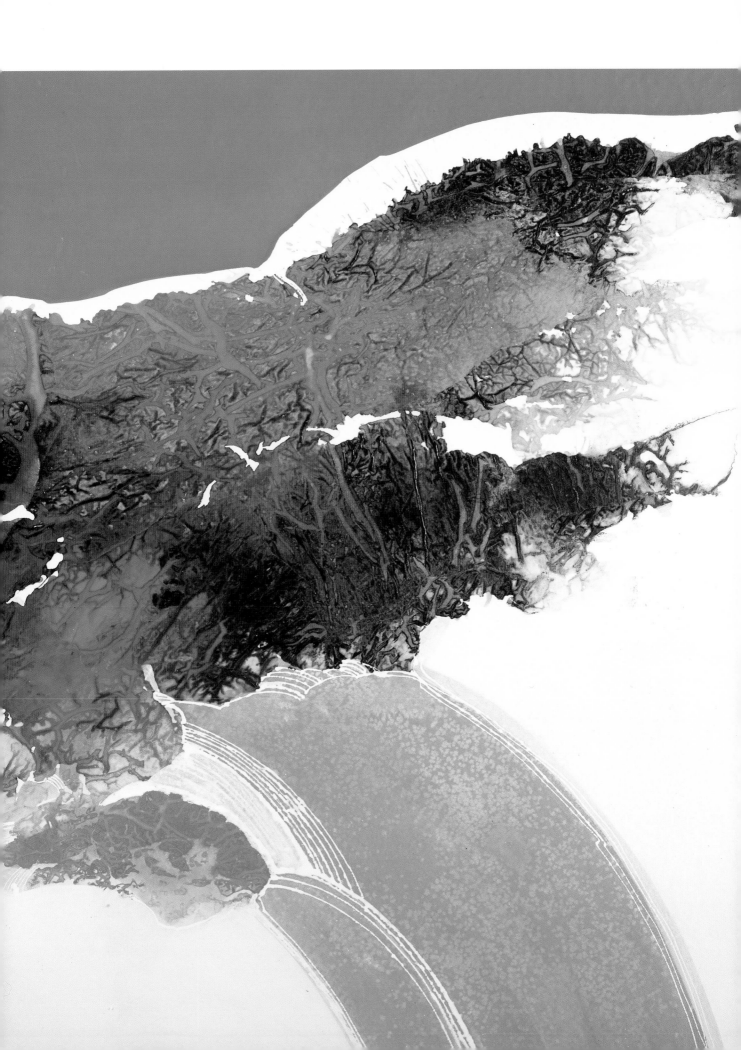

Color and Composition

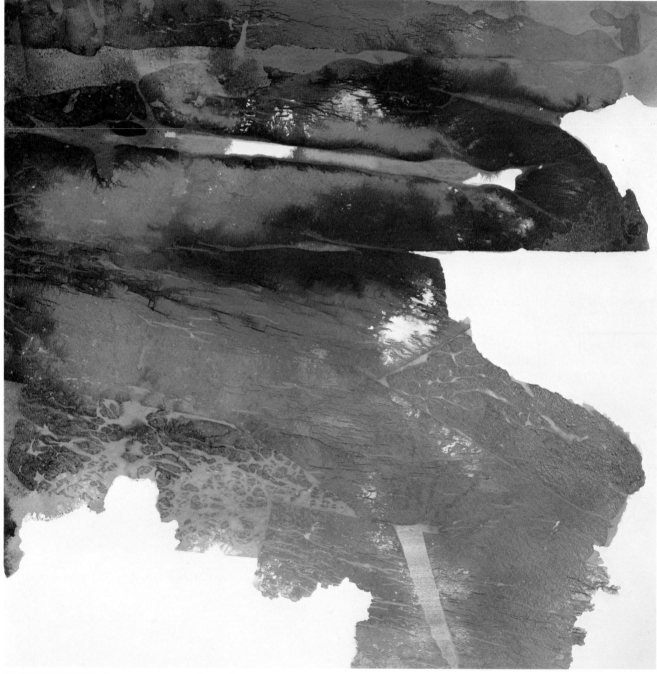

MAXINE MASTERFIELD, *GENTLE DESCEND*. 42" × 42" (107 × 107 cm), ink on Morilla paper.
Collection of the artist.

When facing a blank sheet of paper, your first decision involves two of the most basic artistic concerns: color and composition—where to place the color, how much color to apply, and what colors to use. Even working in a spontaneous fashion, you will need some sense of design to make these decisions. Following stringent rules of color and composition is a good way to start. But you will eventually have to evolve your own formulas for producing what is pleasing, exciting, and interesting to you.

Since, in abstract naturalist paintings, you are communicating ideas and emotions—your impressions—rather than capturing a specific locale or subject, the question of where to position an object in a painting becomes less important than deciding how much material you plan to include within the frame of your work and how you can best communicate your subjects to the viewer. Certain basic laws of nature still hold true, too. For example, in painting a distant mountain range, there will always be a foreground, middle ground, and background. And should you decide to zero in for a closeup, you will still have to resolve design problems, making sure your point of focus is neither boringly centered nor awkwardly riding the picture edge. And if your aim is to capture a feeling of life and movement, you will probably choose an imbalanced composition to suggest a direction in which the wind, water, or even the viewer's eye is moving. In the examples in this book, you'll find that the most interesting and resolved paintings have unequal divisions or placements of colors or textures. You will also discover that they usually have one large area dominant or serving to support a smaller, more intricate area that has become the point of interest.

Composition is also important in setting the mood of a painting. Our senses respond to line and spatial placements in a painting. We also respond to the type of lines that predominate. For example, a painting with many curves is sensual and serene. One with points and hard edges is dramatic and exciting. The sharper the edges of the ground planes and the more tangent the meeting divisions of colors, the more exciting and "busy" the effect. Lines also convey moods in nature itself. When a pond, for instance, is calm, its ripples are parallel or curve slightly. When its waters are rough and agitated, the lines on the water's surface are peaked and set off in many directions.

Choosing the color of your painting is also a major consideration before you begin to paint. You can base your decisions on principles as elementary as placing warm colors (reds and yellows) in the foreground and cool colors (blues, greens, grays) in the background. But you can also feel free to do just the opposite. I feel as comfortable painting clear skies over rich-colored mountains and deserts as I do painting a warm sunset over a cooler sea. It all depends on the effect I want to achieve.

Here are a few general rules to keep in mind: Lighter colors appear to advance toward the viewer while darker colors appear to recede. Warm colors are more lively and stirring than cool colors. Very rich and bright colors should be used sparingly with muted colors because they "pop." Complementary colors (blue with orange, red with green, yellow with violet, etc.) used as pure hues—that is, unmixed and intense—vibrate when placed next to each other, creating a visual stimulation.

I usually begin a painting by pouring colors on the paper and allowing them to mix spontaneously. But I have more control than you may think. From experience, I essentially know what to expect when they mingle. For example, I know that the most interesting (but not necessarily the most desirable) colors are produced when secondary colors are mixed together—mauves, khakis, tans, and grays. I also know that there are some pigments that are intimidating and dominate over colors too easily. To learn about your own colors, I suggest that you begin with a simple, basic palette and add new colors slowly so you can see how they behave with your other colors. Practicing the color pouring project I recommended earlier should also help.

The "gentle descend" of the title refers to the meandering, indirect, curving motion of the paint and the gradual warming of the colors, from the cold sky down to earth. The colored, positive portions and white negative spaces separate the composition into planes. Working with these two contrasting elements—light and dark, color and white areas, positive and negative spaces—simplifies the painting. After painting for many years, a cycle becomes apparent, an alternation between intricacy of design and simplicity. I am most intrigued by the moments when such transitions (between simplicity and intricacy) occur. Then elements of several directions are present and interesting possibilities for paintings are multiplied.

In the upper left-hand corner, I poured blue ink and tilted the table. As the ink flowed downward, I added burnt sienna, then more blue. Then I leveled the table and added layers of waxed paper and left them to dry in place.

Using Color to Evoke Objects

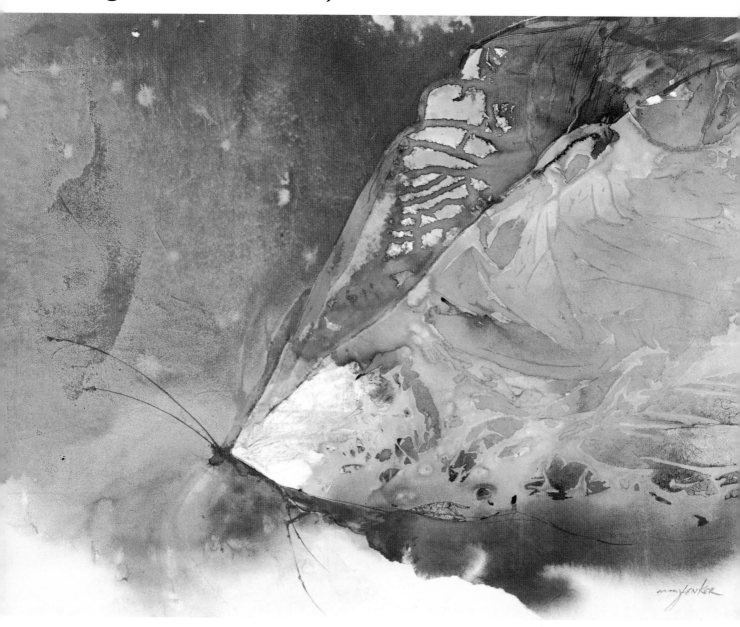

MARTI M. FENKER, *FLYING COLORS*. 28″ × 24″
(71 × 61 cm), collage on 4-ply Bristol board.
Collection of Phillip Campisi, Columbus, Ohio.

Speaking of Flying Colors, *Marti Fenker writes, "I'm never absolutely sure where a concept for a painting springs. In fact, the less I know about what I want to paint, the better it seems to be. Preconceived subject matter seems to give me an instantaneous block! I work spontaneously and let the paint 'do its thing' and the resulting color, configurations, etc., activate my imagination and suggest a subject. I love the freedom of this method and the excitement of taking control—but in a subtle way. I never want to 'wrestle a subject to the ground' and always keep part of it a little out of control.*

"When I began Flying Colors, *I started on a fully saturated paper and poured the color on, using the three primaries, working with intense color, and letting the paint flow with the aid of water sprayed from a Windex bottle. I began with yellow, then red, then blue, and by tinting my board, I let the colors blend and produce secondaries. As the paint began to set up, I laid a cloth on the wet wash and covered it with Saran Wrap to give it some form and texture. When I lifted the cloth, I saw what appeared to be the veining of a butterfly's wings. That was my inspiration for* Flying Colors. *I then began to define the broad areas of color into a shape conforming to a butterfly's wings, adding more color and using more darks to define the big shape and adding more definition to the smaller vein shapes within the wing. My*

values were actually controlled by the process of the paper's drying and by adding more paint to the drier areas, working from light to dark.

"I wasn't satisfied with the way the area around the butterfly was working. I wanted a more mysterious, ethereal quality to offset the boldness of the butterfly. So I decided to start another painting that I could collage the butterfly onto. I spent quite a lot of time deciding its size and ended up with the same outside size I had originally started with—probably because I wanted the butterfly to almost fill the picture space as it had in the original.

"I proceeded as before, working wet-in-wet, pouring on the same colors. But this time I let them mesh to create more grayed areas. When they dried, I cut and tore the butterfly off the first painting and remounted it on the second background. Uppermost in my mind was choosing a placement that would most strikingly proclaim, 'Look, here's something in nature so small, so exquisitely beautiful, that it ought to be made really large and important, so everyone could see how gorgeous butterflies really are.' My final steps were to design the body and antenna."

ROCK WALL (Gros Ventre, Wyoming), photographed by Howard Stirn.

This rock wall, with its fissures and slanted openings, recalls the veins in the butterfly wing. The warm earth tones and line traceries in both pieces result in similar compositions and movement-at-rest qualities. Both focus on a triangular shape, with surrounding vertical/oblique lines that give a sense of lifting and power to the compositions.

Patterning with Colors of the Southwest

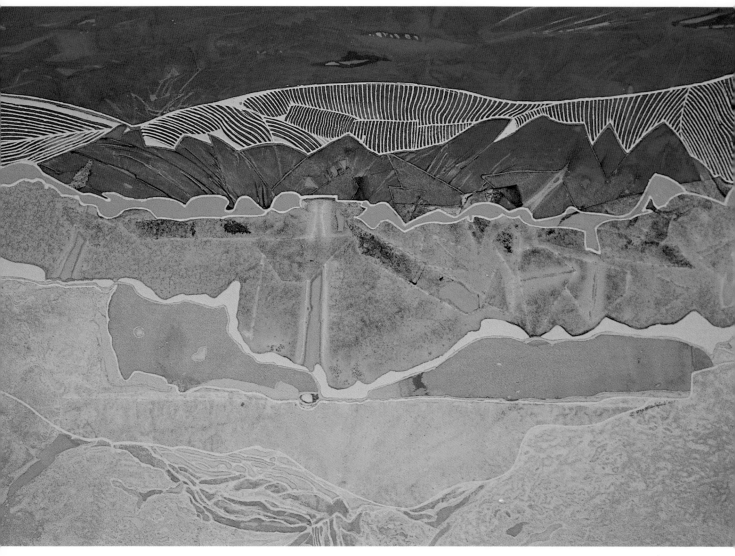

MAXINE MASTERFIELD, *BELOW THE VILLAGE.* 34″ × 40″ (86 × 102 cm), ink on Morilla paper. Collection of the C. G. Rein Galleries.

Although this painting is called Below the Village, *I couldn't help but think of an Indian headband. Maybe it's the forceful horizontal layers of color and band of patterned line. After viewing many paintings with Western motifs, I felt this was my response to Southwestern art. I find Indian art to be alive and decorative, and this painting was influenced by that feeling. I divided the three main color areas to introduce a more intricate buildup of horizontal planes. The largest section of sky and mountains, though of one hue, comprises three separate distances in perspective. To produce this feeling of planes with more clarity, I poured each layer of color separately, and left each to dry individually. The burnt sienna was poured first, then layers of film dropped across it. The gray was next, also with a film covering. Then the sienna layer was mixed with white, and poured last. The work was then tied together with the addition of the opaque center gray section, and white lines for definition.*

Exploiting the Brilliance of the Sun

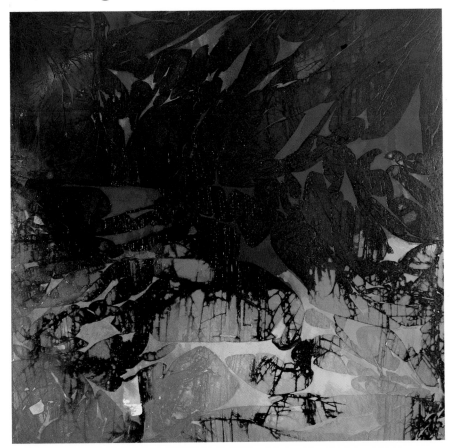

MAXINE MASTERFIELD, *THE HOUR BEFORE SUNSET*. 42″ × 42″ (107 × 107 cm), ink on Morilla paper.
Collection of the artist.

Slowly the shadowy dark areas take over the scene as the sun sets. Sunset is a graceful process, changing the moving branches and leaves to silhouettes. Like opposites of night and light separating the span of day, the warm bright colors of the sun are played against the cold, dark blue of the shadows. The more emotional direction, achieved by using basic, bright, primary colors, was quite a departure from my earth-toned scenes. Depicting the emotion I felt from a thought was more immediate than presenting the scene itself.

I used the plastic wrap method in painting it. The plastic caused the blue to melt into the oranges and follow the folds of the plastic cover. The traveling, seeping ink, which I used to halt the reds and oranges, was given free reign to wander until it was depleted. It was part of my need to express the freedom of movement I felt.

MAXINE MASTERFIELD, *BRIEF MOMENTS*. 38″ × 38″ (97 × 97 cm), ink on Morilla paper.
Collection of the artist.

The title Brief Moments *describes the brilliant sunset silhouetting trees at the most spectacular and contrasting moment. The movement of the trees in the breeze accounts for the slightly blurred effect of the seeping color. After the initial pour, the composition of this painting was changed with the addition of a violet black that advanced and claimed a larger proportion of the foreground. The brighter colors then became the background, and peeked through, as the sunset invades the encroaching shadows. Usually darks recede and bright colors are in the foreground. This is an example of the opposite situation.*

Exploiting the Brilliance of the Sun

Letting Colors Dictate the Subject

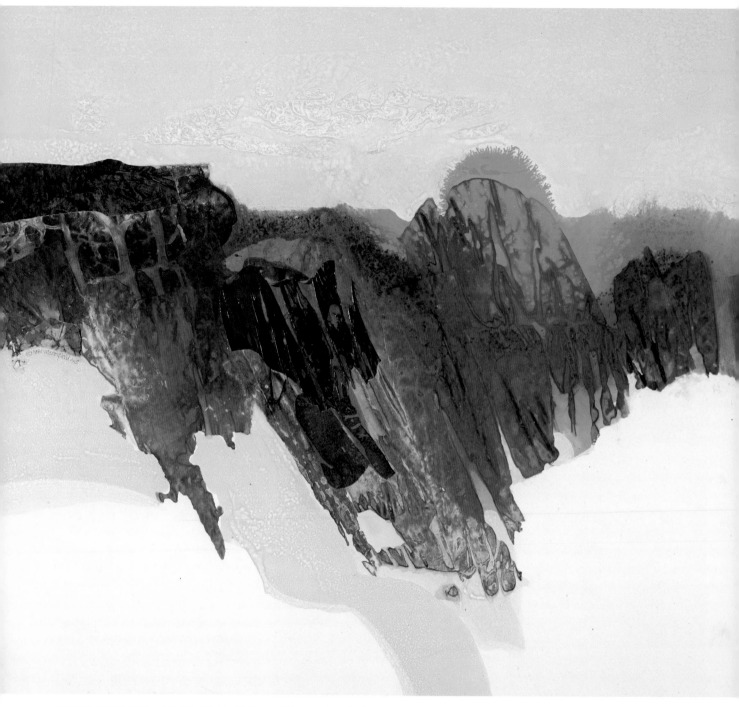

MAXINE MASTERFIELD, *TERRAIN*. 36″ × 42″ (91 × 107 cm), ink on Morilla paper.
Collection of Mr. and Mrs. Wayne Buffington.

As this painting began to develop, I was delighted to see the sun rise on the horizon. Forms appear, and before they disappear you must capture them. It is important to remember that with a free-spirited approach to painting, you must allow the material to suggest the subject, rather than dictate the subject in advance. Only when you recognize a shape as a rising sun does it become the sun. It is again your relationship and contact with nature and your understanding of its symbols and their meaning that form your perceptions. The abstract naturalist painter paints a mixture of conscious and unconscious material. Sights and memo-ries are stored data and their retrieval is triggered by visual and emotional events. What you put on paper is the united perception of what is felt and seen, and the interpretation of it all. I call Terrain *a one-plane painting because all my emphasis is on the middle plane. The high-keyed background sky and foreground serve as negative spaces in the composition. Red and raw sienna was poured, then invaded by blue, which crawled underneath the crumpled wax-paper shapes. The one-directional movement also preserves the feeling of serenity.*

56

Intensifying Color Through Memory

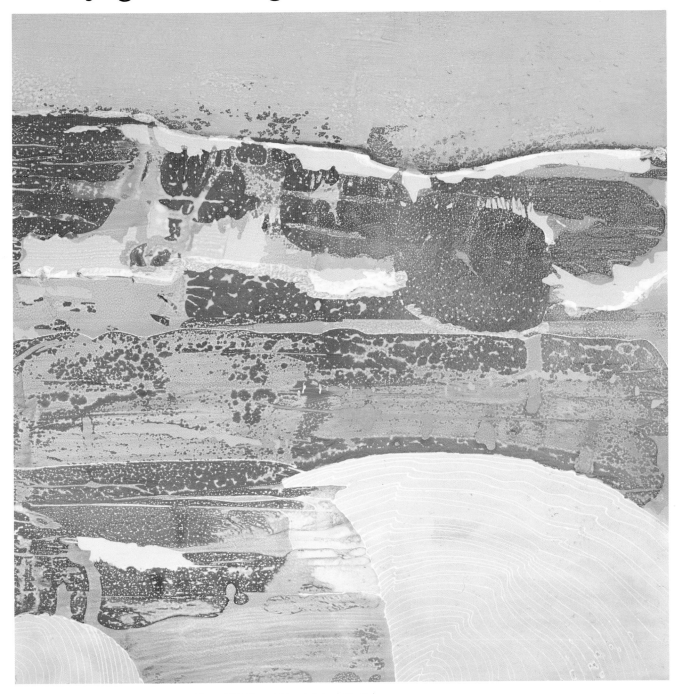

MAXINE MASTERFIELD, *SEAS OF SAND*. 40″ × 49″ (102 × 124 cm), ink on Morilla paper.
Courtesy of the C. G. Rein Galleries.

A jeep ride across the sand dunes of Cape Cod inspired this painting. Of course, the dunes were never this colorful, but they could have been. My colors are deeper and more vivid than the reality, as good memories usually are. The white washes that beaded on the waxy textured surface muted the colors just enough to calm the effect. I began with the usual three picture planes of color: burnt sienna and sepia at the top, burnt sienna in the center, and raw sienna on the foreground. Large shapes of wax paper were cut into elongated ovals and placed into the layers of color. When the ink dried, the wax paper was lifted, white ink was washed over the three planes, and gray ink was used to cover the sky.

Evoking the Sensations of a Moonlit Forest

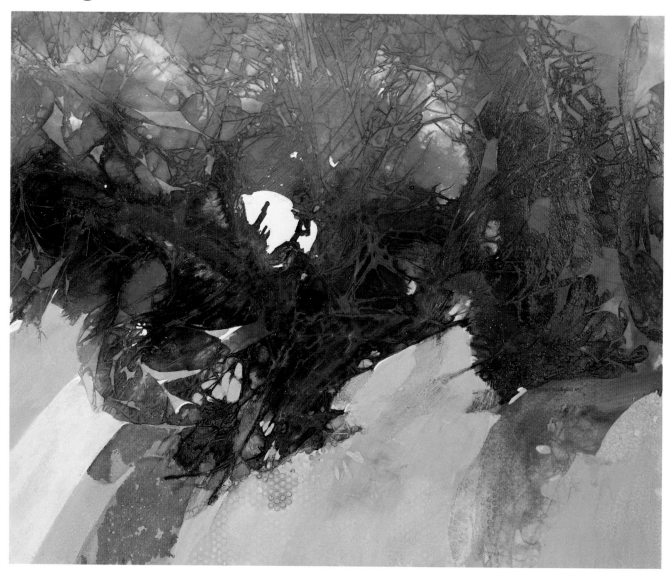

MAXINE MASTERFIELD, *LUNAR SUNRISE*. 32" × 46" (81 × 117 cm).
Courtesy of the C. G. Rein Galleries.

The contradictory title of this painting is in tune with the feeling of mystery and complexity I saw in this work. This is a much more diverse painting than most of mine because I decided to incorporate into it all the techniques I had discovered in preceding years. The subject appeared to me to be a dark forest with the moon beginning to rise. Across the horizon there are multicolored trees, and in the foreground, flowing water. This time I painted four planes: the gray foreground, the dark blue and then orange middle grounds, and then the blue sky. Basically, I used two blues with burnt sienna and magenta. Whenever the blue touched the sienna, it turned green. Whenever the magenta flowed into the sienna, the orange was mixed. The end results were very colorful considering that I had used only three initial hues. The gray foreground is a wash with bubble plastic laid into it for the unusual patterned texture. The other textural shapes were made with film wrap and wax paper.

Painting a Flickering Light

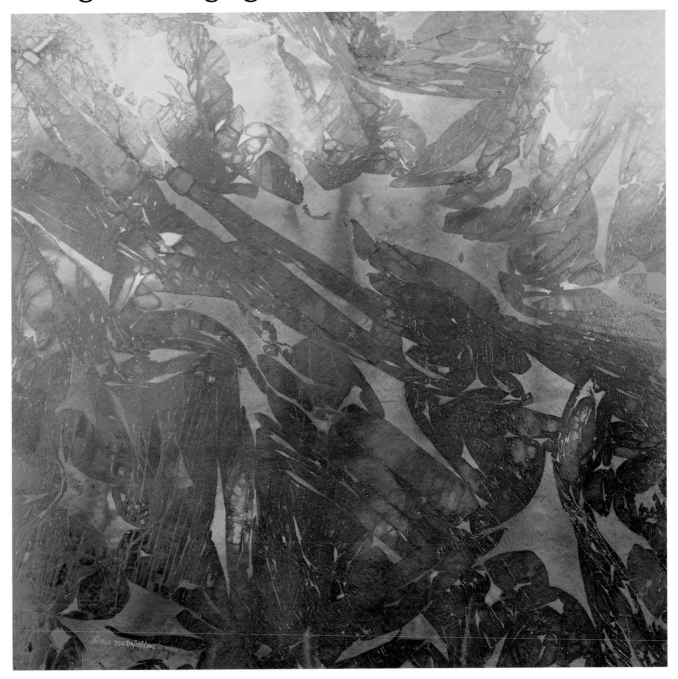

MAXINE MASTERFIELD, *THE FIRST LIGHT.* 40″ × 42″ (107 × 107 cm)
Courtesy of the C. G. Rein Galleries.

In this, one of my bright-color series, the sun is rising above the horizon and leaves are beginning to descend to the ground. Imagine being the size of an insect and having leaves fall on you when you are barely awake to the new day. The adrenalin shock produces a "fight or flight" event of intense awareness. This feeling is encouraged by the lively hues. This is the theme of First Light. *By putting myself in all kinds of perspective circumstances, my paintings take on different meanings. Expressing those meanings challenges my creativity. The predominance of yellow first, then pink, keeps both the color key and energy level of this work high, like with my intended message. This proportioning or emphasis is an important theme/composition factor.*

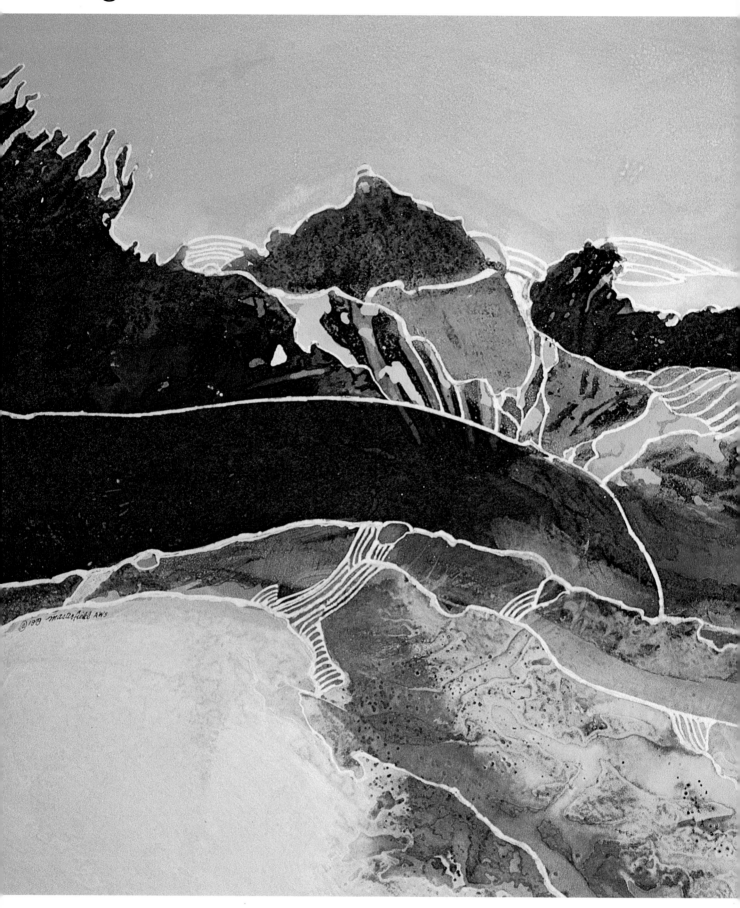

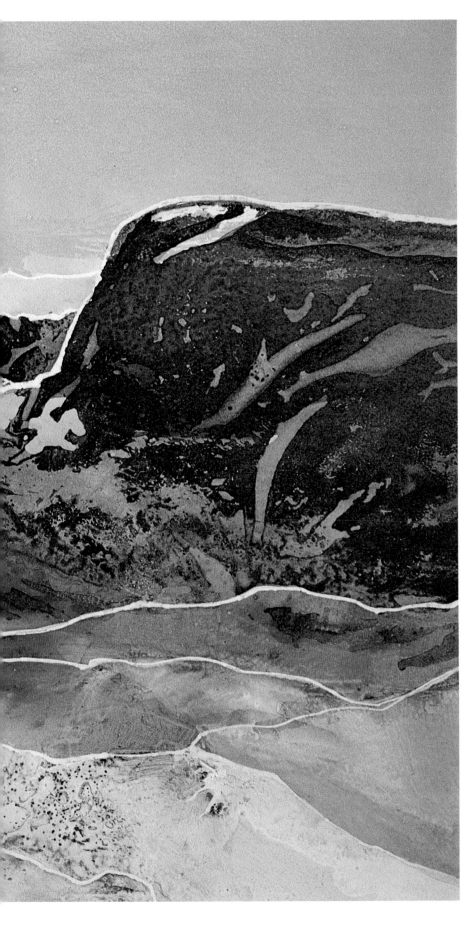

MAXINE MASTERFIELD, *VIOLET LIGHT*. 36″ × 40″ (91 × 102 cm), ink on Morilla board. Collection of St. Joseph Hospital, Arizona.

The feeling of shadow and contrast under a pale, clear sky is complemented by dimensional details. You can travel through the view with your eyes, over and through to the other side of first this mound, then around that dune. I defined with line what I wanted to be evident for others to see, too. That is the way this painting and all my paintings have developed, with that need to reveal what I feel. Sometimes ways of suggesting a breeze, or other movements is desired. Here I projected a calm mood by using curved planes and by choosing a composition that moved in one direction, with no acute angles. The colors chosen are in a subtle, narrow range, leaving it to value contrasts to create drama. The main interest is in the middle ground, while the more muted, textural detail is in the foreground, suggesting variations of concentration as well as distance.

The original pour began with inks of indigo blue, raw sienna, and sepia. Salt was sprinkled near the bottom and a large sheet of plastic placed over the entire surface. When it dried, the plastic was removed. I added white line drawings to define the shapes, and put in a blue-gray sky.

Form and Texture

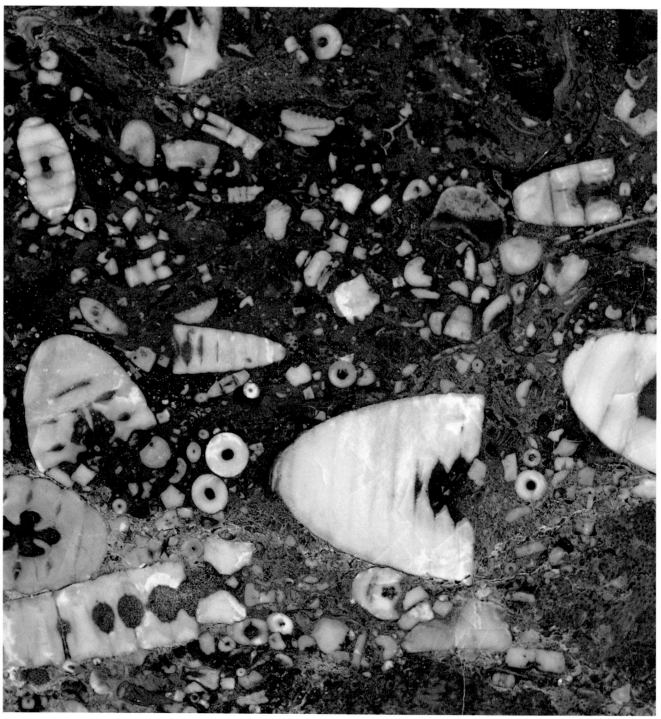

CRINOIDS, photographed by William Horschke.

There are no new forms in existence. Whatever you think you have invented or designed has already been used again and again in nature. After all, is there any difference *in form* between a rock-shaped cloud and a cloud-shaped rock?

I once saw an entertainer on television whose specialty was blowing bubbles. He made an example of a bubble that was surrounded and touching six bubbles of equal size. The center bubble formed a perfect cube. Until then, I believed bubbles could only be round shapes. I have since learned other lessons from observing nature. For instance, I always believed tree roots were in the ground—until I saw an ancient banyan tree. I also used to think mathematicians and scientists had invented cubes and other geometric shapes—until I saw countless, perfectly shaped crystals.

Anything can exist in nature.

A line can be either straight or curved, and the extent of its curve can vary indefinitely. A three-dimensional form can be flat or round—or can have both flat and rounded sides on the same form. The smaller and more numerous its facets, the more textured the form will appear. Yet even a form that seems flat and untextured to the naked eye will, under magnification, appear as an infinite number of three-dimensional forms. Such is the fate of grains of sand on sandpaper.

Since there is no one "correct" shape for a rock, tree, or flower, all variations, imaginary or witnessed, are acceptable. As an artist, you can create shapes freely because somewhere in nature such a shape actually exists. Some forms are just more familiar and identifiable than others. You can create texture by building up your materials or mixing a textured substance into your paint, or by pasting specific textures onto the paper. I prefer optical textures to tactile ones. Although the inks I use are denser in certain areas because they are trapped into forms, the pattern of shapes actually suggests a texture rather than creating one physically. I don't add grainy or other tactile substances to my inks for texture, although I do toss coarse salt into the wet ink at times. When it dissolves, it reacts chemically with the ink and the result is the matted grainy look of uneven color. I also use other substances such as alcohol, oil, and wax, to repel or attract the ink and create various textures.

Shapes can be both accidental or planned, depending on the material you choose to hold the ink into position while it is drying. Sometimes I form patterns by crinkling or pulling folds into the heavy or thin plastic coverings or wax paper. Other times I cut shapes out of discarded paintings and lay them onto a painting. The thickness, stiffness, or other qualities inherent in the materials I use affects the shapes that are formed. When you get to know your materials well, you will be able to control such effects.

Experience has taught me that there is a relationship between control and contrivance. When people ask how I control the painting process, I usually say that the idea is not to control but to let things happen. But, of course, there are built-in controls. I can't forget the lessons of taste and preferences developed over a lifetime; they are always reflected in what I paint and how I do it. The only real control I exercise now, though, is not to get locked into a strategy that blocks a lot of the unplanned things that can happen when I'm painting.

The hardest form of control is not control over the medium, but self-control. If you calculate every step and detail of your work toward a fixed, preconceived outcome, even if you achieve your ends, there are no surprises. And I've noticed that whenever anyone attempts this degree of control, the outcome appears contrived. Struggle—or the lack of it—shows in art.

You have to learn not to be afraid to experiment. Good things happen when you let them. Painting with a free spirit means letting go of the strict controls that hinder discovery. And even if you don't like the results, all is not lost. There are many ways to use or save paintings you don't like. But beyond that, each experience, every painting, is a lesson; and what is learned is never wasted.

You might think these shapes a collection of machine-made parts, cogs, washers, anchors, and pegs. With the present penchant for science-fiction, perhaps it is a deep space flotilla rendezvous. But these are fossilized sections of prehistoric crinoids, small marine animals also called sea lilies. In life they were flowerlike in form and generally anchored to the sea bottom by a stalk opposite the mouth. Imbedded within the rock, each particle is now trapped in a foreground plane. Yet the size differences make the smaller pieces appear more distant and give the effect of an action still photograph.

Expressing the Texture of a Rocky Coastline

MAXINE MASTERFIELD, *RECEDING SEA.* 38″ × 42″ (97 × 107 cm), ink on Morilla paper. Collection of the artist.

These coastline cliffs, with their rounded forms, contrast with the structural design of the architecture above the cliffs. The painting is a combination of waxed paper shapes and plastic letter stencils (in the building forms). Lines were added and white was brushed across the foreground after the ink was dry. Notice the lacy tracing of the wax resist in the white waters and the dark rocks. The same rounded rock forms that the foaming sea is splashing against are echoed in the rounded, integrated shapes of the Norway pine bark in the photograph.

NORWAY PINE BARK, photographed by William Horschke.

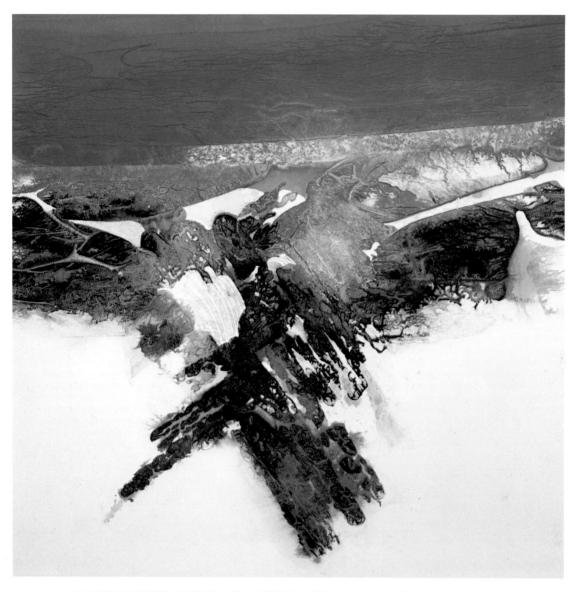

MAXINE MASTERFIELD, *SEAWARD*. 40″ × 40″ (102 × 102 cm), ink on Morilla paper.
Collection of Dan Medina and Tom Romeo.

The rocky shoreline of northern California was the inspiration for Seaward. *Everything felt intensified under that light. The sky, almost too blue, was barely separated from the sea. Greens were deeper, ochres almost blazed yellow. The rocks were vibrant with glints of scarlet. Texture was rampant on all surfaces. Even the sky appeared to be an intricate texture. All energies were at full throttle. Brightness seemed to drown out even the sounds of the sea.*

To achieve the textures of the foreground, I cut crumpled shapes of waxed paper. The middle ground had larger crumpled pieces, and the sky was a continuous sheet of waxed paper across the top, uncrumpled. As the painting began to dry, I slowly peeled back a layer from the top, and added canning salt. The salt made the textured line of water reflection on the horizon. When the ink was dry and the dropcloth lifted, white ink was added across the bottom for water and foam, and line.

Describing the Forms of Rocky Cliffs

SHALE WALL, photographed by Howard Stirn.

VIRGINIA COBB, CANYON WALL. 32″ × 40″ (81 × 102 cm), mixed media on 4-ply rag board. Collection of Dickerson, Earley, Hamil, and Dennock Law Firm, Houston.

In reference to this painting, Virginia Cobb says: "Canyon Wall *was the first of a series of canyon theme paintings in which a stone was the theme source, and then became part of the finished painting. Each painting in the series derived from the stone—using the colors, shapes, and designs within it—and was built up from there. The implied theme is that each separate part of the canyon wall contains all the elements of that whole.*

"The composition was not pre-planned, but allowed to develop with the flow of the painting. I always seem to start somewhere near the center and work with a fairly centered format. I worked in watercolor, and added some collaged papers that related to the textural surface of my subject—two pieces of stone inlaid on the surface of the painting. Additional information on my ideas and techniques can be found in connection with my painting Life Cycles no. 12, *on page 134."*

The flat planes and textures of the shale wall in the photo are similar in appearance to Virginia Cobb's painting. Both subjects have a mosaic quality, where line both separates and unifies. The photograph was taken at Gros Ventre in the Grand Teton area of Wyoming, while the painting was based on Cobb's memories of rock formations in the Lookout Mountain area of Colorado, where she once lived.

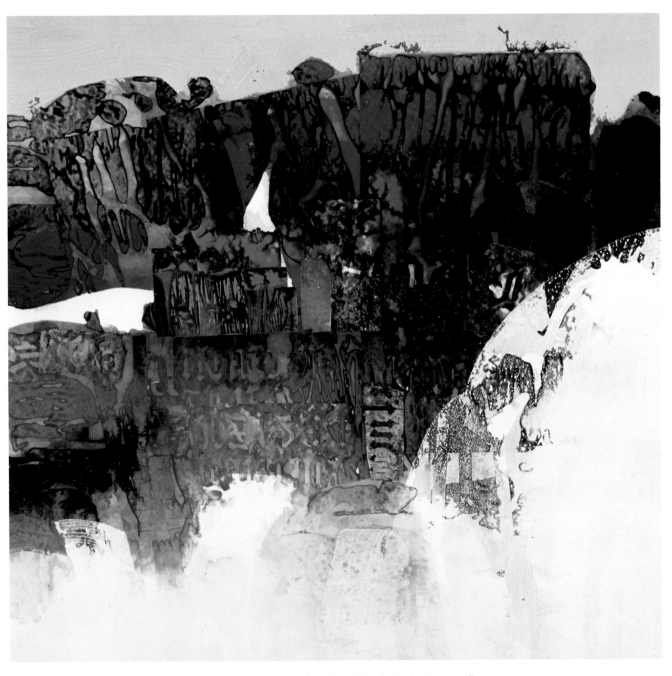

MAXINE MASTERFIELD, *A SUNNY WALL.* 40″ × 42″ (102 × 107 cm), ink on Morilla paper.
Courtesy of C. G. Rein Galleries.

*Like modern cliff dwellings facing the sea, this area seems inhabited, if not
by people, then surely by some other creatures of nature. Although the forms
and textures in* A Sunny Wall *flow into each other, the colors are used to
separate areas into tiers of shapes. The colors are festive, but the contrasting
white keeps the colors from slipping over the line into garishness. The colors
were Steig inks of gold, blue, rose, and magenta. After the colors were
poured in rows, the lettering was placed down and crumpled wax paper was
placed over the letters. The combination of waxed paper and commercial
lettering caused a resist. When dry, a wash of white was applied across the
bottom of the painting and white ink lines were drawn. A mixture of blue
and white ink was added to the sky, and a touch of salt was thrown in for
texture.*

Evoking the Shapes of the Natural Landscape

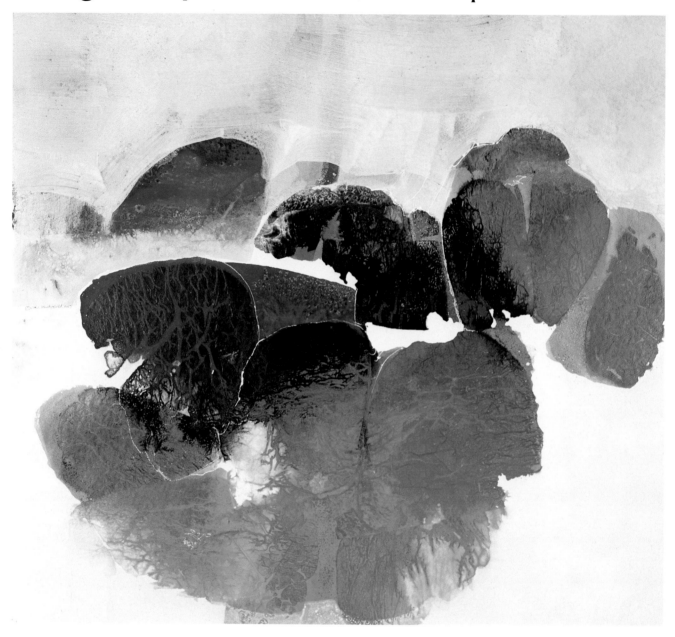

MAXINE MASTERFIELD, *SLEEPING FLOWERS.* 38″ × 42″ (97 × 107 cm), ink on Morilla paper. Courtesy of C. G. Rein Galleries.

These large shapes are like flowers that open and shut each day in the rain forests of South America or an imaginary wonderland. I decided that including leaves and stems would have been unnecessary details that would dilute the fantasy aspect. The basic shapes are organic, but the color seepage is formless and suggests a metamorphosis. This process of change, from bud to bloom, sometimes within the same flower, reminds me of Georges Braque's work. He integrated several views of faces into a single unit, a double-exposure effect, in some of his late 1930's paintings.

After pouring the inks, I cut waxed paper into semicircular shapes and lay them onto the wet ink. Neighboring colors mingled where they touched, adding interest and uniting the arrangement. The color in the sky was added while the other inks were still wet, causing more color to crawl.

MAXINE MASTERFIELD, *REMEMBRANCE OF THINGS.* 40″ × 40″ (102 × 102 cm), ink on Morilla paper.
Collection of Mr. and Mrs. Steven Shore.

I started this painting on a cold day in February. It was painted for a dear friend who had just died in January. Originally this was executed with the dark side up, and looked very much like ruins and snow-covered monuments. The mystical dark sky was perfect for the mood I was in. But when I turned it around, I kept seeing a rider on a horse. He seemed to have a halo or space helmet on. Later my attention was drawn to the word "peace" written across the painting. Many possibilities and revelations occur to me now as I look at prints of the work. It absorbed a great deal of feeling while I was painting.

I used a combination of film and Saran Wrap for the shapes and texture, using only three ink colors: sepia, burnt sepia, and later, white. The plastic lettering was most effective. For the most part, the textural effects seemed more ethereal than usual. Even after defining edges with line, the lines seemed to float suspended, rather than becoming part of the form.

MAXINE MASTERFIELD, *SILENT STONES.* 40″ × 40″ (102 × 102 cm), ink on Morilla paper.
Courtesy of C. G. Rein Galleries.

This is the last in a series of monument theme pieces I had painted after the loss of a close and dear friend. At first the colors were somber grays and earth tones. As time and acceptance restored me to the present, color returned to my work. Here the monolithic shapes are merging into the warm and rounded suggested life stream. This parallels my leaving mourning to celebrate life again. The duality in life of past and present is helped by the shapes and textures of more solid straight edges on shapes with cryptic writing. These are what was, and can't be changed. The still pliable and pulsing energy of what is just becoming is felt in the bright, rounder shapes. Washes of Steig rose ink and FW olive were applied, and while the ink was still puddling wet, the lettering, then the crumpled wax paper, were added. The white line was added last.

Discovering Rhythm in a Pattern of Shapes

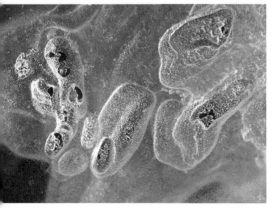

MAXINE MASTERFIELD, *WINDSWEPT TREES*. 38" × 40" (97 × 102 cm).
Private Collection.

There is a strip of land on the Florida Keys, called Alligator Alley, where rows of fir trees line one side of the road for miles and miles. This area inspired a series of paintings with layered planes and repeated, similar shapes. I poured inks into three horizontal sections and laid waxed paper over them. Where one area touched another, the color began to crawl upward, forming the trees. Very little drawing was required after the painting was dry; I felt it was complete as is.

ICE FORMATION, photographed by Howard Stirn.

These shapes, with bubbles trapped inside them, seem to symbolize a stage in the life cycle. Their rounded, slanted, encircled qualities remind me of the trees in the painting.

MAXINE MASTERFIELD, *HABITAT*. 40″ × 40″
(102 × 102 cm), Ink on Morilla paper.
Courtesy of the C.G. Rein Galleries

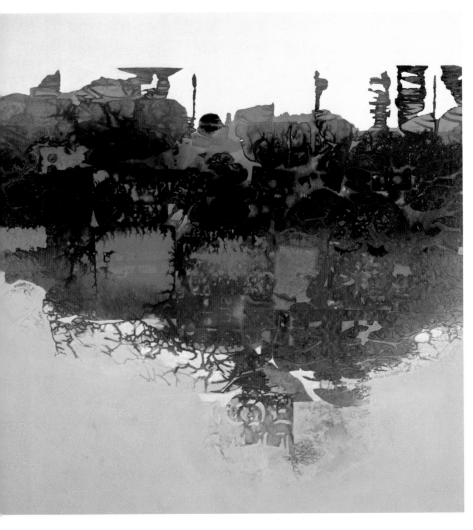

*Inspired by Arizona's high desert
community at Arcosanti and the
Sedona rock formations, this paint-
ing has a very ancient and Spanish
feeling. The shapes are especially
exotic and ritualistic. The exception-
ally intricate fingers of texture are
rootlike and give an organic sensa-
tion to their probings. It seemed as if
the sand was mirroring the sky and
fracturing the hill images in its
grainy ripples. The figures on the
plateau alternated between icons,
Dali surrealist figures, Druid altars,
and fantastic chess pieces.*

*Habitat was painted with a
combination of cut shapes of film and
waxed paper. A large, heavy plastic
cloth was laid on top of the wet ink,
letting the plastic fall where it would.
The areas across the top where the
ink crawled became the hilltop
figures. Because the white in the sky
worked so well, I toned down the
foreground with a beige wash,
adding a small amount of salt for
texture. Notice the letter stencils
used in the center foreground. They
added more mystery and diversity to
the texture content.*

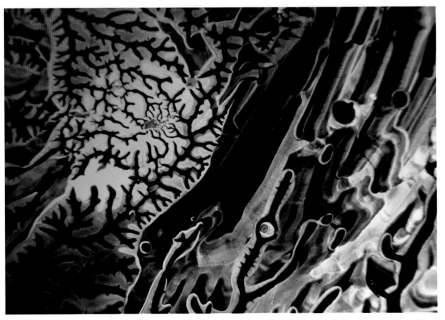

DRIED PAINT, photographed by Howard Stirn.

*Enamel paint spills on a glass surface
dried leisurely, veining and tunneling
under its crusty surface. This photo-
graph of the underside of the glass
exposed all the secret and varied
paths the drying process followed.
Note the distinct difference between
the two patterns. This blend of
diverse textures was also prominent
in* Habitat. *Both examples also share
the drama of the contrast in color
and light. Leaving textures to the
work of time, temperature, and
humidity, is naturalistic indeed.*

Using Forms to Evoke a Landscape

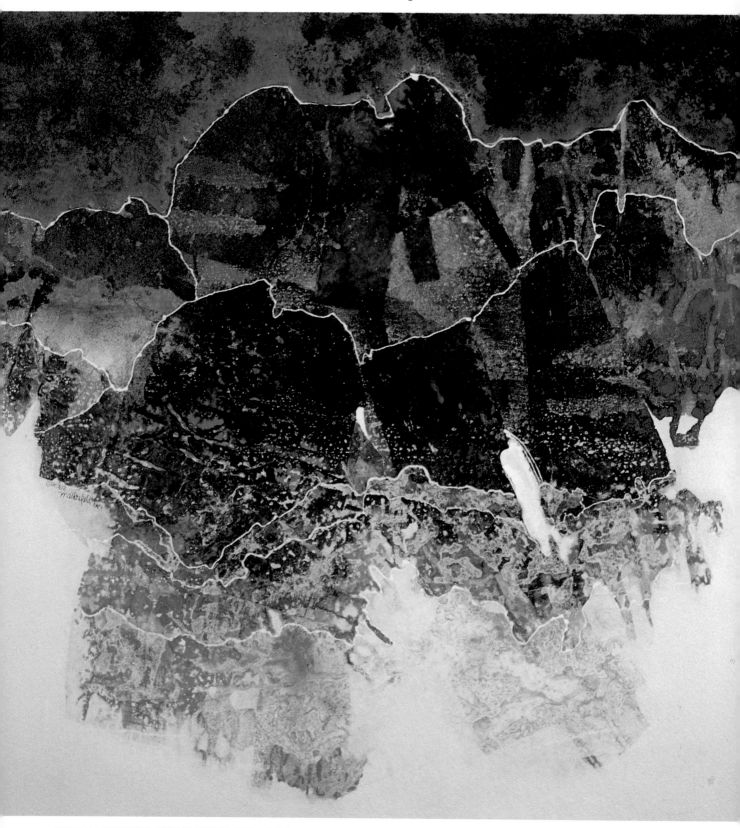

MAXINE MASTERFIELD, *EARTH'S IMAGES.* 32" × 32" (81 × 81 cm), ink on Morilla paper.
Collection of the C.G. Rein Galleries.

There is a relentlessness to the ocean's beating against these rock cliffs in this painting. The contest is to see if soon the cliffs will crumble into the sea or if the exhausted sea will ebb into peaceful resignation. They have both been there so long, and like ancient enemies who can't remember how the feud started, they are going through the motions out of some ritualistic habit.

The strong uneven shapes of the cliffs delicately outlined against the brooding sky contain textural planes of color and shadow. Waxed paper was used for shapes, and the sea's watery foam was an added white ink wash under an oil cloth. White ink line was used to emphasize the water crests as well as the cliff edges.

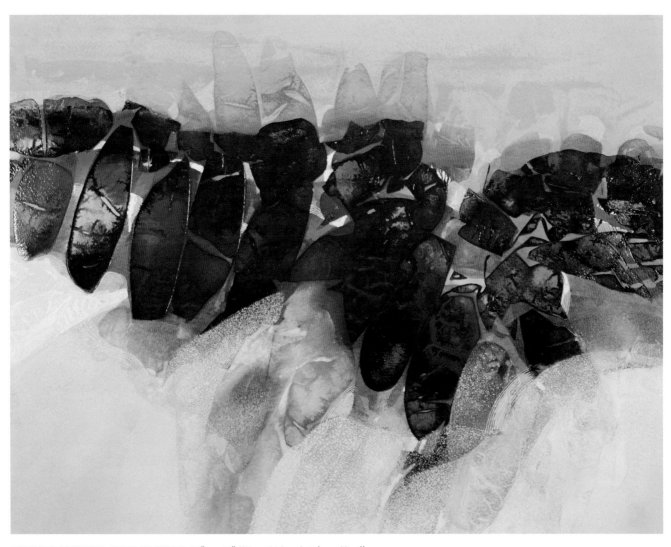

MAXINE MASTERFIELD, ECHO OF STONE. 34″ × 44″ (86 × 112 cm), ink on Morilla paper. Collection of the Pittsburg National Bank.

Misted from above and sprayed from below, these dark stones in the above painting emerge into sight. There is a unity about them that suggests a wall, but somehow the spaces and overlaps still separate each form. Like the scales of a dragon, each shares a common source, yet is complete itself. The density of color, together with the interspersed sheen, gives a richness to the rocks that contrasts dramatically with the diaphanous foreground and background.

This painting began as a single ink pour but ended with three layerings of colors and an airgun spray. Many colors were poured at first, and the initial shapes dried very pale. Then I decided to add darker shapes in the layering process with the use of cellophane cut into elongated oval shapes placed in a row across the middle ground. The first layers were of brighter colors, then deeper shades were added. A light gray ink mixture was added across the rocks at the top, letting the darks show through. I sprayed white ink lightly across the foreground, using a mask to provide water shapes.

The final touches included adjusting the edges in the painting so they didn't seem awkward, and adjusting the whites so they were strong but not too glaring. After evaluating the painting, sneaking up on it for several days to try for a fresh look, I felt that the painting was indeed finished.

Reveling in a Fantasy of Texture and Movement

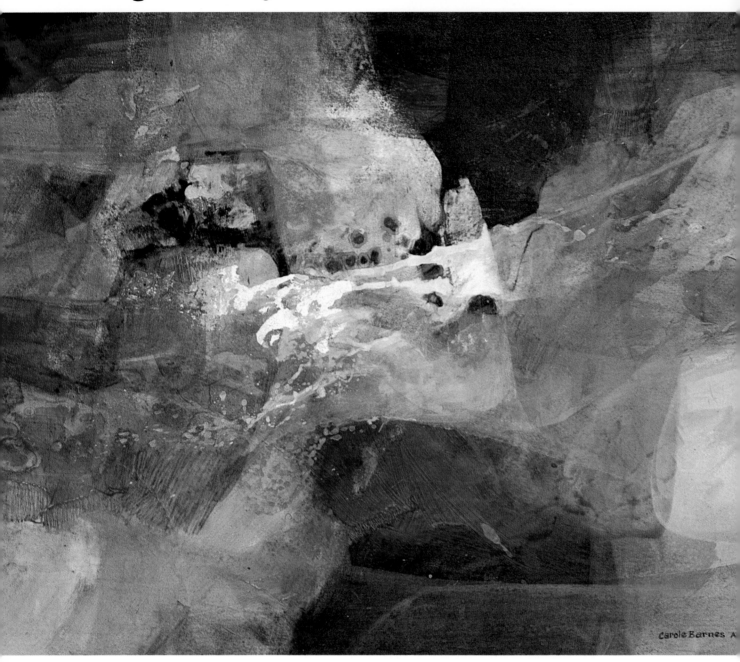

CAROLE D. BARNES, *ENERGY WITHIN THE EARTH.*
22″ × 28″ (56 × 71 cm), acrylic on Strathmore
Gemini paper.
Collection of the artist.

"I love to experiment," Carole Barnes explains. *"There's great fun in doing something new that I haven't done before. Although my work always ends up in a nature theme, this painting is a breakthrough in a way, an exciting change, because it's more abstract and less tied to a realistic subject like trees, land, or mountains.*

"Although I usually begin with color, line, shape, and texture, I let my compositions evolve as much as possible and try to capitalize on unexpected happenings. The result is a constant interaction between technique and critique.

"For several years I've enjoyed experimenting with reds, pinks, and oranges glazed over each other to make rich darks and strong compositions. This painting grew out of one such experiment. I was working warm tones against light, cool, textured tones to set them off, when the painting started to take shape. I realized that I wanted the lights to come from within the painting, to be in the inner part of the work, and I wanted to bounce the warms against the lights.

"To control the values, I push and pull the paint in and out of the picture planes, lightening and darkening them until it 'feels' right. I work mostly from light to dark and from bright to dull. In this case, I built up the reds and orange reds in glazes, making sure that they were not thoroughly mixed. I also used an acrylic wash-off technique: when part of an area was dry, I would wipe off the whole area, leaving soft, sensitive edges. Some of these edges would push forward into the picture plane; others pushed back deeper into the painting. I also used a decollage technique, tearing off areas of the paper to reveal the white paper below. I reinforced these light, textured, washed off areas with sharp white paint and cool aqua paint. When I arrived at the contrast of rich warms against cool whites, I felt that the 'being' of this painting was decided."

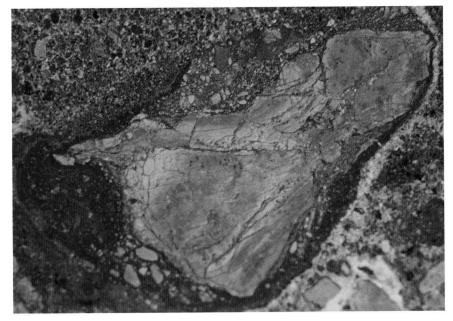

WET ROCK, photographed by Howard Stirn.

This section of stream rock shows not only the interesting pebbly texture, but also the veining and lines that appear in the painting. The uneven craggyness of the shapes and the contrast between the rock shapes are also in both painting and photo. The light that shines through the waters intensifies the color and gives feeling of energy.

Project

Start with your favorite theme, a subject like rocks, trees, or flowers. Glaze and evolve shapes, working all over the paper. When it starts to suggest an interesting composition, color scheme, or something special, turn the paper around (that is, make it vertical if it was horizontal, or vice versa) and finish it from that new perspective. Put glazes or "skins" of opaque white or neutral color over areas you want eliminated, and continue to work the painting until you are satisfied with the way it looks. After a while it will seem to "be" or to say "this is it" and from that point on it is just a matter of adjusting it and honing in on areas to make it all work together.

Composing a Scene Through Rocky Shapes

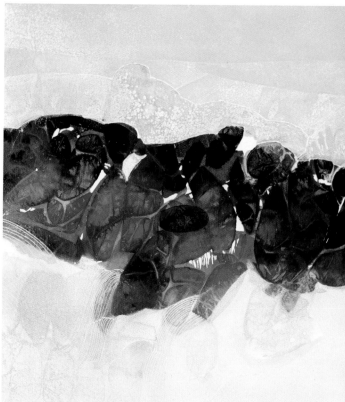

MAXINE MASTERFIELD, *OCEAN EDGES.* 40″ × 84″ (102 × 213 cm) diptych, ink on Morilla paper. Courtesy of the C.G. Rein Galleries.

The structure of rocks and stones depicted in this painting seems to hold back the full force of the rushing water. You can almost feel the sting of salt-water spray whipped by the wind. The brilliant, warm colors glowing from the deep, rich rocks are clues to the life involved in the scene: slippery organisms clinging to the rocks, and small-shelled, swimming creatures being tumbled and swept in the tides. The dense spray reveals a hint of more background rocks, while the foreground splash allows glimpses of submerged rock shapes. When it comes to impressions and the forms that create them, there is nothing so universal as the rocks and sea.

Building the richness and solidity of rock shapes in this diptych required many layers of added shapes and drying processes. Film was used for the forms, and the colors were primarily red, magenta, blue, and sepia inks. The dramatic rock wall edge was achieved by painting out the background with a gray wash, thus effecting the sharp contrast. The white wash that produced the foreground waves is accented with white line to give some directional movement.

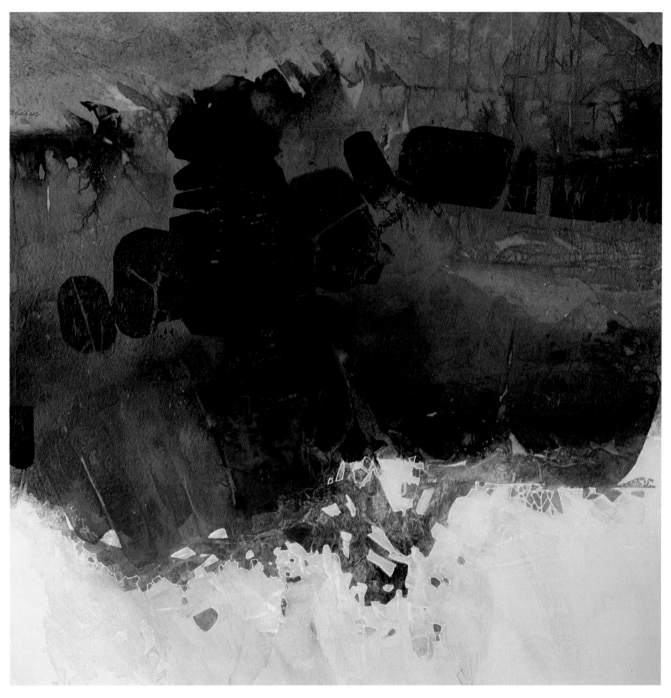

MAXINE MASTERFIELD, *TEMPLES OF STONE.* 40" × 40" (102 × 102 cm), ink on Morilla paper.
Collection of Avon Lake Library, Courtesy of the Baycrafters of Bay Village, Ohio.

The title of this painting came after I had been reading about monoliths left by man, centuries ago. Monoliths were temples built in the memory of loved ones, temples of stone piled one atop the other. The rich colors and depth of the shapes give the stones in this painting an energy, and their loose, random structure suggests the life processes going on around them.

After the first colors and textures were established, I felt that the middle ground needed some darker and more definite shapes. I cut rock shapes out of waxed paper, laid them across the center of the painting, and placed some sepia ink under the shapes. I also added a touch of magenta under the foreground forms. After the painting dried, all that was needed was some white lines.

Painting Out

BRAZILIAN AGATE, photographed by William Horschke.

In the depths of a small Brazilian agate is this illusion of a waterfall—or is it a glimpse of the ocean and horizon from a vantage point between cliffs? Whatever you make of this vision, it is forever awaiting your inspection, locked in stone. The amount of detail in the formation is just enough to suggest a resemblance to a natural scene without becoming complicated or forming a pattern. Its beauty does not rely on intricate detailing or some standard or easily identified formula. Its beauty is as basic as simplicity and strong design.

Composition was stressed in pouring color, and again when adding forms through waxed paper and plastic film techniques. Good design is part of every step in the painting process. A good design stands up no matter what size the work is. To test the worth of a design, Leonardo da Vinci used to view its reflection in a mirror. Other artists turn a painting upside down, on its side, or at different distances or angles to see it objectively.

If you have ever walked into a room that was a riot of patterns and textures in drapes, rugs, upholstery, wall coverings, and decor objects, you will have found yourself seeking some solid resting place for your eyes to focus on. You would be just as confused in a white-on-white environment. There, any touch of texture, color, or pattern would stand out and gain attention. The same idea holds true for paintings. Whether a painting is intricate and cluttered or simple and sleek, your eyes always need a focus.

Paintings that do not hold up, especially at a distance, usually have no defined planes or major shapes. They are evenly intricate, strong, or weak throughout. There are no stated focal points or recognizable separations. On the other hand, paintings with "power" are usually dominated by one or very few simple but definite forms. Many times, a group of forms combine to make a focal section that reads as a single shape. What sets up this design, and holds it together, are the other planes in the composition.

When a painting appears to have too many textures and forms, it is because they are not supported by either simple contrasting planes or a basic incorporating composition. Recomposing a painting with this problem can be done by painting out details and textures in an area to reclaim old planes or establish new ones.

This is not to say that every successful painting must have large areas with very little going on. There are many cases in nature where pattern on pattern is effective as well as beautiful. But nature tends to separate one intricacy from another either with color, edges, contrast, or pattern rhythm.

In the preceding sections there were paintings where washes were painted over areas in order to make them sky or water, leaving one area dominant. The decision of where and how much painting out is to be done is always the artist's. No one design formula fits every subject or occasion. Even stating that simplicity is the best goal, in regards to nature, is untrue. As beautiful as we may find a clear blue sky, we should not have to forego the wonders of swept or cumulous cloud vistas.

The artist has other choices too. You can choose any angle of view or distance from your subject you wish. You can also move an area of your painting from one plane to another by painting over it—for example, lightening a middle ground section in order to push it into the background. There are many ways to correct a composition. To make the best decision, you must first resolve what it is you want to correct before you can decide how you want to change it. Acting without forethought may not only fail to solve the problem, it may make it even worse.

One way to choose a course of action when the problem isn't clear is to decide first which portions of the painting you really like and want to "save." If there is more than one section, and they are not close enough to be included in one major composition shape or cannot comprise separate compatible shapes in a composition, you must sacrifice the area that is the least inclusive in the overall composition. Fractured attention is never found in good design, so where there are evenly dispersed pockets of interest, you would have to sacrifice several of them.

There is a logic or sense to everything in nature, even if we don't know what it is. And so an abstract naturalist painting should also have logical order, even if the viewer doesn't know what inspired the work. If there's a logic behind it, a sense of order will be felt. Paintings that are "unresolved" are just that. The artist has never quite come to grips with the original thought and how to present that thought intact. To "resolve" a painting means to separate its parts, analyze them, and make up your mind on what to do about them. While mostly subconscious for some artists, for others this process of resolution is the most conscious effort in their work. But without this preliminary analysis, whether you have natural talent or a studied art, successful works are mere chance. Artists who say they don't even think about such aspects of their work, but have consistently resolved and well designed art, simply aren't aware of how integrated this process already is in their makeup.

As mentioned before, we are an accumulation of everything we have ever experienced and believe. Even when, over time, our opinions and interests change, the ingredients of their evolution are not changed or destroyed, but merely refiled under new headings. So an instantaneous feeling of what looks right or not is a manifestation of design sense. What to do to make something feel right becomes easier with experience and trial and error. When *not* saddled with general and universal man-made rules, you are more likely not only to develop an individual style, but discover unique and wonderful ways to be creative as well.

Simplifying the Foreground by Painting Out

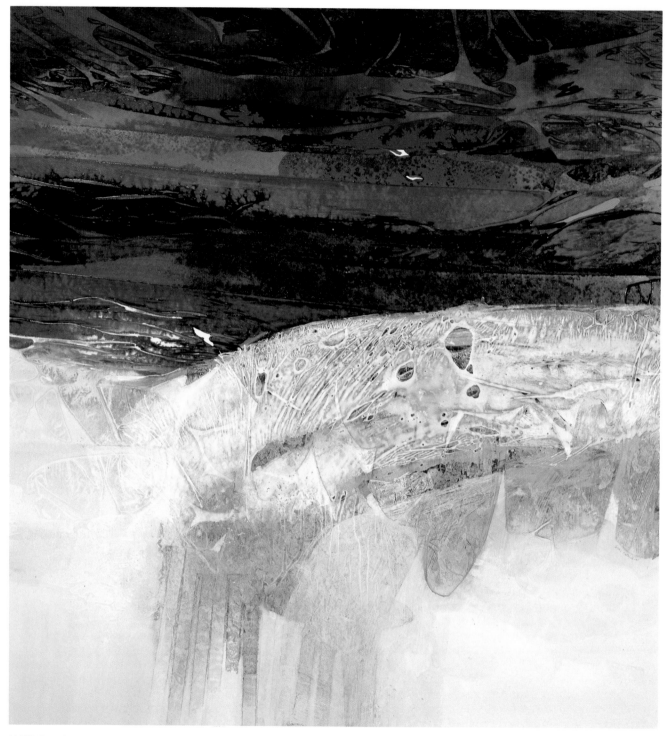

MAXINE MASTERFIELD, *BEACH GRASSES.* 40″ × 42″ (102 × 107 cm), ink on Morilla paper.
Collection of the artist.

Beach Grasses *describes the final colorful show of day, when the textures and colors are at their peak, before the peaceful night takes over.*

Beach Grasses was painted in two drying steps. The Saran Wrap was laid in rows and ink was poured over it in layers. Canning salt was then sprinkled on the wet ink and the painting was covered and left to dry. After the initial shapes and textures were formed, I found that the foreground seemed too busy, but what looked like a

setting sun in the background was perfect. So I kept the background and simplified the foreground by adding a pour of opaque white ink. At the time, I didn't know the white would later become an overpowering wave; all I knew was that the painting needed balance. Then I covered the wash with plastic wrap. When it dried, the trapped air bubbles were left behind. The three white areas of paper needed just a touch of help from my drawing pen to turn them into birds.

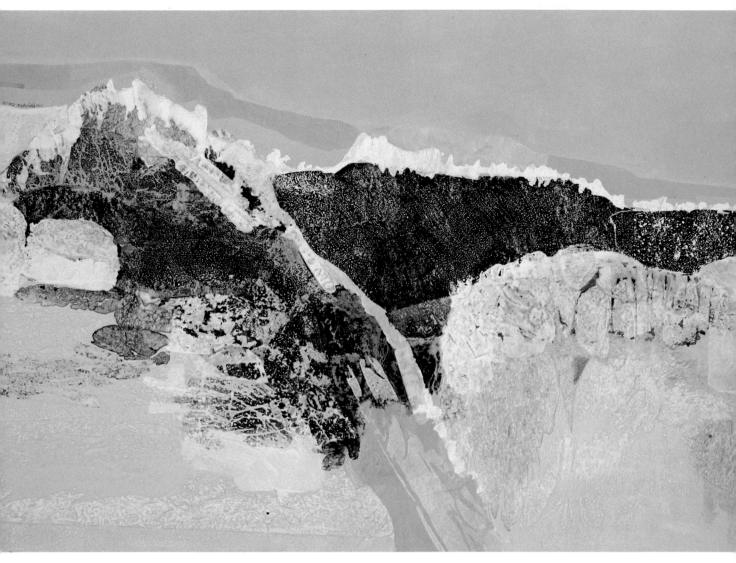

MAXINE MASTERFIELD, *ONE DAY IN WINTER*. 40″ × 60″ (102 × 152 cm), ink on Morilla paper. Collection of Foster Schoenfield.

Both the chill and grandeur of this painting expressed the feeling of being overwhelmed by winter. The assortment of colors and textures tended to expand the view by suggesting more and further planes. One Day in Winter was painted during the coldest winter I had ever experienced. The windows of my studio were buried in snow and I felt as though I was buried with them. No one dared to go outside for fear of frostbite. All the paintings made during that time were done with whites and grays, since my palette was directly influenced by my natural environment.

I began with a wash of burnt sienna ink in the middle ground, and placed blue-black ink above it. I added the whites and grays in the foreground in the second pour; when they dried, they formed textures. The gray sky was added last, without any undertexture.

Pouring and Texturing Broad Areas of Sand and Sky

MAXINE MASTERFIELD, *SANDY CREEK.* 11" × 14" (28 × 36 cm), ink on Morilla paper. Collection of the artist.

The pervading feeling of warm breezes in this painting is produced by the bright and earthy colors of the sky and by the direction of the sand texture on this sand dune. I began the painting by pouring raw sienna and burnt sienna inks over the entire surface of the painting. When it dried, I poured white ink into the foreground and placed a heavy plastic over it. The weight of the dropcloth caused a rippling effect that I've never been able to duplicate since. It looked like white sand that *had been moved by the wind to form the ridges. The four birds that sit on top of the ridge are slightly humorous in nature, a throwback to my days as a greeting card artist. I was compelled to add legs and beaks, to make them more realistic. This is one of my two-plane paintings, where the middle ground, the blazing white sand, is the focal plane, backed up by the textured background.*

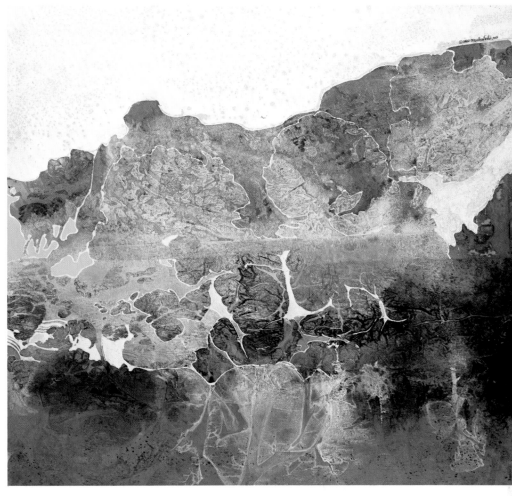

MAXINE MASTERFIELD, *SUMMER THUNDERSTORM*. 36″ × 40″ (91 × 102 cm), ink on Morilla paper. Collection of Mr. and Mrs. Harry Rosenweig.

There is an undulating spirit in this painting, with changes and reflections suggesting a fantasy setting. There is also the feeling of an active landscape, with trees swaying, wind blowing, and puddles of water shining, suggested by the outlined edges of shapes upon shapes.

This painting began with the waxed paper method and proceeded with overlays of white ink after it dried and the covering shapes were removed. Then the waxed paper was laid over it a second time and was left to dry over the white ink. The white wash in the sky was textured with canning salt. This painting remained in my studio a long time before it was resolved.

Painting Out over an Acrylic Resist

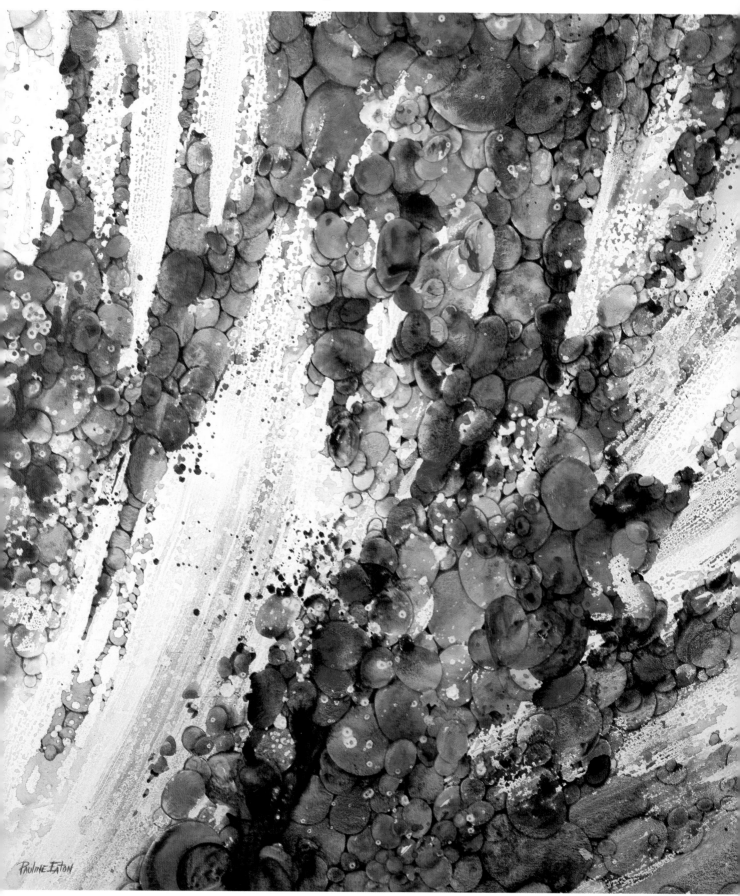

PAULINE EATON, *CRIMSON SHOAL.* 30" × 40" (76 × 102 cm), no. 110 Crescent board.
Collection of Charles and Victoria Hill, San Diego.

"I was born in Neptune, New Jersey, and now live on the Pacific coast," Pauline Eaton says, "and have had a lifelong fascination with the ocean. In Crimson Shoal, I wanted to capture the energy of the tide and motion of the waves and foam as they encounter a shoal of water-rounded beach stones. In my exploration of sea themes and of watermedia itself, I have always searched for a means of revealing transparent layers of perception and creating the illusion of boiling foam. One day I heard of the rule that watercolor could never be used over acrylic. Whenever I hear someone say 'never' or 'always' or declare any sort of rule, I see a red flag and have to break that rule, or at least prove it wrong by my exception. So I decided to paint watercolor over acrylic. I treated the paper with a diluted acrylic gloss medium (matte medium didn't work), before I painted on it and this gave me just the tool I needed. The acrylic acted as a resist that gave me both bubbled and smooth areas, according to the degree of pressure and the amount of paint to water in the combination. (More paint, less water, and heavier pressure makes the watercolor adhere better; the opposite creates a resist.) This was the breakthrough I needed to convey rushing waters with verve and flexibility.

"My compositions evolve from what I call my 'scribble sketches,' where I search for a value pattern and determine whether the format will be horizontal or vertical. Deciding the structure in advance leaves me free to develop the color and areas of interest as I'm painting. For Crimson Shoal, I chose a large piece of paper (I love painting big), coated it with a 50 percent solution of acrylic gloss medium and water, and let it dry. The initial watercolor washes created the resist bubbles of quite wet strokes of constantly varied pigments. This was then developed into more solid gestural strokes to express water and stone. The colors alternated between warm land areas and cool sea tones. The foam areas (the sea and tide) were applied with lots of water and a light touch, while the stones and darker areas were more heavily painted. They were also dashed with alcohol for 'burbly' effects and textured with a bit of salt.

"When dry, I pulled out the details with what I call my 'draw-and-mop method' I draw around the object with a small pointed brush, then blend and soften the outer edge with my 'mop' brush—a no. 6 or 8 Grumbacher Series 619, with its head sizzor-trimmed into the shape of an old-fashioned shaving brush. Additional finishing touches include checking for a balance of detail and adding loose washes with final splatters and splashes of fresh color.

"I've always said that painting a watercolor is like having a conversation. You may start out to say something in pigment, but the paint talks back and says its own thing. You then say, 'No, I want you to do this,' and then it answers back again. This is unlike other media that lie in place when applied. Watercolor has a mind and method of its own, and you must constantly step back, see what's happening, and keep on adjusting the 'conversation' of tone, color, value, and composition."

Using Gouache to Evoke a Wintery Scene

MAXINE MASTERFIELD, *STORMY WINTER.* 36" × 36" (91 × 91 cm), ink on Morilla board.
Collection of the Alcan Aluminum Corporation.

This chilly scene of the Chagrin River in Ohio is enlivened with color that tops the cliffs and is reflected in the water. The horizontal planes are connected by vertical edges and angled rapids, and there is a busy movement in both water and sky. In Ohio, there is a beautiful river called the Chagrin River. During salmon spawning time, it is usually quite cold and sometimes snowing. Most of the summer and autumn leaves are gone, and the river is gray. But the cliffs have touches of pink and mauve, and the water is high. Stormy Winter reminds me of just such a place.

I poured a generous amount of red, magenta, and sepia inks over the paper and covered the painting with waxed paper. When it was dry, I added washes of white gouache and touches of white lines to define the water and birds and create a wintery effect. The darkest colors, where the waxed paper textured the ink, are in the center of the painting.

Finding Airbrushed Effects in Nature

BRAZILIAN AGATE, photographed by William Horschke.

Here are six views of a cut and polished stone. The first example shows an overall view of it, then we gradually move in for a closer look. In examining closeups of the sliced geode, we can find various abstract compositions.

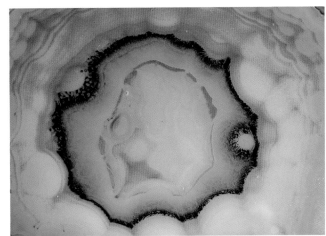
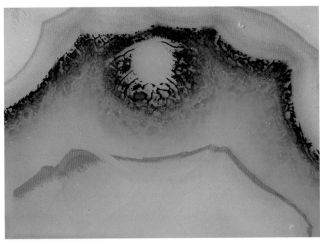
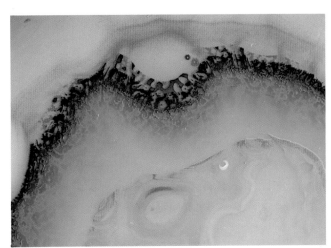
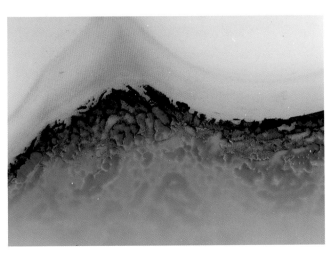
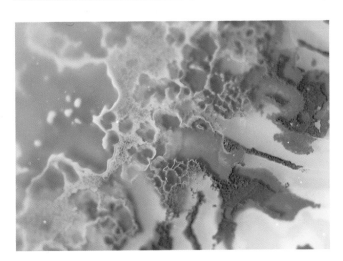

Painting Out with an Airgun

MAXINE MASTERFIELD, *WINTER'S FIELD*. 40" × 40" (102 × 102 cm), ink on Morilla paper. Courtesy of the C. G. Rein Galleries.

The subtlety of color and texture give a formality to this painting that borders on regalness. The overlapping areas of sprayed color blend to give a mauve feeling to the snow. The crossed movement of the central organic construction and the dominating textures and shapes of the surrounding areas tend to focus attention on the snow-clad tree.

 The idea for Winter's Field *came when I returned from a visit to Florida with several branches of a long-needled fir tree. I placed the branches in the center of the paper and poured raw sienna and gray inks over them. While the colors were still wet, I placed pieces of bubble plastic into them for shapes, then covered the whole thing with a plastic sheet. When it dried, I found that the ink had gathered around the branches, capturing the tree form. I airbrushed white gouache with glitter mixed into it—which looked like snow with subdued sparkles—as a finishing touch.*

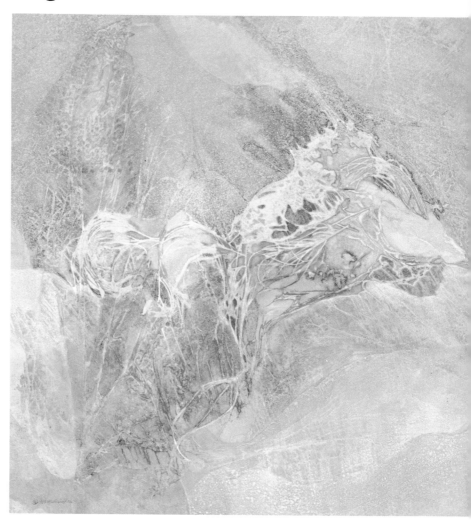

ICE FORMATIONS, photographed by Howard Stirn.

The same diagonally-situated radiating forms found in the painting separate the foreground from the background in this photo. The organic shapes of the frozen air bubbles have a graceful pattern and movement. Touches of color peer through the clear water to give contrast. The more evenly frosted opaque water areas here have an effect similar to the airbrushed treatment of white ink in the painting. It is as though nature painted out the water's depths by lightening the background.

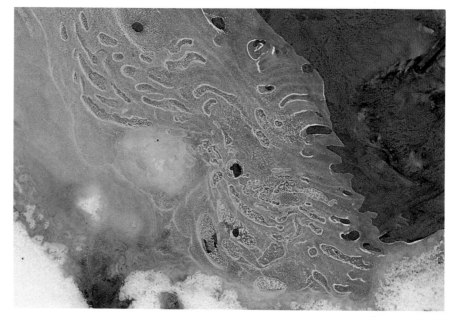

MAXINE MASTERFIELD, *EARLY MORNING LIGHT.*
40″ × 40″ (102 × 102 cm), ink on Morilla
paper.
Collection of the artist.

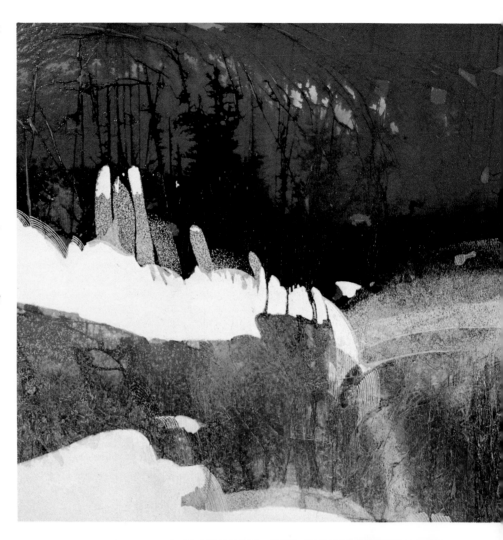

*Here the mood of the morning is
captured in the basic separation of
light and darkness of the creation
itself. The sun has not yet assigned
colors to specific forms and in nature
is caught in a sublime chaos. This
painting brings memories of the first
morning light coming over the hill
just as it reaches the horizon. The
foreground is in shadow, but above
the light is so blinding that all details
of trees and forest shapes are
obscured.*

*This painting seemed too harsh
after pouring ink and adding tex-
tures. I had just discovered the small
aerosol airgun and decided to see
how I could use it to simplify this
painting by spraying the bottom with
white ink. The results gave me the
blinding effect of light I needed,
without distinct lines or hard edges.
The natural mystery was preserved.*

DETAIL IN A TIGER'S EYE AGATE, photographed
by William Horschke.

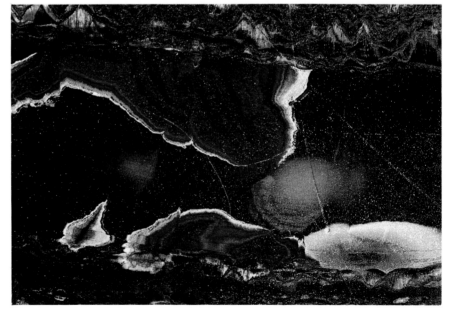

*The same abstract drama—with soft,
almost feathered edges—is evident
in this detail of an agate formation.
Again, the power of creation is here,
separating matter into some ecstatic
order. The photographer has made
the most of contrast and color.
Texture predominates in darker
areas. In nature you find the same
illusion of gradual graininess that the
artist achieves with an airgun.*

Using an Airgun to Get Dreamlike Effects

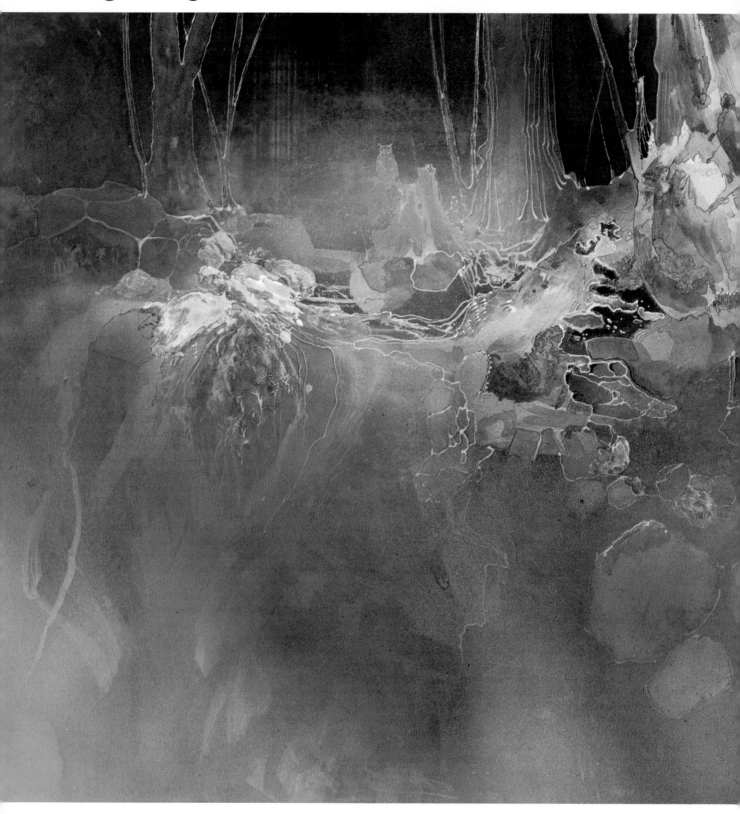

JOAN ROTHERMEL, *DREAM SERIES NO. 6.* 26" × 35" (66 × 89 cm). Mixed media on no. 112 rough Crescent board.
Collection of the artist.

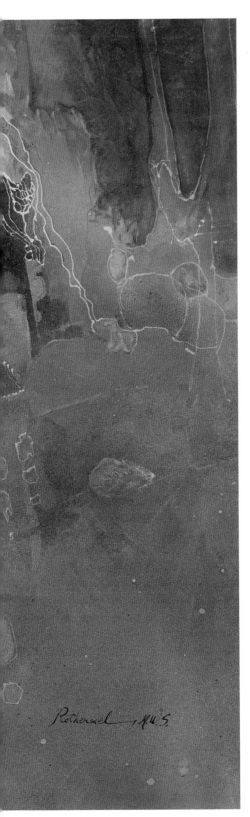

"As children," Joan Rothermel recalls, "we were filled with wonder over new sensory experiences. A work of art can bring back this sense of awe and recognition. The inspiration for my paintings comes from many sources, usually natural forms in combination with an aura or mood of obscurity and loneliness. When I am by the sea, I drink in the overall impression of waves dashing against rocks or rushing up the sand and slipping back to meet themselves in a litter of foam; of gulls and clouds and dune grasses bending in the wind. My partially nonobjective paintings are not preconceived, but seem to grow like a culture in a petri dish. In large part, they seem to have a will of their own, with my own hand being a puppet. The strings directing the puppet are my subconscious feelings and intuition. In some stages of a painting I'm just 'doodling' with paint, while in others, I'm painfully aware of each gesture, while trying to achieve an asymmetrical balance of colors, shapes, values, and other design elements.

"I began Dream Series No. 6 by pouring a rather large area of liquid frisket over the watercolor board in a random shape. (I used frisket because there is still a small bit of 'purist' in me that appreciates the glow of transparent watercolor over the white of the paper, and I wanted to preserve this area as long as possible. Without the frisket, this area of jewel-like tone usually shrinks considerably as I paint. I then poured on concentrated liquid watercolors (using only the permanent hues) in sections around the masked areas, blending them with a large brush. As I worked, I squinted my eyes to determine if the composition was holding up and to see where to apply opaque white, middle tones, or darks. I applied the liquid watercolors with narow-tipped bottles and the usual variety of brushes, from a no. 1 rigger to a no. 14 round. I also applied fine white lines with opaque liquid white in a plastic bottle with a needle-like tip. The frisket preserved the white of the paper and more importantly, it established a pattern of light. After color was poured on and had dried, the frisket was removed and acrylic white was painted on with a palette knife or sprayed on with an airgun to feather and soften some of the harsh frisket edges. From then on, it was a matter of building shapes that were reinforced by both light and dark linework. The latter was sometimes accomplished with a striper brush and sometimes with the syringe bottle. As I worked, the shapes began to suggest natural forms and I retained them to a certain extent, giving rise to an imaginary landscape. The dreamlike quality was achieved with muted colors and flowing lines—and by spraying on finishing touches of opaque white and liquid watercolors with an airbrush to achieve an aura of mystery and illusion."

Project

Working on a watercolor board or stretched paper, apply some liquid frisket in a pattern that will eventually comprise the white and/or light-toned areas. Using any watermedia mixed to a liquid consistency, try using three colors—one warm and two cool, or vice versa. Apply these colors in any manner desired, allowing some blending of paint. After this has dried, remove the frisket and build up the painting according to the theme it suggests to you.

Achieving Hard and Soft Edges with an Airgun

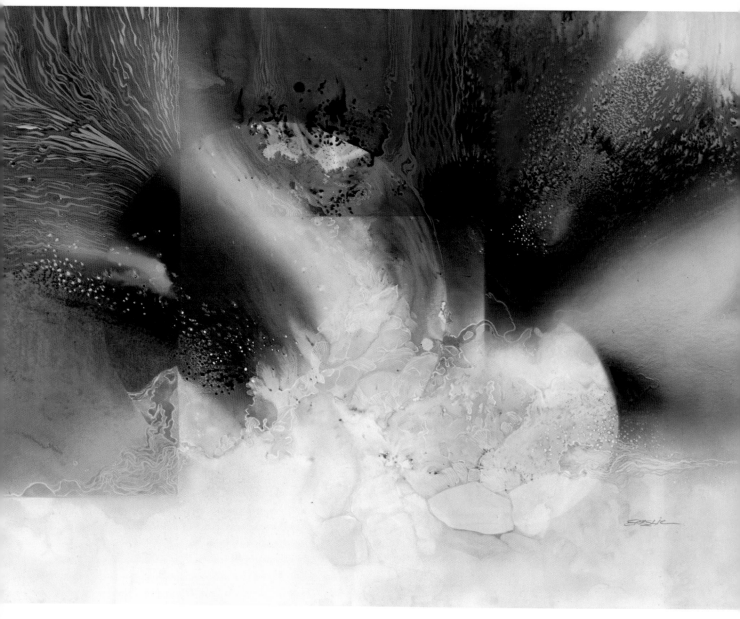

SALLY EMSLIE, SOLAR WATCH. 30″ × 40″ (76 × 102 cm), mixed media on no. 110 Crescent board.
Collection of the artist.

Sally Emslie describes Solar Watch as follows: "I believe that the concept for this painting stems from my years as a stewardess. You get to see a lot of sunsets from this bird's eye point of view, and many of these sights are spectacular in their color, texture, and mood. Someone once told me that you couldn't paint a picture of the sun with any real success because it was too beautiful, but I, like many artists before me, just had to give it a try.

"I began Solar Watch with a general composition in mind and stayed with it because it was working out and so I saw no need to change it. But there have been many times when I have changed my composition in midstream because I am always trying to improve a composition—and if I can, I do! Although I'm working on a 30″ × 40″ board right now, I'll probably move on to a larger paper size as time goes on because I don't paint from the wrist. I paint from the shoulder—and that requires space.

"This particular painting began in the upper left-hand corner. I worked from light to dark and warm to hot colors, supported by cools. These colors spelled 'fire'—the fire of the sun. In the beginning, I deliberately let a painting get out of control. I love this. It's what gives the painting its spontaneous appeal. Yet, apart from occasional side trips, I never let it get too far from the beaten path.

"I always begin with a lot of water, and so I seal the edges of my board with paraffin to prevent it from separating into layers. The overflow is no problem because I work on a large table my husband designed for me that resembles a Bathinette, and the excess paint and water drains into a bucket below. When the water on the illustration board is heaviest, I pour my selections of ink, dyes, and thinned acrylics together. I use bottles to pour on the inks and dyes, and a soup ladle for the acrylics. The ladle permits me to add as much or as little acrylic color as I need.

"As the water drains off, a marbled effect is created. When the flow has stopped and there is just a shine on the surface, I create textural effects with such items as cloth, plastic wrap, and drops of oil. When the colors and rhythm are visually pleasing to me, I turn on an overhead fan for fast drying. This is also when I study the painting before me, thinking: 'Do I need more? Do I need less? Is it time to resolve my design concepts?' When it's dry and these decisions are made, I use pen and ink and brushes to accent areas for greater visual interest.

"The airbrush, used with discretion, can be a very effective tool. In this case I used it to create hard and soft edges, leaving a feeling of three-dimensional qualities. I blocked out certain areas first with cardboard circles and squares, then used the airbrush to create an illusion of dreaminess. I like these soft effects; it gives the viewers a chance to use their own imaginations. For finishing touches, I like to use a detail brush to create high contrast in key areas.

"I rely on my instincts to tell me when a painting is finished, and the more I paint the better I get! I like this painting because it has both drama and color, and I feel that I've made a rather difficult design concept, 'the circle and the square,' work—and that gives me a feeling of accomplishment."

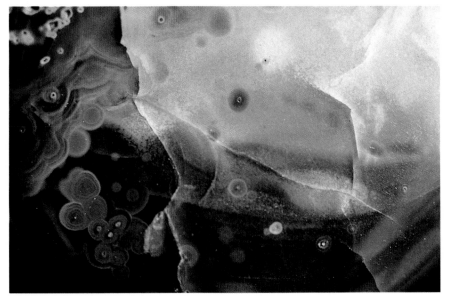

POLISHED AGATE, photographed by William Horschke.

This agate formation inspires the imagination with the same qualities of metamorphasizing life sources that are in Solar Watch. Nature, too, contains contrast, hard and soft edges, basic forms, and accents of color that produce a dramatic effect. The congealed vapors and smoky forms in the stone create subtle transitions of light into dark— nature's version of the airgun.

Painting Out to Strengthen Contrasts

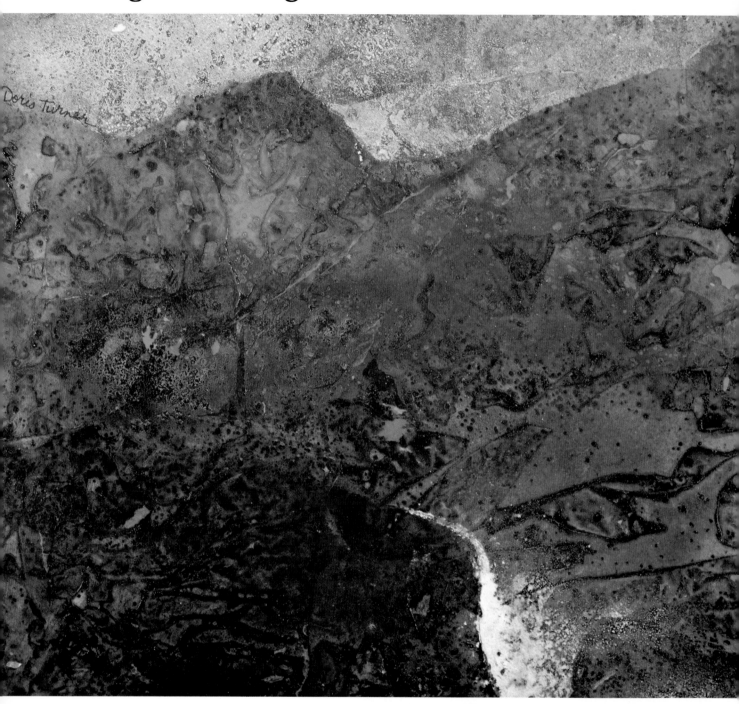

DORIS TURNER, *MONTEREY COAST*, 21" × 23" (53 × 58 cm), inks on Morilla board. Courtesy of Albert's Art, Inc., Boston and Osterville, Mass.

Doris Turner shares her vivid recollections of painting Monterey Coast: *"For weeks, I had wanted to clear my shelves of an excess of black india ink and had programmed 'black' into every color scheme. As a result, I constantly had to draw into the dead black areas with a squeeze bottle drawing pen full of bleach or opaque white ink to lighten it. The black areas were so dull and flat, they didn't even respond to salt, which usually scatters and sparkles the colors. I also risked overworking each painting by doing this.*

"When I began Monterey Coast, *I was in a black mood from these struggles. I stretched four small watercolor boards and chose colors to match my dark mood: blue and burnt sienna to replace black; a red and a green for a darker black; and raw sienna for a contrasting light area. (Selecting and premixing my colors avoids too many surprises while painting.) Without worrying about extending beyond the edges of the paper, I squeezed my plastic squirt bottle and directed a stream of dark ink in an irregular up-and-*

down motion, like the chart of the rise and fall of the stockmarket. I didn't plan an overall shape or design on the paper, but just poured one color over another. Since the paper was small, I wanted it to look as if it were a piece of something much larger, like part of a scene being viewed through a window, with a beginning and end someplace else. Then I carefully worked out a rising 'flight' pattern across the paper with torn bits of waxed paper, and laid it over the wet ink. Normally, when it dries, the wax is transferred to the painting, creating a shiny resist area for further overpainting. But it was a hot summer day—in the high nineties—and when I dried the painting outside, the heat bonded the small waxed paper shapes to the paper and I lost the pattern—and for a moment the painting. However, after studying it and squinting, I thought I could detect hills and mountain ridges. I decided that, if I lightened the top a bit, I could divide the land from the sky and create a landscape.

"So I laid a sheet of waxed paper over the painting and traced a line along what I saw through the paper to be my top mountain ridge. I then cut along this line to create a stencil. I had intended to do a series of ridges, but this line proved to be enough. So I taped the stencil in place and with a small airbrush, sprayed a fine mist of raw sienna and mostly white inks across the waxed paper mountaintop. Then I sprinkled it very lightly with salt so that the color wouldn't be too solid and out of keeping with the other surface textures.

"Stepping back, I suddenly recognized the landscape. It was Monterey Bay, California, where my daughter lives—and suddenly the deep green in the lower left was the sea! This was no longer a dark mood painting; this was a place I loved. I took a flat aquarelle watercolor brush (no. 8), and holding it vertically, I tamped out with its chisel edge a curved, pleasing coastline to divide the water from the land and lead the eye deep into the dense majesty of cliffs and sea. And one last time I sprinkled salt onto the white line (whose tapered end I touched with blue for distance) to suggest the ocean spray against those giant rocks.

"The final painting was still moody, but now the mood was warm and loving. By adding the simple finishing steps—the waxed paper line, water-color airbrushed colors, and salt—and by carefully positioning my mat to make it a good composition, I was able to finish it better than I could have by overworking it with drawing."

Project

Pour inks in a pleasing shape or design, then try pouring the ink without considering the edges of the paper as boundaries. Think of the ink as describing a continuation of life or a moving rhythm, not a self-contained moment.

Creating Realistic Effects with Paintbrush and Airgun

Project

Get into the habit of looking and seeing in a unique way. Create an emotional feeling in your work. Technique is not enough. The painting must move us in some way.

SYLVIA GLASS, *CRYSTAL CLEAR TROPICAL WATERS.* 27" × 49 ¾" (69 × 126 cm), watermedia on heavy-weight illustration board.
Courtesy of the Adrienne Simard Gallery, Los Angeles.

Sylvia Glass writes, "As I walk along the beach, I look down at the sand near my feet, at the foam of the sea as it reaches the sand, and at all of the activity created by the interaction of the two. I look to one side and see an expanse of sand with a rock here or there; sometimes I see decayed beach forms pushed up by an earlier tide, shaped and changed by a hot sun. Or I walk in the desert and see the vast expanse of sand shaped by the rhythms of the wind going back forever in time and onward to infinity. Both are mysterious sources of wonder.

"My paintings take one square inch of sand, sea, or shapes and expand them to fill an entire painting surface. But they are more than a mere expansion of space. They are an expansion of the concepts of silence, contemplation, peace, and renewal of the human spirit. My paintings describe sea and desert (silence and the contemplative mood), flowing water (the energy of the sun, the flowing quality of life—birth, growth, death), the duality of land and sea (a combination of sea and desert and flowing water into a new magical form), and spirit (man's emotional and spiritual reaction to the symbolic forces represented by these natural forms). In particular, I try to give reality to imaginary forms and shapes, to create the illusion of three-dimensional actuality, and to present a glow of light within my paintings—in short, to combine realism with fantasy.

"To achieve these goals, I work in a layering method, with water-based paint in a spray gun, enriching the surface with a brush and hand-applied paint. I use color as the mood dictates, working from dark to light. Although I have a general plan, my entire way of painting is experimental, and losing the way is often part of the painting process. I use rock salt for texture and as a mask, and I use any other ideas that come to mind when I need a certain look. (Nothing is left on the painting.) In this painting, finishing touches consisted of adding the shadows of the rocks."

LEOPARD-SKIN AGATE, MEXICO, photographed by William Horschke.

Within the rock's surface, what appear to be many stones at the water's edge are outlined as if by shadows. The colors of the rock range from warm through cold, and have segregated themselves in the small-node perimeters. Like the stones in Crystal Clear Tropical Waters, *the formations in the agate vary in size and color but are somehow related in mood. Both photo and painting share these textural changes.*

Achieving a Layered Effect by Painting Out

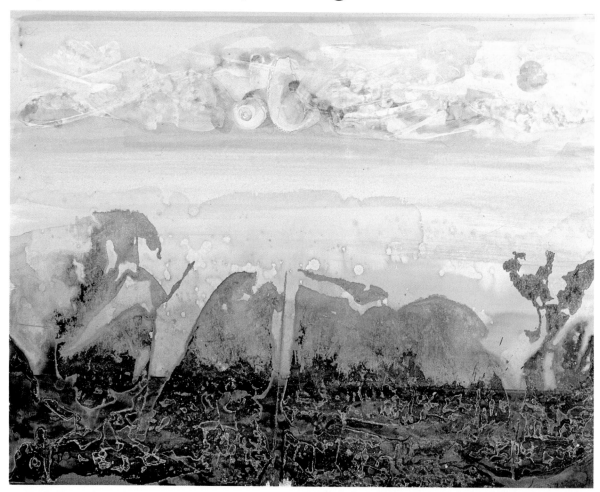

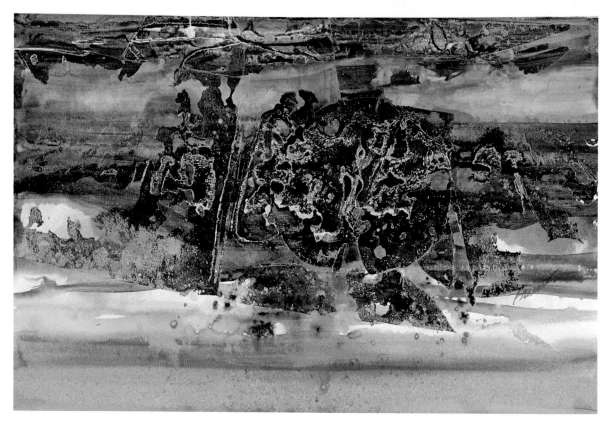

MARY BEAM, *HIGH TIDE*. Diptych, 60" × 30" (152 × 76 cm), acrylic and watercolor on no. 100 Crescent board.
Collection of Mr. and Mrs. Christopher Ries, Columbus, Ohio

Describing High Tide, *Mary Beam writes:* "I had just returned from a visit to the ocean and the memories of the sea were fresh in my mind. Watching the tides rise and fall, I wanted to respond to the sense of vastness and agelessness of the sea. I usually don't preplan my paintings. Visualizing the whole painting in my mind before I start is dangerous because the finished product may never live up to my expectations. However, in this case, I developed the whole theme in my mind before painting it and planned it much the way it happened.

"I decided to make the painting large to portray the vastness of the ocean, and I wanted to show the layers of the sea, the things the eye misses. I tried to sort out the different stimuli and arrange them in my mind into a design that would express my feelings.

"I began at the bottom and worked up. I selected acrylic colors—burnt sienna, phthalo blue, and iridescent pearl—and mixed them on the watercolor board with a large brush. Using the acrylics in a liquid, fluid manner, I developed patterns that suggested the murky bottom of the ocean floor. Then I covered the wet paint with a plastic overlay and manipulated the paint into organic forms and natural-appearing shapes. As I began to see the ocean in layers, I decided to develop the painting in the strata format. I gessoed the section where the shell or fragmentary shapes would be, modeling the gesso with a spatula into the shapes I wanted, keeping the area wet with water from a spray bottle. When that area dried, I painted the shapes with a subtle suggestion of watercolor. I worked from dark to light, achieving the lighter values through glazes of watercolor. Their transparency contrasted with the heavier acrylic. Iridescent paint was also applied in a transparent wash; it made the entire painting glimmer like rays of light hitting the water. Finally, I added a few more brushstrokes to the top to give a greater hint of form to the shells.

"I am always learning from my work; the paint always reacts differently. Here, for example, I got a green that I hadn't anticipated when the colors mixed on the board. But I liked it—it reminded me of algae in the sea—and so I left it there. Paintings are never perfect from the start. All my paintings have compositional errors until I finish them and resolve the design problems. And sometimes I leave them—a compositional error can make a painting more personal and interesting. However, this painting never got out of control; the images were well-organized in my mind, and painting most of it was a joy. I am satisfied with this work now. It expresses my feelings about the sea and my love of nature, and I hope it shows the viewer a new way of experiencing the phenomenon of the sea."

Project

Model some shapes in gesso on a Crescent watercolor board. Let the gesso dry thoroughly and when it is bone dry, paint into the forms with watercolor. You can also model lines and textures with this technique, and perhaps discover a new range of textured shapes.

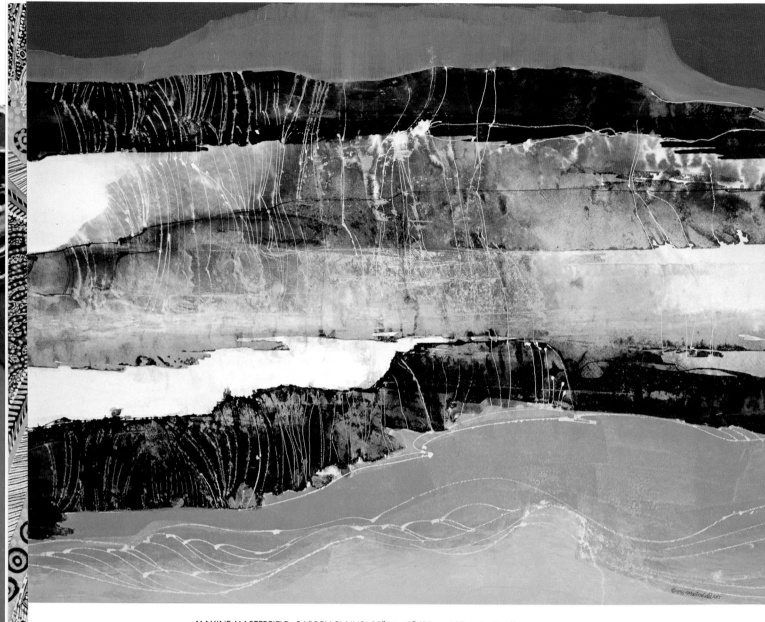

MAXINE MASTERFIELD, *BARREN PLAINS.* 32" × 40" (81 × 102 cm), Morilla paper. Collection of Sally Gabel.

This painting has a quality of constancy and serenity because of its unidirectional, almost unfaltering plane flow. In almost parallel strata, the layers of sky, rock, land, and water maintain their peaceful coexistence. I needed to somehow introduce just a touch of agitation to the scene, a subtle change of direction to fracture, but not break, the tranquility.

I consider this one of my simplest paintings because it began with a controlled pour where each color remained on one plane. Some monoprinting was used, but the key to this work is the white line. To introduce that whisper of motion, I moved the line in a downward motion, like marshweeds, very lightly crossing all the horizontal planes. I allowed the additional lines in the water to show the direction of the current. The dark, flat wash added to the sky defined the horizon and counterbalanced the pure weight of the water. The finished work seemed to describe a bleak phase of nature waiting for the spring, when birds would nest and add more life.

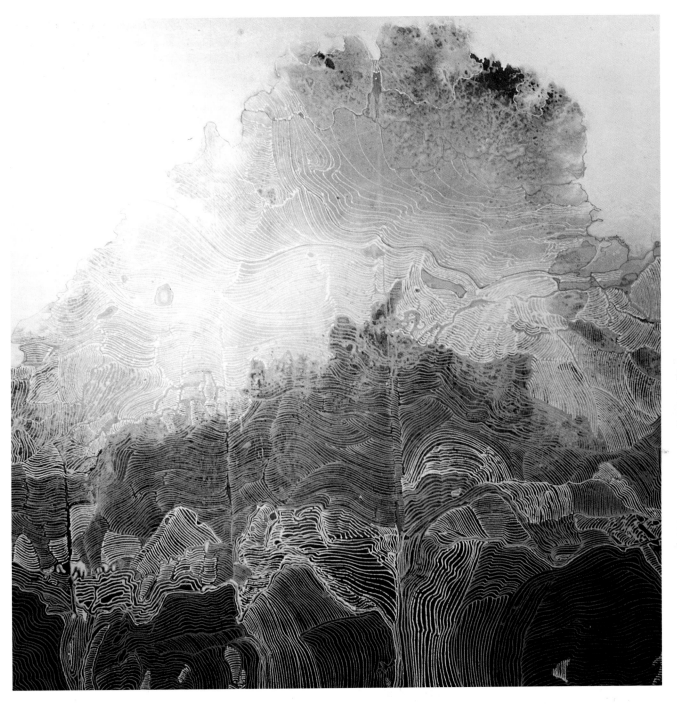

MAXINE MASTERFIELD, *SUBTLE TRUNKS*. 40″ × 40″ (102 × 102 cm), ink on paper.
Collection of Mr. and Mrs. Roy Hausted

*Like the fine lacework of an Atlantic thorny oyster or the lines found in a
fossilized coral,* Subtle Trunks *resembles many products that show nature's
flair for the intricate detail. I had just discovered the needle pen as a draw-
ing tool and had to fill every available inch on the painting with my new toy!*

*I began the drawing near the top, and as I moved across the work, it
became easier and easier. Once I sensed the trees forming, I knew where the
lines belonged and what their direction would be. The white and gray
mixtures of paint allowed the undercoating of colors to serve as a sustaining
background, the supporting cast to the line's leading role. The line does not
interfere with this painting; it dominates it. This was my ultimate endeavor
in my love affair with line. Nothing since has come close to its earnestness
and dedication. Like a first love, it cannot be repeated.*

Using Line to Emphasize Shapes

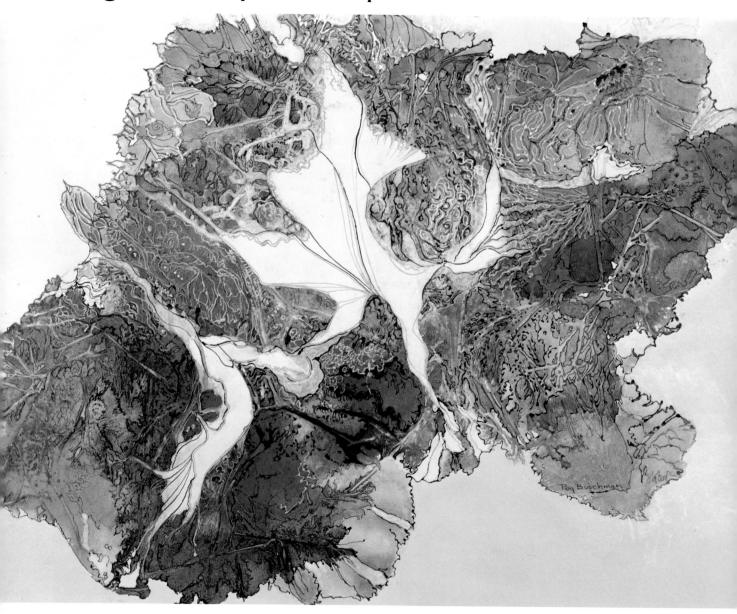

PEG BUSCHMAN, *FANFARE*. 20″ × 27″ (51 × 69 cm), watermedia on Morilla board.
Collection of the artist.

Peg Buschman writes of her work, "My original concept was to get a sort of floral or garden look. I wanted a picture that was active and gay, a happy picture. The theme, which is probably just 'excitement,' has developed mostly unconsciously by the use of bright floral colors, contrasting shapes, a strong diagonal thrust, and active 'pulsating' lines.

"I started by pouring the strongest colors—red, blue, and orange—onto the paper and let them dry under a sheet of Saran Wrap. Feeling that the painting needed a pale color for relief, I poured a little pale green here and there, and again applied the plastic wrap. When dry, or almost dry, I drew lines into the painting, emphasizing shapes that the plastic film had suggested, for example, a dark green over a pale green to suggest veining.

"I worked from dark to light in this painting. Wherever the colors seemed too dark or rounded, I added lines in white ink or pasted on white paper in sharp, splintery shapes to break up the stodginess of the painting. The white areas read as positive shapes, although since the background is white, they could also be seen as negative spaces. I drew into the collaged forms to tie them to the surface of the painting. For the most part, I am not actually depicting petals, stems, or flowers; and the white forms are not intended to look exactly like birds, but I want all the forms and lines to wiggle and flow together in an organic way that suggests living things. I prefer my shapes to be ambiguous, to be read as different images by each viewer."

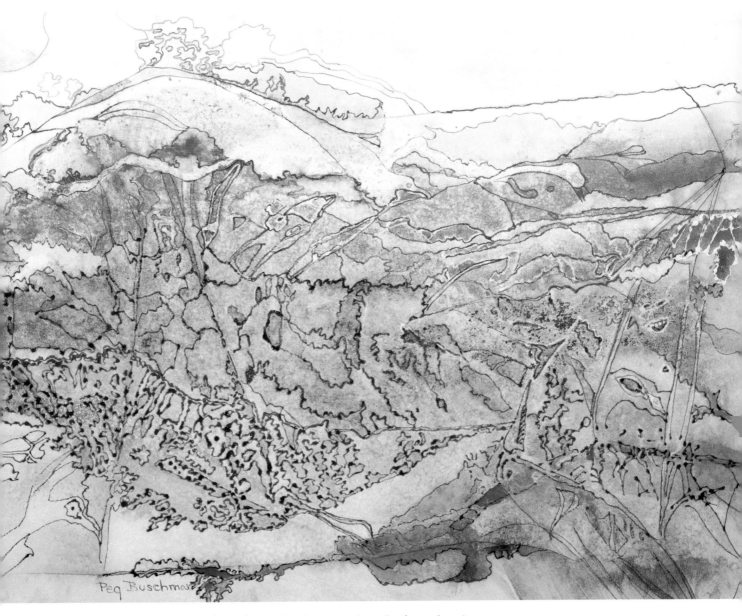

PEG BUSCHMAN, *THE EARTH BELOW.* 16" × 20" (41 × 51 cm), watermedia on Strathmore Aquarius paper.
Collection of the artist.

"I wanted to paint an impressionistic landscape using cool colors in the background and warm ones in the foreground and at the same time flatten the picture plane through a total lack of perspective," Peg Buschman explains. "My aim was to find new shapes and images while making a picture that would say 'landscape.' The landscape was to be layered, with a horizon, layers of vegetation, and subterranean levels, but the painting evolved into something a little different from what I had originally imagined.

"I started by pouring a wavy line of blue ink across the top. Then I continued to pour other typical landscape colors onto the paper. Squirting or pouring ink or paint onto dampened paper is a favorite technique of mine. I like to let the ink take its own course for a while, though you have to be careful not to put too many colors down while they're wet or they'll all run together and make a huge mess! As I poured the inks on the paper, I added a little salt for texture and drew into them when dry, for definition. To keep the painting from becoming too harsh, and to produce interesting lines, I poured a little white ink over most of the picture and covered it with Saran Wrap. When it dried, I emphasized the forms the plastic wrap suggested by drawing into them with inks related to the background area. When I drew into the bottom layer, the painting was finished. This painting taught me to relax and let what is on the paper dictate to me without too much 'cerebration.' "

Evoking Feathery Rhythms with Line

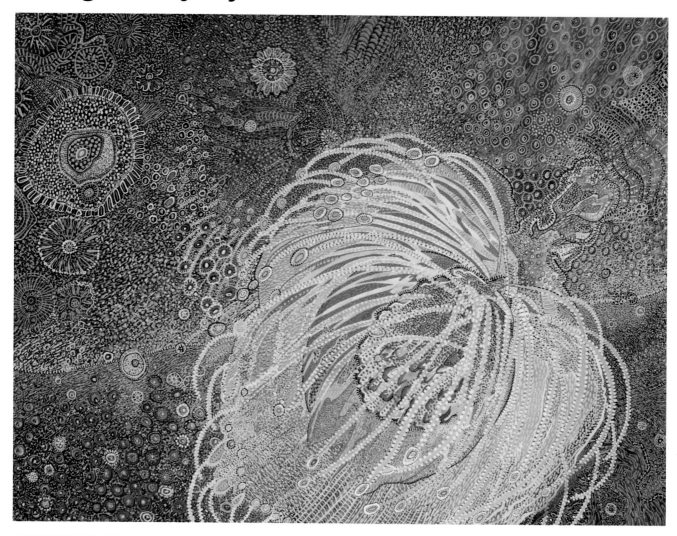

JUANITA WILLIAMS, GARDEN MAGIC. 20½" × 29" (52 × 74 cm), watercolor on Arches 300-lb cold-pressed paper.
Collection of the Ohio Watercolor Society.

"The concept for Garden Magic," *Juanita Williams explains, "came from a flower in a planter on Fisherman's Wharf in San Francisco. I had never seen this particular flower before, and it fascinated me. I looked at it for a long time, then took a closeup of it with a macro zoom lens. I wanted to convey the magical qualities that nature had produced in my painting, and tried to do this by highlighting the flower shape, using lots of contrast, and making the flower appear to radiate light. I chose colors similar to the ones of the actual flower, and planned its shape on the paper, but the background just evolved.*

"*I began with the flower, painting it on dry paper with a brush and transparent paint. Then I added Luma white to the watercolor paint and put lines, circles, and dots into the painting. I found it difficult to balance the light shapes in the background with the large flower shape, and had to adjust them several times, gradually darkening the background so the light shapes appeared to glow. By using large areas of opaque paint, the transparent areas left in the painting gain more importance. It was a very difficult composition to carry out. I*

felt I was done when it appeared to have the magical quality and balance I had wished to achieve.

"*Several years ago, I began developing a technique of using lines, dots, circles, and other forms. No one taught it to me; it evolved. Seen from a distance these forms create values; seen up close they are decorative. I like the many different effects I can achieve with these forms and lines, and I recently discovered that they are actually ancient symbols.*

Project

Draw or photograph a closeup of a flower, one you find particularly interesting. Lightly sketch the large, simple shape on your paper in an unusual place, then have fun trying to balance it with smaller shapes in the background.

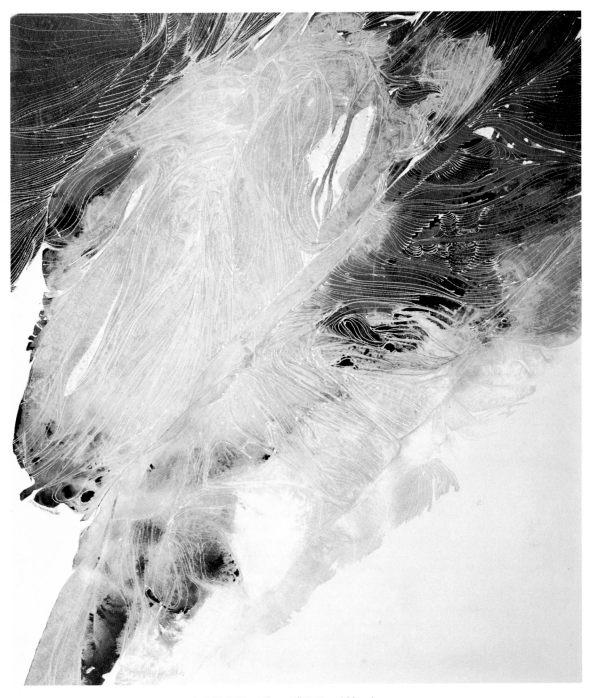

MAXINE MASTERFIELD, *KATY'S FEATHER.* 46" × 40" (117 × 102 cm).
Collection of Pat Shimrak.

It is line that creates the fantasy of flimsy filaments that become a feather. A line must "know" how a feather feels and is moved by the slightest air current. It must anticipate the spirit of what direction is next. The sense and structure of the subject must not get out of character or the identification is lost. If the line is faithful to the inner tempo of the subject even nonrealistic turns can become plausible. As you study the maze lines, try to see kindred arrangements. For example, I related some sections to the swirls of my fingerprints.

After the original pour of earth colors and salt for texture, a feather form was discerned when the whole thing dried. I knew I could enhance this giant feather by drawing in what it needed. I thought of a friend who loved to draw feathers and dedicated the painting to her. From then on, the movement was all mood.

Collage and Monoprint

As you have seen in the demonstration section, collage involves cutting or tearing and pasting pieces of paper onto a painting to rearrange shapes and textures in a way that is resolved and pleasing to the eye. In many ways, collage imitates nature's arrangement and converging of objects of many colors and textures into innumerable sequences. If nature can do this, why can't the artist? There is also another reason for collage. Sometimes some sections of a painting are extremely successful while other areas are mediocre. Rather than preserve a painting that is mixed in quality, or discard it altogether, I often tear or cut it up and collage the best passages onto another painting. I save the poorer sections, too, and use them for monoprinting (see page 28).

Ever since I was a child, when I created miniature villages of sand and stones, I have been interested in assembling diverse fragments into a composition. Sometimes the urge or inspiration to collage has been overwhelming. Many objects have caught my eye because of their shape, color, glossy surface or unusual texture and I have mentally placed them into some configuration. I usually see them as parts of some mystical whole waiting to be formed, like parts of some universal jigsaw puzzle.

I can still remember my first grocery shopping expedition as a new bride. As I roamed the aisles gathering a month's supply of canned goods, it was not the objects but the bright coloring of the labels that decided what I bought that day. I can still recall being obsessed with choosing vibrant reds and whatever would set them off. When I finished, my cart was a collection of hues, not the basis for a planned menu. When my husband came home from work that evening, the kitchen was empty. Instead of preparing dinner, I was busy in my studio. When he opened the pantry, he got another surprise. There was a blaze of shining silver cans in neat rows—with no labels. I had used them all in a glorious (to me) collage. Of course, I was not trusted to do the shopping after that, and I can't remember how many mystery meals it took to use up the unmarked cans. But I do remember selling my collage at an art festival.

Of all the stages in the artistic process, I think that collage is the most helpful in teaching good design. Arranging and rearranging shapes and values develops an eye for effective composition. But learning to see how certain arrangements can work, and understanding why, comes with practice.

To me, stifling the creativity of composition that collage embodies is nonprogressive. I remember times when two artists would work together in unison on a painting, creating beauty with the flowing together of their talents. I feel that collage does the same thing. When I collage several works into one, I am gathering the selves that I was at the moments of creativity and joining them into a single painting. Without mixing mediums or adding foreign matter to a watercolor painting, I manage to create a watercolor painting on watercolor paper.

But not every watercolorist shares my good opinions of collage. I sometimes bristle at the illogical, negative views of some watercolor societies. Several of them refuse to permit collaged works to be shown for the same reason these purists don't approve of the use of opaque white—they don't feel that collaged works are true watercolors. However, many artists—including those whose works appear in this chapter—don't agree with these traditional viewpoints. If you are interested in collage and in exhibiting your collaged paintings, an organization has recently been formed—the North Coast Collage Society (NCCS). Its president and founder is Gretchen Bierbaum, and you can write to her at 254 W. Streetsboro Street, Hudson, Ohio 44236 for further information.

The added encouragement to experiment that collage provides can keep your work from becoming as stale as a rubber stamp. Combining parts of paintings rekindles your imagination and fans the flames of inspiration. Experimentation also keeps you from falling into a rut by repeating a favorite formula that was once successful. Remember, there's little creativity in cloning, even if you are cloning your own work. And there's certainly no growth, in any direction, when you're so satisfied with your work that you never try something new. You can never be afraid to fail. Fear of failure automatically dooms any breakthroughs. Remember, conservatism doesn't make history—it already *is* history!

RUIN MARBLE, DENDRITIC LIMESTONE, photographed by William Horschke.

This is a closeup of one of my favorite rock "scenes." Nature has combined sandstone shapes into an arrangement to create what looks like a mountainscape. The stone is layered and stratified, with the ribbon-like marks adjoined by a milky, delicately mottled section. To the imagination, it appears to be peaks and overlapping planes, and the spreading mineral marks resemble fir trees on mountainsides. This "scene" serves as an inspiration to my art. I have seen such rock strata formations on mountainsides and in gorges, where layers were disjoined and misaligned by faults and quakes. Some rocks contain strata compressed into curling layers, folding back on themselves like the stripes of hard Christmas candy. Jagged, serrated edges of rock strata are often the product of shifting land masses. Nature's process of recreating or reassembling its materials is my inspiration for the artistic process called "collage."

Peeling Off and Adding Paper for Natural Effects

MAXINE MASTERFIELD, *MOUNTAIN LONELINESS.* 36" × 40" (91 × 102 cm), ink and collage on Morilla paper. Collection of the artist.

This was my first successful collage painting (1976). It began with several experiments on my spinning table. I discovered that the ink stained through the watercolor paper, and that if I peeled the layers of paper back, textures and lines were left in the underlayers. The foreground was done this way. Then the middle ground and background were formed by a combination of several paintings, glued onto the work with acrylic gel medium. Because I worked isolated and differently from other water-media artists, I thought I had discovered this kind of collage on my own, and that added to my excitement and creativity.

VIRGINIA HAUSTED, *HIGH COUNTRY.* 30" × 38" (76 × 97 cm), watercolor collage on Morilla paper. Courtesy of the Joan Hodgell Gallery, Sarasota, Florida.

Virginia Hausted "found" these peaks and planes from several paintings in her studio. The reds seem even more vibrant against the cool blues and greens, and the softness of the distant mountains enhances the textured strata in the foreground. Especially exciting is the jagged torn paper line that remained after the paper was torn into elongated rock shapes. The tinted hues result from peeling the paper apart to allow the ink-stained colors to show. The idea for High Country, *actually one of a series of paintings, came from a painting trip to Mexico. There she was influenced by the intensity of the sun, which created strong lights and darks and provoked her selection of the water-soluble Pelikan inks—warm and cool reds, and blue-black darks. "I began by establishing a strong diagonal thrust while working to establish three major planes—foreground, middle ground, and background," she says. "The colors were applied by brushing, splashing, pouring, spraying, and monoprinting them onto the surface of the painting, and they were lightened by spraying water over them and blotting them."*

Project

Lay out some random sizes of Morilla paper. Select a subject and decide which colors will best express it. Build your colors in layers, one over the other: an orange over a yellow, a yellow over an orange . . . experiment with your method for applying the colored inks. After they're dry, select parts of the papers you want to save, tear them out, and paste them onto a large sheet of Morilla paper with acrylic gel medium. You can also glaze more color over them for rich color effects.

Collaging with Stencilled Letter Shapes

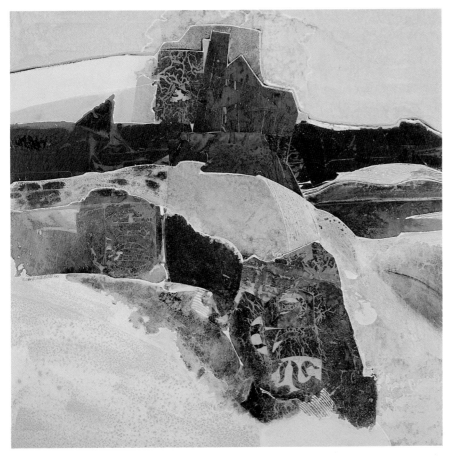

MAXINE MASTERFIELD, *REMEMBERED WALLS.*
40″ × 40″ (102 × 102 cm), collage and ink on
Morilla paper.
Collection of Stephen Strauss, Denver.

In Remembered Walls, *I see symbols etched into a secluded stone on a sandy beach. Behind the monument, a rock wall has similar marks, but these are etched by time and the wind. This is another in my series of monument paintings dedicated to my dear friend Harriet. In the background are structural shapes against a gray sky. The message is one of abandonment and stillness. The composition is a somber repetition of light, then dark, planes that echo the same downward curve.*

The foreground shapes originally were made with a pour of ink and plastic lettering stencils left in the ink to dry. Instead of adding paper shapes to the collage, I cut out the dark coloring around the lettering and added gray ink. The white washes were run over the foreground and middle ground, along with touches of white line. Final details included removing and relocating the paper layers on the work to add new textures and values.

MAXINE MASTERFIELD, *BARN GRAFFITI.* 40″ ×
40″ (102 × 102 cm), ink and collage on
Morilla paper.
Collection of the artist.

Barn Graffiti *provides a glimpse of uninterpretable messages, but we can only concentrate on one small area at a time because there are so many fascinating details hinted at. On my first visit to a quaint Mexican town, I enjoyed the rich textures and subtle colors on a wall, while peasants passed by, unseeing. My visit to New York City repeated the experience. The graffiti there was so enticing, embellishing every wall in reach, that I didn't even notice the buildings or the people. I have been fascinated by parking lots, too, where some rock or fossil embedded in the asphalt will capture all my attention.*

Saran Wrap and large plastic letter stencils were placed in sienna and sepia ink, and the waxed paper method was used to texture the painting. More letters from other paintings were also collaged onto it, to complete the composition.

Composing a Landscape with Colorful Shapes

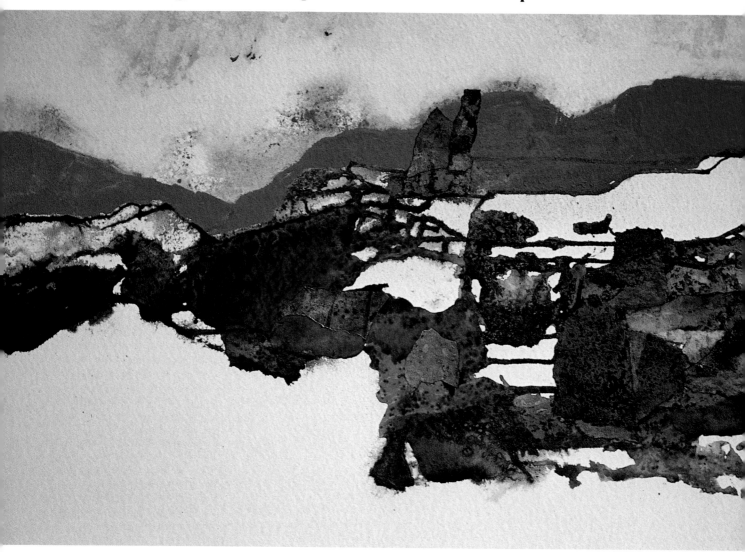

MAXINE MASTERFIELD, *BIRDS IN FLIGHT.* 38″ × 42″ (97 × 107 cm), ink and collage on Morilla paper.
Collection of Mr. and Mrs. J. J. Nelson, Central Bank of Denver.

It is a beautiful cold winter day in this painting, and distant birds make a delayed departure. We are viewing rocks, snow, and seemingly abandoned buildings. The rich blues and grays create a feeling of peace as the earth rests until spring, but there is a sense of starkness caused by the high contrast and the hard edges where the snow begins. The snow almost reads as negative space. The rich browns are the only touch of warmth.

I started this painting on my spinning, tilting table. The flowing brown lines were made by pouring sepia ink and guiding it from left to right. Pieces of color-soaked paper were added as the color began to flow. The gray mountains were added last, but the bird shapes appeared in the sky as I began wiping back some of the poured color. The added shapes integrated well with the rest of the painting, forming natural and manmade structures to support the patches of snow.

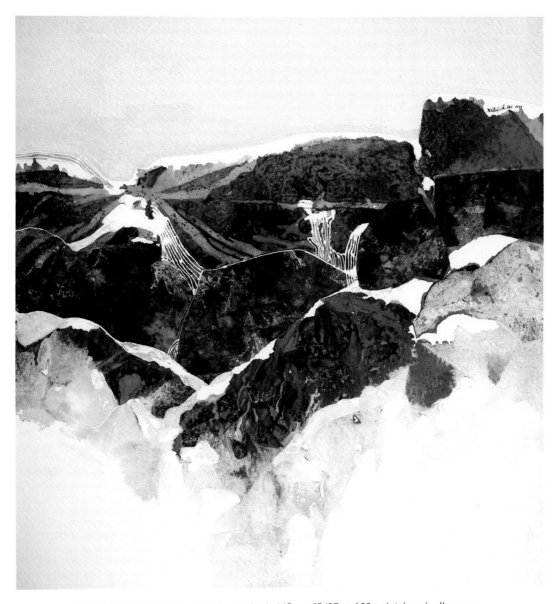

MAXINE MASTERFIELD, *MOUNTAIN SHADOWS*. 38" × 40" (97 × 102 cm), ink and collage on Morilla paper.
Collection of Mr. and Mrs. William C. Douglas.

This painting describes a last awe-filled look at the play of light and shadow on the rocks and water before leaving this vantage point. The rich Arizona landscapes of red and gold rocks were one of my strongest painting inspirations. For some time, I tried to capture their magic on paper, to contain the excitement of my discovery. This was one of my last devotions to this subject. It was time to move on.

Eventually my various techniques begin to mingle. Mountain Shadows began as an ink pouring. Then cut pieces soaked in ink were added and left on for an hour to dry. After lifting the pieces, I moved them slightly to the left or right and glued them down with acrylic gel medium. The shapes were given shadow edges, which had a softening effect. A white wash was added in the foreground. The sky wash and the white lines completed the effects. Some of the clean white paper shows through here and there, becoming one with the added white line. It still amazes me when I find color combinations I don't remember putting there. I kept discovering surprises like that in Arizona, too.

Achieving Mood and Contrast Through Collage

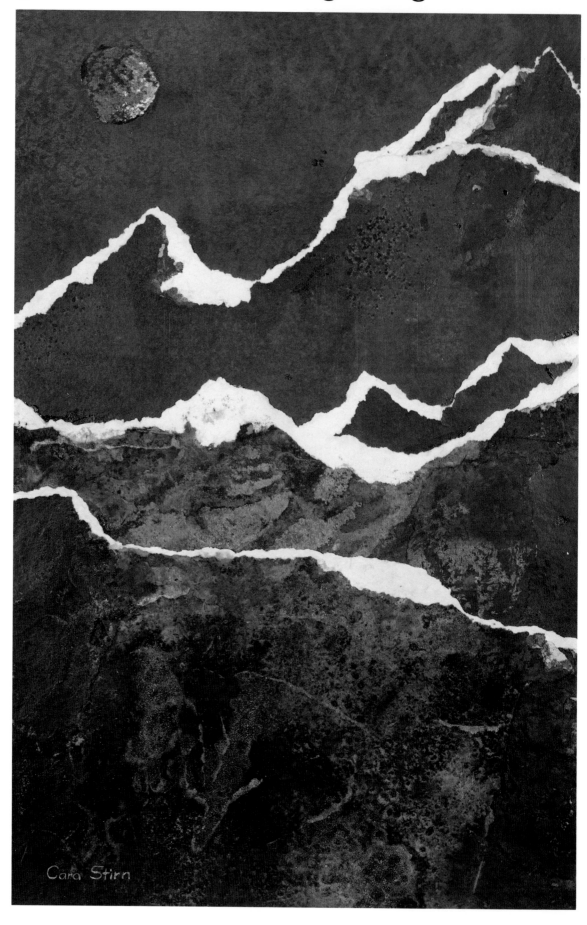

Cara Stirn

CARA STIRN, *BLACK MOON.* 21" × 14" (53 × 36 cm), collage on Morilla board. Collection of the artist.

The idea for Black Moon *came to Cara Stirn one summer evening. "I live on a ranch in Jackson Hole, Wyoming, during the summer months," she writes, "and the cool Western nights have a special beauty and mystery. The dark, mountainous terrain contrasts with the light moonbeams on the Teton mountains, and it is an awesome sight. One evening I decided to capture this feeling in a collage painting.*

"I wanted to show the power of the outlined Teton mountains against a dark sky with a magical moon. The moon is light in value, and I wanted to add interest and intrigue by using its opposite, black. For me, the title Black Moon *does not mean black as a color, but black as in 'black magic.' The moon has supernatural powers. One is spellbound by its secret illuminations on the mountaintops. There are also romantic overtones of the moon transcending your thoughts or feelings to loved ones far away. The powerful mountains and the distant moon are indestructible; they are symbols of permanence in an ever-changing world.*

"For the collage, I chose a partially completed painting that had been done on Morilla paper. A few days earlier, I had covered the paper with Pelikan ink colors of cobalt blue, orange, and yellow, poured on one at a time. After each application of color, I had thrown coarse salt onto the wet paint to induce the texture I wanted. Then, adding a small amount of water, I had tipped the board to mix the colors together. (This is my favorite method of painting. However, I am always experimenting, and some methods are continually changing.) When the painting dried, I ripped some of it into small pieces and pasted them on the painted surface. This was the unfinished painting that I chose to form the background of the collage.

"I began the collage by pouring black ink on top of this painting, using a brayer or hand roller to spread the ink over the painting. I sprayed water on some parts of the ink to thin it so that the colors below would be seen on the surface, then I let it dry. Now the painting was predominately a dark tone.

"Then I tore the paper into three major parts, ripping it so that the torn edges revealed the white paper. Then I pieced them back together to form a complete composition of line and form. (The collage was relatively small in size because the torn pieces of paper had to fit into a specific composition.) I sprayed the front and back of the paper with water and flattened them out on a foam core board. Then I pasted the sections onto the foam core with gel media and rolled them out flat with a brayer. While the paper was still damp, I scratched out the black ink with an Ex-Acto knife to show the white paper, forming the moon.

"The painting had great simplicity, yet it conveyed the mood I wanted to capture. The angular shapes portrayed the strength of the mountains. Contrasting with these strong linear shapes was the soft, round shape of the moon. I used texture in the moon and foreground to contrast with the smooth, flat, almost opaque black of the mountains and sky. The torn paper emphasized the uneven white lines and forms of the composition and made an exciting composition of contrasts. I was very satisfied with the collage. The picture told the story I wanted to convey, that when the dark of night blackens out all that is unimportant, one can see more clearly into the true meanings of life, its esthetic qualities and beyond.

Project

Try a collage with an opposite composition: a white moon and mountains with a black torn line for the composition. After tearing the paper, dip the torn edges into black ink to create an uneven line along its edges.

Getting Stained Glass Effects with Collage

MAXINE MASTERFIELD, ON POND'S EDGE. 36" × 40" (91 × 102 cm), ink on Morilla board. Collection of Mr. and Mrs. Steven Shore.

Like a Rousseau painting, each shape claims its separate identity and place in this synchronized tableau. The colors have the bright purity of stained glass, with the sun behind them. I envisioned the rain forests of South America, where all plants grow to giant-sized proportions. There the climate is perfect for nature's life forms. But there is much competition for space in such jungles, where the sun has to fight its way to the ground through the lush greenery. On the jungle floor, whenever a plant that ends its cycle of straining toward the penetrating sun falls, ten others quickly grow over it. Here at the pond's edge, there is also the never-depleted life source of water, and the fertile ground.

The leaf forms were made after a full range of colors was poured onto the prepared paper. To do this, wax paper was accordion-folded, cut into leaf shapes, and placed into the wet paint. The dark leaf shapes originally came from another painting. Their shapes were also cut out and glued onto the foreground to establish a third plane.

Achieving Unity Through Collage

ROBERT WALTER RAY, *ST. MARK'S, VENICE.* 22"
× 26" (56 × 66 cm), mixed media collage on
Morilla board.
Private collection.

ROBERT WALTER RAY, *VENETIAN TOWERS.* 24"
× 30" (61 × 76 cm), mixed media collage on
Strathmore board.
Private collection.

Robert Ray explains that "these paintings grew out of a trip to Venice. Many ideas came to mind as I surveyed the city from atop the campanile bell tower. From there, this city on water seemed timeless and I could see how objects of nature had been used to form buildings, bridges, and eventually cities. I made sketches on the spot, but these paintings actually developed as I worked.

"I use standard size watercolor paper, cutting it down if necessary. I begin with a point of interest, working from there, keeping the end result in mind. I experimented with getting good, strong color and achieving interesting effects. Composition, in particular, is an area that continually challenges me, and I chose an unusual perspective and point of view for these paintings. By using a limited palette, and keeping the colors down to, say, three, I can control the values and forces so the eye doesn't jump through the painting. I usually let nature define what color goes where, though the creative process produces some interesting results. In this case, I used various browns, reds, and earth tones, working mostly from light to dark. As the painting developed, I worked from memory and reference material, using brushes, sponges, and my hands to apply the pigment. I add linear touches where necessary. I created collaged effects with many different types of papers, various water-soluable inks, and gouache paints, though I have also used printed matter, teabags, glossy film, and acrylic paints. I glue collages onto paper with gel medium."

Project

Save all types of textured papers. Use aluminum foil trays and various colored inks, and soak these papers until the color has adhered. Then, on a large sheet of white paper, arrange these shapes until a composition begins to appear, then glue them down. You can strengthen the composition with line and more color, until you achieve the desired effect.

Collaging with Metallic and Tissue Papers

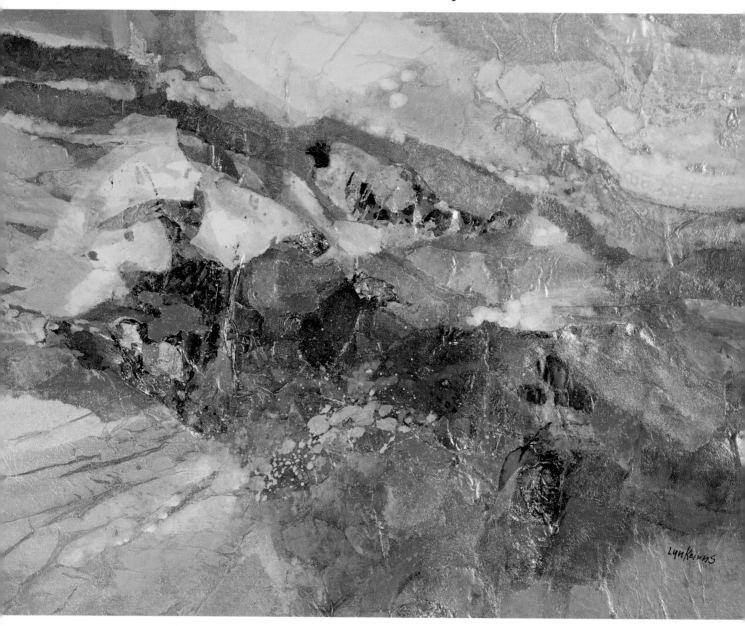

LYN KEIRNS, *ICE FIRE.* 17" × 13" (43 × 33 cm), mixed media on watercolor board.
Courtesy of Windon Gallery, Columbus, Ohio.

"I seldom have a preconceived idea in mind when I begin a painting," Lyn
Keirns tells us. *"However, I find that choosing a word with a sound or
rhythm that excites me provides a good starting point. Ice Fire was executed
in a manner I refer to as a 'painted college.' My goal was to stress the
opposing elements of ice and fire, and felt that a warm and cool color combi-
nation would best achieve this.*

*"I used collage materials of metallic and tissue papers, plus acrylics, on a
no. 114 cold-press watercolor board. I began by adhering the metallic papers
in a flowing formation; the gold, silver, and copper shapes representing the
glittering sun on frozen ice. After building a pattern of textures, I applied
tissue papers to soften the brilliance of the metallics. Throughout the paint-
ing I used alternate layers of papers, combined with acrylic washes and
opaque areas. This process was continued until I felt my goal was achieved."*

Collaging with Waxed Paper

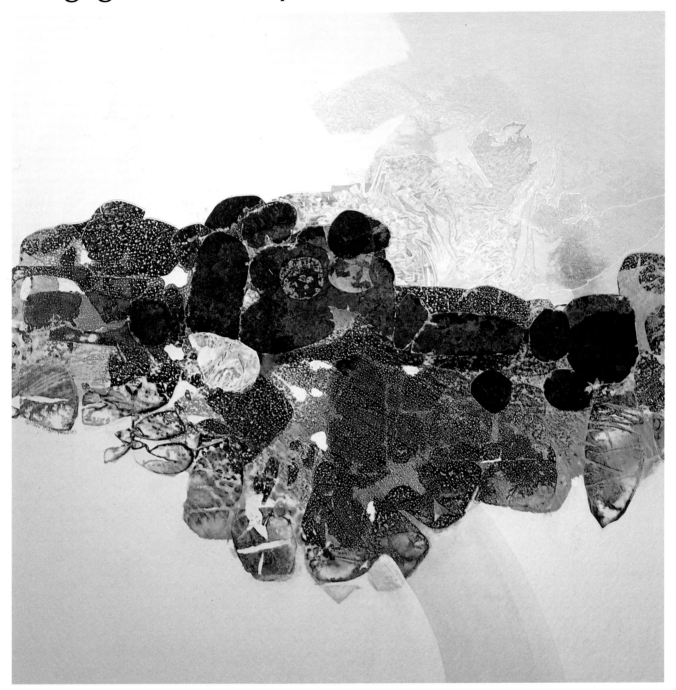

MAXINE MASTERFIELD, *BEYOND EARTH.* 40″ × 40″ (102 × 102 cm), ink and collage on Morilla board.
Courtesy of C. G. Rein Galleries.

I wanted to produce a density of color and a feeling of mass and weight. I used a full range of colors and shapes, from the lightest and brightest to the heaviest, darkest, unfathomable void. As an avid rock collector, I own beautiful agates from all over the world. The dendritic agate has been one of my favorites. Beyond Earth comes closest to the effect of the agate, looking much like an entire hillside covered with these stones.

I began by cutting round shapes from waxed paper. Then I placed them on the wet ink and pressed them onto the paper in a buildup of shapes and left them to dry. Usually, in the waxed paper method, the paper is peeled off and tossed aside. But here the ink had permeated the waxed paper and was too beautiful to waste. So I collaged them, and built up a richness and density I wanted, and suggested veins of the agate.

MOSS AGATE, photographed by William Horschke.

123

Finding New Directions

MAXINE MASTERFIELD, *WATERY WORLD.* 40" × 40" (102 × 102 cm), ink on Morilla paper.
Courtesy of the C. G. Rein Galleries.

Most areas of study set guideposts to aid the student in finding the right direction. No textbook is complete without revealing the best way to do whatever it is that you are learning to do. Yet even when you're shown several ways to get the answer, the problem is that it is only *one* answer that you're shown. There is something wrong with that, particularly in a creative field like art. When people are creative, they not only find new ways to discover the answers, but they often find new answers—and new questions!

Art has a unique role in society. It is a mirror of our culture, it communicates the changes our society is experiencing. No historian would research any era or society without studying its art because art reveals not only the intellectual progress of a nation, but also its emotional state. In the United States, the bastions of watercolor painting have considered what is "acceptable" relatively unchanged for some time. While the rest of the art world has gone through phases like dada, surrealism, and op art, watercolor societies have maintained their ties with the past. But now the age of enlightenment is dawning and, despite the lack of encouragement from conservative fronts, watercolorists and their public are finding new directions.

I feel that watercolor is the most spontaneous and sensuous, as well as the most versatile, of all the art mediums. And even though my particular procedure must allow time for many of its steps, I am basically a "this-instant" person. I stop to look and examine, no matter what the time or place, and when I feel inspired to paint, I work immediately and passionately until I am played out. My only limits are inspiration and endurance, with inspiration being the stronger.

I have long recognized the limitations of conventional, tradition, and safe acceptability as impediments to creativity and progress. I've also learned that fighting them is a waste of precious artistic energy. And so I have chosen to sidestep them and explore watercolor on my own. My rewards come from my own discoveries in experiments. I am free from the anxiety of trying to reach goals set by someone else, free of trying to fit their own prescribed molds of excellence. I set my own goals now.

Our tradition, the art we study and learn from, was never meant to be relived or duplicated. Its purpose is to teach us how we got this far, and what came before us. Its value is to arm us with the knowledge and tools to go on from here without repeating mistakes. Our responsibility is to contribute to the future, and this requires that we add something new during our time, not just preserve what we started out with. I feel that my enthusiasm, curiosity, and love of art are the basics I have to work with. They are also what makes my work a labor of love. The impressions of experiences shared, and any techniques blundered into or sought out, are the artist's legacy.

New trends from artistic milestones in creativity are called "movements" because that's what they do. They move. Man's transit from cave drawings, through the Renaissance, to the present, was possible because of creative energy. Time only moves forward, and those who cannot bear to abandon a present perfection are left behind. Although I love many of my paintings, the best of all will be the *next* one—or maybe the one *after* that!

The paintings in this chapter suggest utterly new directions being taken by the individual artists, or very different directions from traditional and standard watercolor painting. Most importantly, they comply with the free spirit doctrine of not being hampered by the dictates of tradition or limited by any rules that stifle experimentation or individual expression.

In the banquet of life, who but a fool would gorge himself only on pate when there are many other delectable dishes to be sampled and enjoyed. For those who are exposed to hundreds of art styles and schools of expression, there ought to be more than *one* for every taste. I sometimes even find one for every mood too confining! The beauty in nature is never restricted to only trees (or rocks or sunsets). And each person has his or her own idea of what is beautiful. I hope that you will find something to please and inspire you in each of the directions explored and presented in this book.

I wanted to express my curiosity about what happens when two reflected colors meet and merge on a pond's surface. I wanted this extreme closeup view of mingling reflections to convey not just the duel of colors, but also the sparkle of the water and the image-distorting ripples. To communicate these sensations, I minimized the area of concentration and directions of focus. This is a simple statement in two colors, with the shapes of the lettering occasionally breaking the simplicity of line and form. The forms were created by laying sheets of film across a painted surface, which also caused a high gloss and dull surface contrast in texture.

Experimenting with New Materials

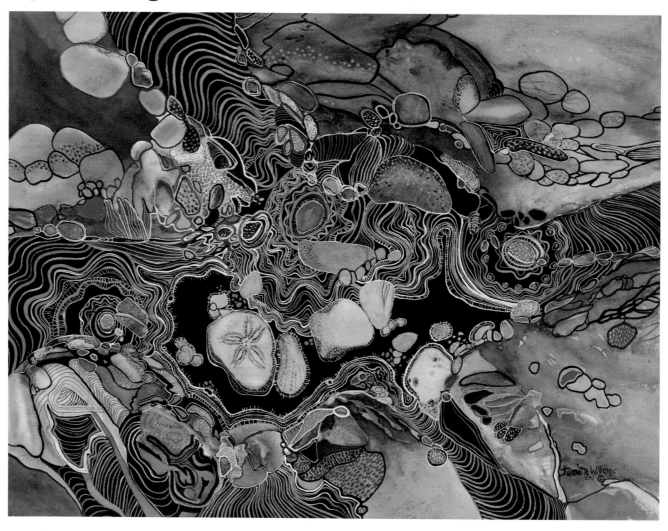

JUANITA WILLIAMS, *TIDEPOOL TREASURES.* 20½″ × 29″ (52 × 74 cm), Arches 300-lb cold-pressed paper.
Collection of the artist.

"Tidepool Treasures," *Juanita Williams explains,* "describes my excitement upon seeing my first tidepool—that is, really looking into it. The shapes and textures of the shells and rocks, as well as the movement of the water, fascinated me.

"I attempted to paint the subject in a fairly representational way, through shapes and texture applied later. The lines depict the constant movement, not only of the water, but of the shells and rocks as well. The colors I chose are ones you generally see at the beach. The blue lines are reflections from the sky. I used washes in the beginning and a layering process after that. The composition depicts a tidepool with its many entrances and exits, and showed that it's not always a hole in the sand and rocks. The dots create the illusion of texture. The design on the sand dollar shell adds a touch of reality.

"Occasionally I plan a composition, but I didn't plan this one. After trying various sizes and types of paper and watercolor board, I settled on a full sheet.

"In the beginning I used muted colors in relation to the beach area, working with an overall wash of browns and grays. At this time I was trying out gouache paint and using metallic inks along with the transparent watercolor paint, plus Luma white. Then I switched to dark opaque paint and painted negative shapes into the damp wash, leaving some areas transparent. The opaque light colors of lines were then painted over the dark areas. I retained control over the painting by working with opaque paint and painting in layers. But I also experimented. That's where the knowledge and bravery of the creative artist takes over. You can't create without taking chances.

"I was going through a transitional period of being a purist watercolor painter at the time. I finally came to the conclusion that the results of a painting justify any materials I might choose to obtain that means. My materials here were Winsor & Newton watercolor paint, gouache paint, metallic ink, and Luma white paint, applied with brushes. And I learned that you can create the illusion of transparency by using opaque paint. After adding a few more decorative touches with dots and lines, the painting was finished when I could not think of another mark that would improve it.

"This particular painting satisfied my need of expressing nature with all its mysteries, but I could use it as a starting point for another tidepool painting and end up with something totally different. That's what creating is all about."

Painting Fantastic Worlds

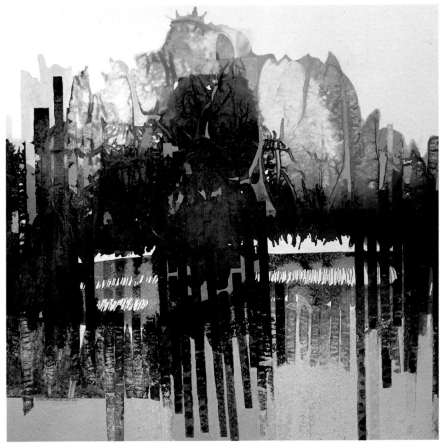

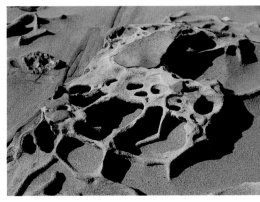

ERODED ROCK NO. 3, Photographed by Howard Stirn.

This photograph of "real" eroded rock gives us the surrealist feeling that, like Tidepool Treasures *on the opposite page, it is imaginary. Its textures appear as dots; the contrasty shapes and surprising colors seem painted onto the dense shadows. Perhaps truth is stranger than depiction.*

MAXINE MASTERFIELD, SEASONS IN SPACE. 40″ × 40″ (102 × 102 cm), ink on Morilla paper.
Courtesy of C. G. Rein Galleries.

MAXINE MASTERFIELD, RETURNING IMAGES. 42″ × 42″ (107 × 107 cm), ink on Morilla paper.
Collection of the artist.

I've always enjoyed reading science articles. These two paintings were created after reading about future plans to grow plants in space. I read that seeds would be planted in gravity-free environments, and would grow many times larger than on Earth. I envisioned flowers with roots and leaves extended in all directions, floating past meteors, moons, and other planets, encased in their impervious greenhouse shells. In that new environment, the seasons would depend on their position to the nearest sun.

The subjects of Returning Images *are the floral and leaf shapes floating above a landscape.* Seasons in Space *is a more structured version of the greenhouse, with the feeling of a capsule as a functional, well-planned unit.*

Both paintings required a combination of the waxed paper method and cellophane strips. After the inks dried, the painting-out method was used on Seasons in Space.

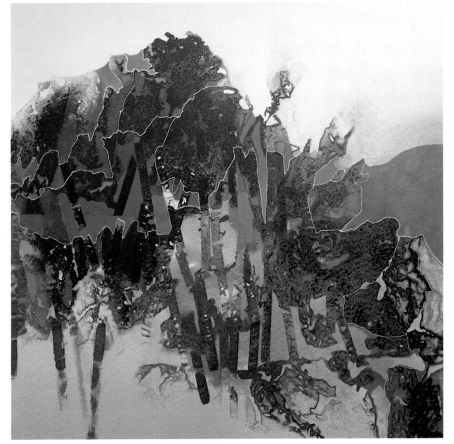

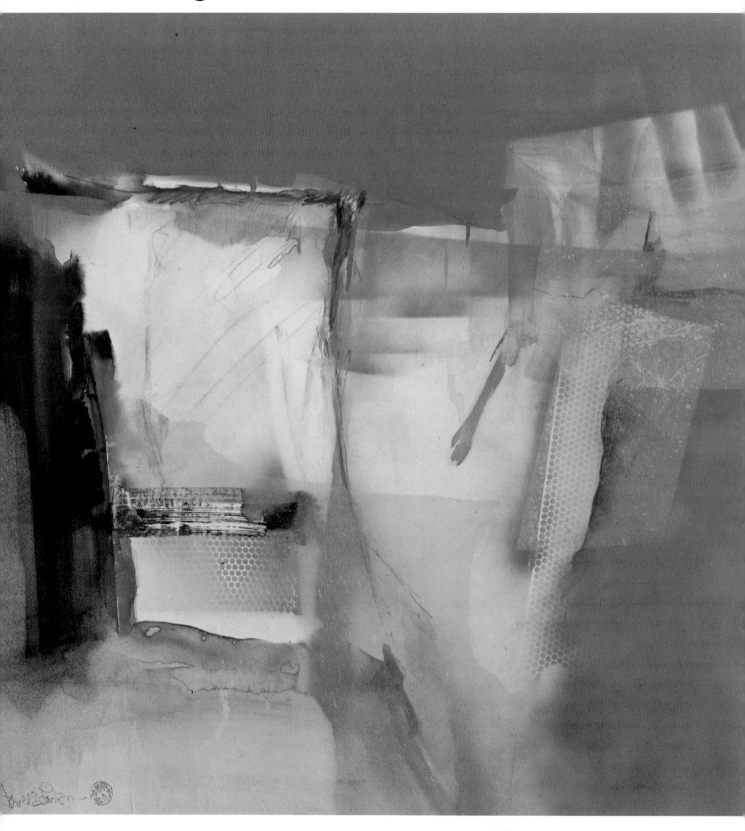

HAROLD E. LARSEN, *ROCKSPACE*. 30" × 40" (76 × 102 cm), mixed media on no. 181 Bainbridge board.
Collection of the artist.

Harold Larsen writes: "Watercolor lends itself to many explosive and inventive applications because it allows the images to flow more freely than other media. This is one of a series of rock and mesa formations done without direct reference to local color, based on that free flow of the medium. Although it was inspired by land forms and shadows, I wanted to evoke a mood rather than paint something specific.

"I began the painting with a series of drawings in watercolor pencil and crayon, both of which were completely water soluable in the succeeding overwashes. I worked over the entire painting at the same time, moving from place to place to balance the composition. Colored watercolor crayons were drawn over and scribbled on the dry surface, then water was brushed on to dissolve them. The blue and red pigment was painted on, blended with crayons, then lifted off, airbrushed, and collaged. I controlled the values by adding and subtracting color and by juxtaposing related colors. By going from light to dark, I was able to define form and light dancing across surfaces.

"The painting started out differently and evolved to its present form. Experimentation is involved in all my work, but because I work consistently in the watercolor medium, I have full control over the results. As forms began to appear, I lifted off color by scumbling and wiping the surface with a clean brush. Final layers of pigment were added with an airbrush to create soft and hard-edged grounds that floated over and around the rock forms. I also added small textural details to play against the broad masses. Then I laid transparent, hand-colored papers over the painting as collaged floating veils of color. By reducing colors and textures to their simplest forms, I hoped to convey the essence of my visual experience. I knew I was done when there came a time that anything else added to the surface would overburden it."

Project

Put three related colors on a full sheet of watercolor paper, with no preconceived ideas of subject matter or direction. Put on one color wet-in-wet, one semi-dry, and one on dry paper, and intersect two of these colors. Then turn the page around and see what they suggest. Pick one of those directions and finish the painting in the mood of the subject suggested by the initial painting.

Combining Dyes with Acrylics

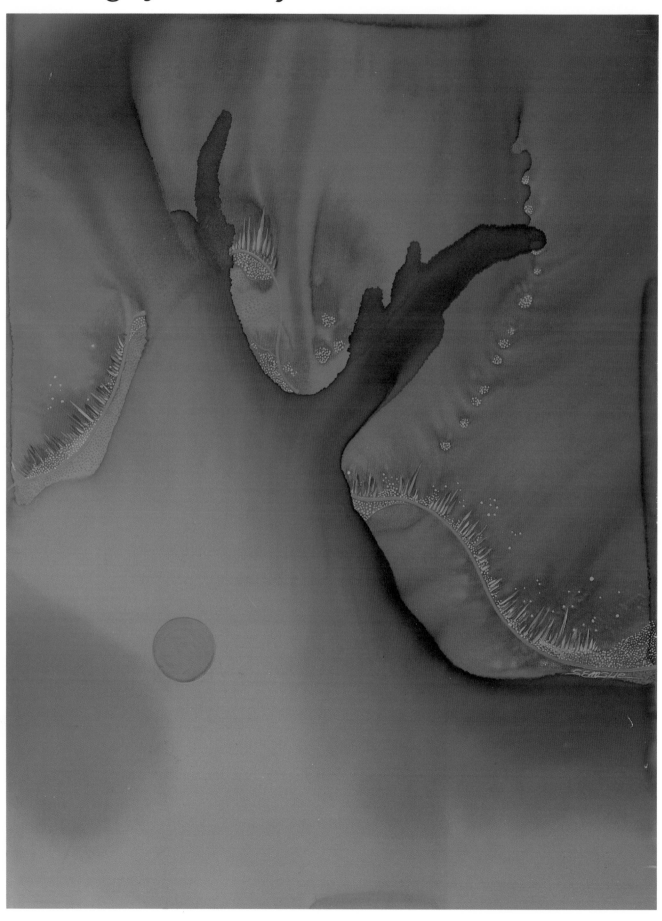

SALLY EMSLIE, *RISING MOON.* 30" × 40" (76 × 102 cm), mixed media on no. 110 Crescent illustration board.
Collection of the artist.

"This painting," Sally Emslie says, "grew out of a need for an intense visual experience, and it was created with the quickest of strokes and a limited palette. I aimed for simplicity, but not at the expense of a great visual experience.

"This composition was not preconceived. With the mood foremost in my mind, I chose the colors for their symbolic reputations for sensuality. I mixed burgundy dye and vermilion acrylic with water into a transparent solution that I could pour over the watercolor board. Working from light to dark, I mixed the dyes and acrylics together in a very fluid manner—using very hot water with them, as an experiment. The colors appeared to become more vivid when they dried. It took me weeks to get the blue circle and line to look right, though the red moved exactly as I wanted it, except for a dimensional quality that I like. I feel that the circle and line now give it these qualities, and the painting has the bit of blue I like to put in everything I do.

"I stopped work out of fear that if I did any more to it, I would lose my original concept of the quick stroke and limited palette. The painting might also lose its intense visual impact.

DETAIL OF A BRAZILIAN AGATE, photographed by William Horschke.

This section of the agate presents an eerie netherworld scene one could imagine to be a moon, surrounded by netlike black clouds, lighting misty scarlet mountains. The overall effect here is less dramatic than the painting, but the mood is still one of fantasy.

Giving Form to an Idea

"Each time I look at blank paper," Marvin Smith explains, "the experience is different. This time, the texture of the paper glowed silvery yellow in the directional light, casting purple shadows like ripples of beach sand in the sun. I concentrated on the glowing center, almost spotlighted, luminescing, throwing the edges into a dark haze. Seen out of focus, the edges repeated and echoed themselves, shifting like hypnotic fantasies, golds and yellows on a blue field, a living medium of floating planes. Only after the fact did I realize that the frame I 'saw' in the blank paper was a theme I've explored before: subjective and internal enclosures, from physical force to money, sex, fear, and madness, protecting, imprisoning, and defining.

"I quickly drew brushlines and laid washes, and used tape resists to enrich and give the 'light crystal' quality to the frame, working a wet wash of pale Prussian blue, then bleeding organic, rich, and dark paramecium-like marks into the damp blue base. I further defined the space with hard-edged strokes of ultramarine blue. I felt many sensations: organic space, a bit chaotic; mechanical planes, angular forms, lapping and receding; planes refracting and moving into the depth of violet space, layered and ambiguous; erruptive yellow, toothed and edged, punctuating red and amber biological forms emerging from the hard blue, breaking the weak side of the pentaform frame, penetrating a world with flattened dimensions . . . and decorated two-dimensional planes falling into deep space, pulled back into the picture plane. Since I proceeded with no preconception of how the finished work would look, the composition remained a series of constantly changing contingencies, tracks of processes. I controlled the values by the amount of water I used and by washing, erasing, scraping, sanding and other techniques.

"The progress of the painting was exciting. Each step opened and closed doors, presented options, suggested visions I could not have dreamed or imagined. Some parts flowed without effort, while others were extremely difficult and resistant, like climbing rough, unknown terrain. Although I had no specific plan, I never lost sight of my direction. In the end I became objective: clarifying and defining aspects of the painting to reveal it as an entity. I added dark accents, hardened or softened some edges, pushed in or pulled out colors. The painting was finished when the image became coherent, when the interrelating events became a whole 'story,' with all the pieces set into relationships, and when further changes became arbitrary."

MARVIN SMITH, *ENCLOSURES*. 29" × 35" (74 × 89 cm), 300-lb Arches paper. Collection of the artist.

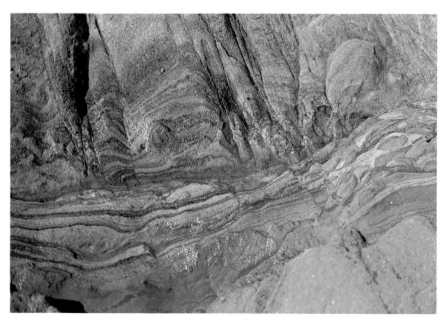

GRANITE COMPOSITION, photographed by Howard Stirn.

Like art, nature has a variety of lines, directions, and layers; these rocks have texture, color, and movement. As you can see in this photograph, nature has its own way of expressing boundaries and enclosures.

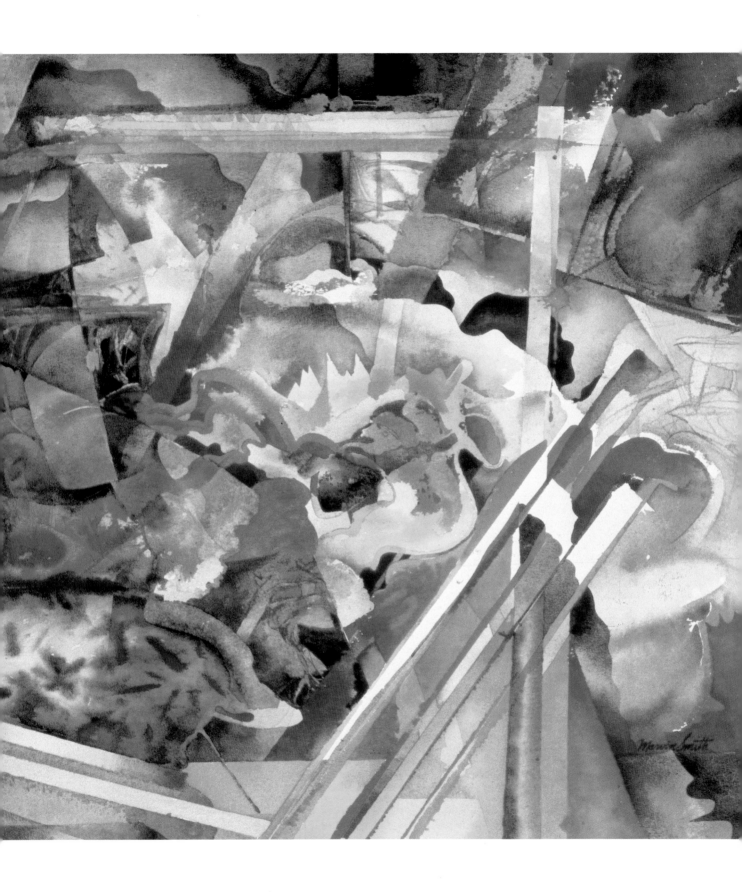

Letting a Painting Create Itself

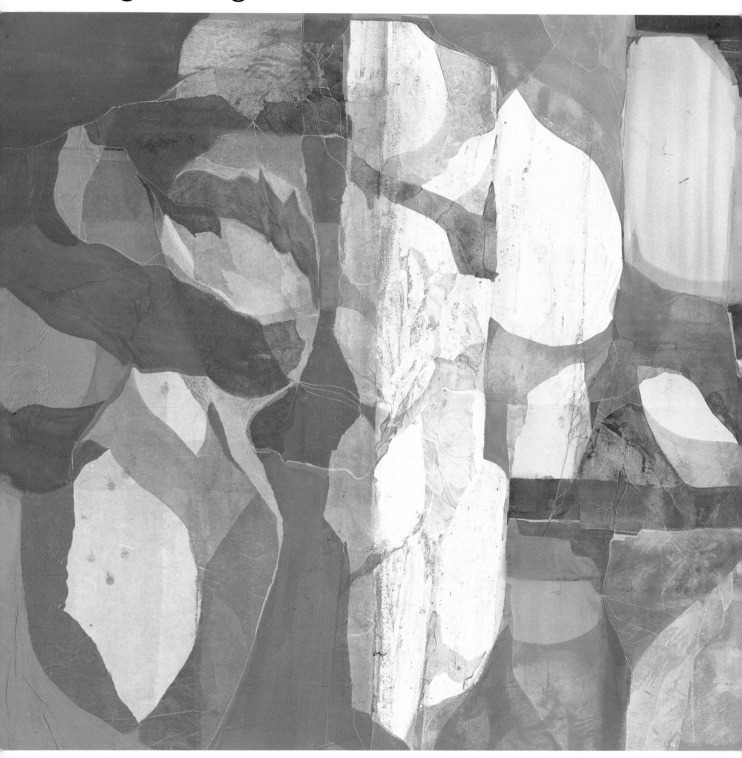

VIRGINIA COBB, *LIFE CYCLES NO. 12.* 32″ × 40″ (81 × 102 cm), watermedia on 4-ply rag board.
Courtesy Jack Meier Gallery.

Virginia Cobb describes her painting process as follows: "I like working in a series because no one painting is the 'all-important statement'; each painting is a part of the whole and complete in its own way at that stage of my development. This painting is one of a series based on the cycles of nature, on the idea that each living form originates from a source and returns to that source as part of the natural process, a continuum. The source for this painting was a dying blossom from a Japanese magnolia tree. The drying flower itself suggested the initial forms and colors, and from there the painting, like the blossom itself, evolved in the process of its own development. Each new element that was added—color, line, texture, and so forth— determined what followed. No part of the overall effect was preconceived.

"Painting, for me, is like putting the pieces of a puzzle together. It is also like a juggling act. I am constantly moving the colors, revising, lightening, or darkening them, until the balance of the painting feels right. The first decision I make is selecting a paper (its size, shape, and surface), and from then on the composition changes many times as the painting evolves. When a painting loses its direction, as it so often happens, I set it aside for a later, more objective viewing. When I think a painting is finished, I put it on an easel in the studio for several days of editing. Each time I walk past it I see an area that can stand to be refined. When I no longer find flaws, or they become so small that they're insignificant, I asume it is time to part with the painting."

Project

Paint three different versions of a natural form like a leaf, shell, stone, or flower, viewing it from a different vantage point each time. First paint the form as a shape—contained well within the page—in a created environment. For example, if you choose a dried weed pod, you can paint it standing upright in a snow bank, fixed there as a remnant of summer—or you can paint it fallen on the ground among dried leaves and stones. You can put it in a jar of dried weeds, surrounded by other collectibles—or alone on a shiny surface with nothing else but the reflections and shadows it has created for itself. The possibilities for relationships of color, texture, pattern, etc., would change with each interpretation. The choice, of course, is yours to make.

For the second painting, you will enlarge the weed pod (or other object) so that it fills the entire page, touching the edges of the paper at several points. The shape of the object itself will now break the page into shapes, too—negative shapes. You must now decide how to best use these negative spaces. Do you want to relate them to the subject—or contrast them against it? Will these shapes allow movement into and out of the central form—or will they isolate the subject from its surroundings? The questions you ask yourself, and your answers, will make your painting individual. It is important to learn to ask yourself these questions.

In the third painting, you will again enlarge the form, this time allowing it to overflow the page at all sides—like a camera's eye viewing the subject through a closeup lens. This time the design of your painting will come entirely from the colors, textures, lines, and shapes found within the form itself. This is a good way to teach your eye to see subtle relationships within small areas in order to better understand the designs in nature.

135

Painting Qualities Instead of Things

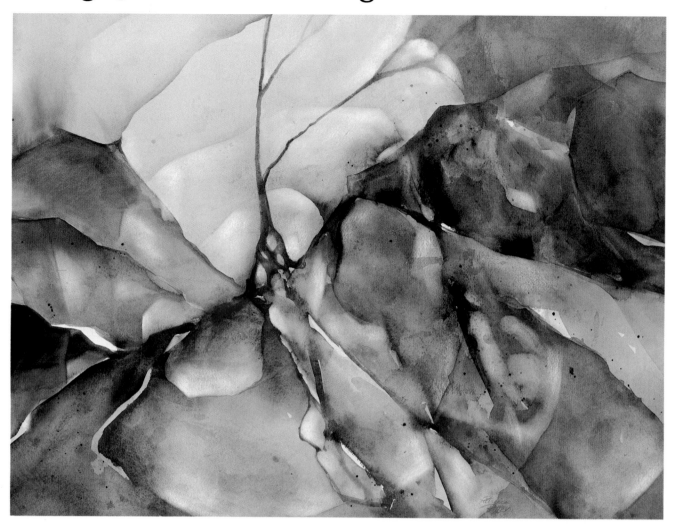

PATRICIA F. RITTER, *FAR ON THE BLUE.* 18″ × 24″ (46 × 61 cm), 140-lb Arches paper.
Collection of the artist.

Patricia Ritter writes: "In Far on the Blue, *I wanted to "find" a mysterious, dreamlike rocky landscape—trees, rocks, and clouds—by letting the subject itself emerge from the paint in almost a psychic experience. Although I didn't have a specific rock in mind, in order to suggest 'rock' I thought of its characteristics: hard edges, texture, and coldness.*

"I began by wetting the lower part of the paper diagonally, below an imaginary horizontal line. At first I applied the pigment loosely and freely on the wet surface, but as the subject emerged, I began to clarify it. I used Winsor & Newton watercolors: indigo, turquoise, Hooker's green, burnt sienna, alizarin crimson, and mauve. In general, I mix my colors on the palette, and combine complements to get grays. I also mix color by glazing. When I want to cover the entire painting, I wet the paper under the faucet first and glaze yellow ochre or burnt sienna over it to warm a painting that's too cool; or brush alizarin or mauve to cool a too-warm painting. I may even wash off the color of the entire painting; it leaves a patina of color to paint over and gives great depth to the finished color.

"While I try to save white areas, I'm not afraid to lose them either. I know I can always scrub out 'lights' with a toothbrush or bristle brush (sometimes I cut a stencil from a 0.003 mm acetate with an Ex-Acto knife first). I find these 'found' whites softer, warmer, and more pleasing than the pristine white of the paper. To get rid of large areas of white and tone down the blue-white of the paper, I float a pale wash over the surface.

"Improvisational painting is exciting, but it requires fast decisions to bring order to the work. For example, in one area in Far on the Blue, *an extension of the cloud formation forms a shape of its own. I brought it out by washing out some areas and glazing around others. I also worked on the tree shape, mainly in the root area, and washed out more lights in the rocks to balance the cloud formation. I used grayed colors to create a sense of mystery and loneliness.*

"Aside from my fascination with the fluidity of water and paint, I feel that my paintings are investigations of the organic world and express my visions of secret landscapes, hidden flower gardens, and fragments of time.

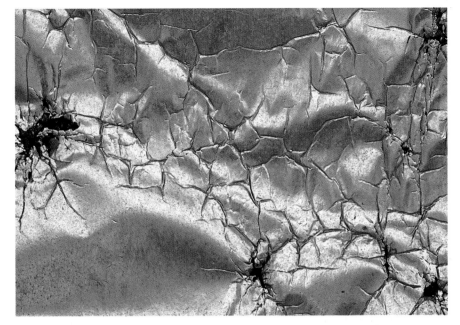

CRIMPED METAL, photographed by Howard Stirn.

This metal is cool and reflective, yet there is a feeling of softness in its raised ripples and arching crimps. The crevasses form textures and shapes, the punctures and cracks give it depth, and its pattern of lines echoes the same movements and sensations—from delicate to impervious—as the painting.

Project

Choose a subject, but instead of a specific image, think of its qualities: rock-hard or flower-soft edges and textures, grayed or clear colors, rounded or irregular shapes. Prepare your paper by wetting it with water and a brush or sponge. Work comfortably, allowing plenty of room for hand and arm movement. Begin by applying the lightest and brightest colors and look for textures resembling that of natural objects. When you begin to see images in the paint, perhaps after you've placed a bright shape in the midst of other colors, you can start capitalizing on these unexpected effects. For example, you can paint out unwanted passages with a darker color and, as the paper dries, you can begin rendering finer details. As you respond to what is happening on the surface, you can return to your original subject and let the memory of its general appearance help you to shape images on the paper. A dark wash placed behind an image will strengthen it. Paint that is too dark can be washed out with a bristle brush or a toothbrush. You can highlight an area with a color—you don't have to go all the way to white, a light color will do the trick. Glazes can give you hard edges, and if your painting is too cool, you can warm it up by rewetting the whole paper and glazing it with thin, transparent pigment—a yellow ochre or burnt sienna, for instance. If your painting is too warm, glaze it with alizarin crimson or mauve. If your lights seem to disappear, you can remove paint with a bristle brush and water.

At this point you can decide how far you wish to carry the painting. Do you want to leave it abstracted? Or bring it to a recognizable state, a semi-abstraction? Or make it realistic? The main idea is to let your subject emerge from the pigment and, by manipulation and embellishment, bring order to chaos.

Experimenting with Color

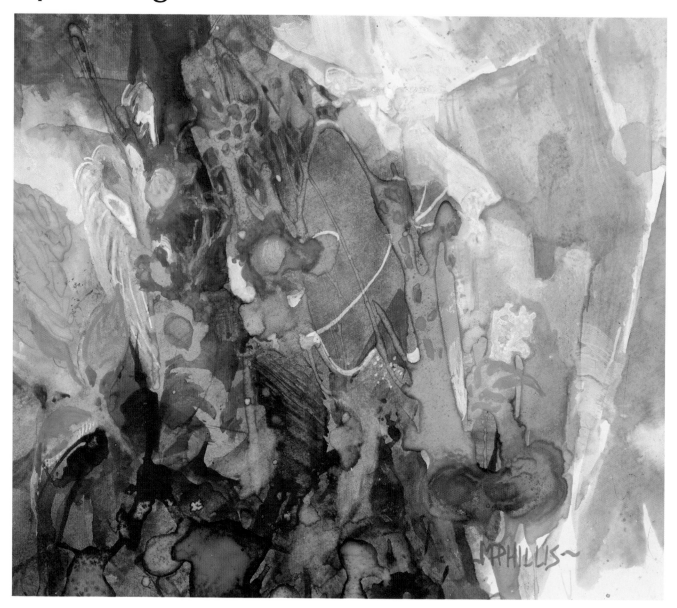

MARILYN HUGHEY PHILLIS, AUTUMN FORMS. 6" × 7" (15 × 18 cm), mixed media on 3-ply Strathmore 400 Bristol vellum.
Collection of Maxine Masterfield.

"The immediate idea for Autumn Forms came from working with spontaneous shapes of color on paper, letting them suggest the painting's development," says Marilyn Phillis. "But the deeper concept for the painting came after years of observing natural forms in a woodland environment, and from doing sketches and studies of designs. I wanted the painting to have an abstract quality, which would give it more universal meaning than a strictly botanical presentation. Recording visual facts only tells a partial story; I prefer to show more of the inner eye of the spirit in response to the environment.

"The painting began as an experiment. I had wanted to try some shape effects on smooth paper and since I often work small when I'm trying something a bit different, I picked up this small sheet of paper to practice on. I deliberately left a margin of about 1¹/₂" (38 mm) to allow some leeway in designing the composi-

tion. (I also try to leave a fair amount of white paper for as long as possible.) I start my compositions on the right side (since I'm left-handed) and work to the left.

"Although I usually work wet-in-wet, this painting was started on dry paper to get maximum color and accidental shapes. I began with no specific subject in mind; I just wanted to experiment with the glowing effects of the yellows. I dropped aureolin yellow on, literally squeezing it in blobs from my brush, then floated in yellow and raw sienna inks, letting them spread and run, and tilting the board to which the paper was taped to direct the flow. When the desired effect was achieved, I quickly dried the paper with a hairdryer. Then I rewet some areas and added sepia ink. Brushwork was kept to a minimum at this stage.

"I try to keep my mind as free from preconceived ideas as possible in these early stages, while designing, organizing, and placing the shapes. Yet after a painting

starts, I almost always get a twinge of panic. In this one, I had to find a way to use the variety of happenings in the initial yellow and raw siennas. I also had to find a way to simplify the structure so that the painting took on some feeling of mass areas and proper breakup of space. As the lighter darks were added, they began to unify the design, and from then on, future additions were subject to the overall thrust of this major dark shape. I worked from light to dark, modifying colors and values with glazes, and emphasizing specific areas with bright, surprise touches of greens and reds. I also muted some of the brilliant yellows to emphasize the earthy quality of the palette. My darks were raw sienna; a mixture of viridian, light red and raw sienna; and some sepia, and I made a brown from Winsor green, raw sienna, and light red. I used Winsor & Newton watercolors, Pelikan and Luma inks, and Luma white gouache, and applied color with a brush, by pouring and tilting the board, and even with an eyedropper.

"In my paintings I try to emphasize mass shapes and a diagonal direction—to create a feeling of movement and drama. To that end, I particularly enjoy combining watercolors with inks, seeing how they can enhance or modify each other. Ink is permanent once on paper, while watercolor leaves more freedom for adjustments. Inks are also more intense and shine through the paper with a luminous quality you can't get with watercolors alone. But since some inks aren't permanent, I always test my inks for lightfastness when I buy a new color, and spray the finished paintings with an ultraviolet light screening agent.

"I textured the paint with pieces of plastic wrap (on the middle and upper left), leaving them on the damp paint until it was dry. I also painted negative shapes into dark areas, to create subtle variations in shape and texture. The paint in the lower left was spattered on and lines were added with opaque white. The opaque paint also added intensity, lightness, and body to the painting. The lower areas were textured by puddling the colors and by the various drying stages. In the end, I added linear touches and fine brushwork. I also put small touches of red in areas that had been open shapes for a dash of brilliant color and the suggestion of flower forms. I finished the painting with a few darks and some touches of opaque white. I stopped when I sensed a balance but still had enough conflict in design and color to establish the mood I wanted. In retrospect, I would have liked to improve the white line in the middle of the painting—it's three-pronged end should have been more graceful and the spatial divisions should have been done differently. Yet, apart from such minor things, I am pleased with the final result.

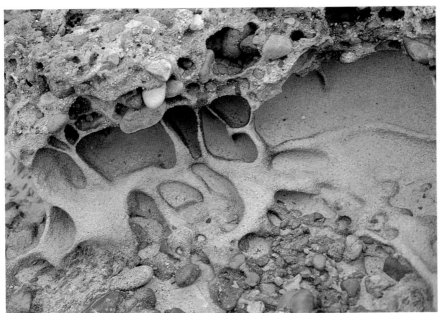

SANDSTONES WITH PEBBLES, photographed by Howard Stirn.

As in the painting Autumn Forms, *this photograph also contains a variety of shapes, surfaces, and textures. These stones have been worn smooth by the action of other stones, the flowing water, and the passage of time. Between their smooth, rounded surfaces and jagged, grainy ones, the play of light and shadow adds dimensionality and reality to the forms. Nature and art connect once again.*

Project

Working with a limited palette if you're a beginner, or with more diversified hues if you're experienced, load a 2″ (51 mm) brush with pigment and squeeze splashes of paint onto the paper. Try to vary some of the blobs, and tip the paper so the runs form linear patches. Begin to develop a rhythm and movement by tying areas together. Try several such compositions. One of them may begin to suggest a theme for further development.

Cutting Up a Painting to Convey Depth

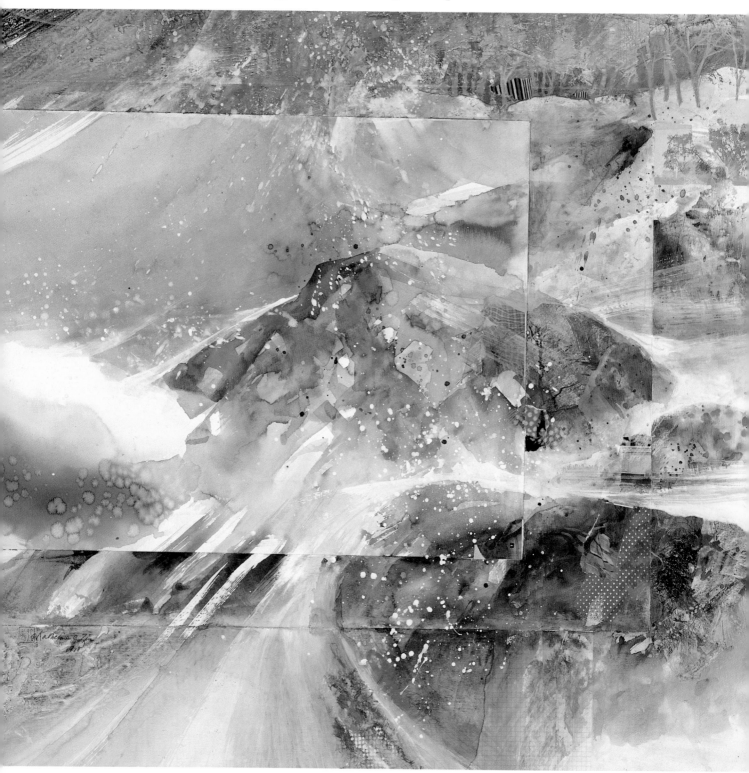

KATHERINE CHANG LIU, *REVERBERATION*. 32″ × 34″ (81 × 86 cm), mixed media on Arches
140-lb paper.
Courtesy of Louis Newman Gallery, Los Angeles.

"Reverberations" writes Katherine Chang Liu, "was inspired by the Blue Ridge region of Virginia, where the air is pure and smells like cool grays and greens in early spring, and warm umbers, oranges, and purples in autumn. I wanted to play the visual game of having a single image shattered then combined; I also wanted to convey the feeling of water splashing down from mountain paths onto my face. Since I didn't want to do a straight painting of mountains or one with water-runs, I decided to cut up the painting surface and use those dividing lines as a device to convey depth. I did a small sketch to decide the shapes and values in this painting, though the colors and textures evolved later.

"My working method is half-planned and half-spontaneous. I prefer to have a good idea of the composition and values, but paint splashily and quickly. I enjoy the freedom of combining any media with watercolor—I'm not a purist. I love to draw with a pastel pencil, or to airbrush areas, or collage small pieces of paper onto the painting as I work. My small treasures of little branches, rocks, pebbles, tree barks, and shells help provide inspiration for paintings.

"In my work, I look for a balance of contrasts. I like to intermix large, quiet spaces with small, textured shapes. I try to sometimes suggest more than one level of seeing in a painting so I can play with different planes and depths. The success of a painting, however, has little to do with the amount of time I spend on it. Sometimes the better ones are effortless and fun to make; sometimes a painting that goes through many days of labor and pain ends up shredded, to be recycled back into hand-made paper.

"Reverberation was planned to have three different planes suggesting three levels of depth and more than one level of seeing. I drew the rectangular shapes on the paper first and coated the whole area with gesso except for the small inside rectangle. This allowed me to have different textural changes from one plane to the next. The painting was then freely painted with watercolors (ultramarine blue, cerulean blue, burnt sienna, ochre, gamboge, mauve, and olive green). Bits of collaged paper were added to reinforce the texture, and pastel pencil lines were added to give more definition to an area or sometimes just to change shapes into lines for variety. Working from light to dark, I built up the painting with big, bold washes using large brushes, looking at it now and then from a distance to judge the general effect. Halfway through, I thought the painting seemed too busy, so I washed out a large area in the lower right corner with mixtures of burnt sienna and ultramarine blue to take out some bits of white and make that area less textured. I built up the painting with bold, big washes using large brushes and added finishing touches at the end with a smaller (no. 6) round brush. I like to paint freely while still keeping a certain amount of control by planning where the important shapes should be. At the end, I added some lines and textures with pastels and collaged on some paper to enhance the texture or bring a certain color into an area. I knew I was done when, after a lengthy break, I returned to the painting and saw that adding any more would have been too much and would have made the painting too tight. Looking at it now, I think it could have been bolder, but I'm satisfied with the balance of color and texture."

SHALE POCKET, photographed by Howard Stirn.

Nature has created a similar surface to Liu's painted one, as this photograph shows. Each section holds its own, yet is still part of the composition as a whole. The textures and colors of the shale are rich.

Project

Gesso a portion of the paper ground and work with the textural change built right into the paper, building in design elements to fit this textural difference.

141

Selecting an Unusual Format

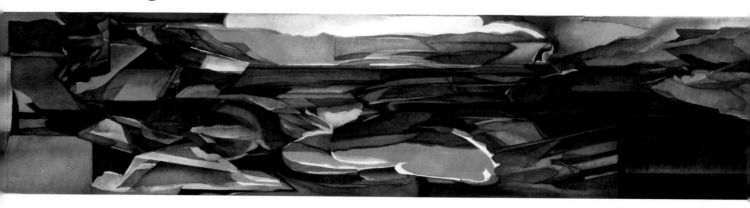

MARK KRIEGER, *INDIAN RIVERS*. 8" × 38" (20 × 96 cm), watercolor on Italia paper.
Collection of BancOhio, Cleveland.

Mark Krieger explains that "this is one of many paintings where a long horizontal format has evolved from my interest in musical structure and Oriental landscape. The painting took a long time to finish—over two years. Other paintings came and went while it remained in the studio, stretched on its board. Work on it was sometimes done on impulse, and sometimes after much consideration. The final image is very close to the original idea.

"Although my images are based on the landscape, they are also influenced by the nature of the watercolor itself. Washes of pigment suspended in liquid will flow along the contours of a wet paper surface. The shapes left when the water dries and the paper stretches are 'natural' in a very real sense, since the flow of pigment obeys the same natural, dynamic laws that form landscapes. Thus flowing shapes often resemble those created by the movement of clouds or by the slow geological forces that shaped the earth. Thus, some of the qualities of nature, both accidentally and inevitably, become part of the painting from the start. As the characteristics of an image emerges, I try to develop it, while keeping the freshness of those first ideas.

"I work in light washes—a finished area may contain as many as twenty. I try to maintain transparency, building on what is already down. Sometimes I empha- *size a single form; sometimes several shapes blend together under large washes. For weight or substance, I tend to wash over a color with its complement rather than darken it so I can get a luminous quality in my low-key areas. For intense color, I build many very light washes of the same or related colors over an area. This distributes the pigment evenly and allows me to bring out nuances that might have been lost had I used one or two heavy washes. I use very few colors: three or four blues, earth colors, and warm and cool reds and yellows. I avoid fugitive pigments. My paper is a printmaking paper called 'Italia.' I found it as a graduate student and it is ideal for my method of developing, refining, and deepening effects.*

"I strive for an intense, abstract parallel of nature rather than an evocation or impression of any particular scene. Many visual impressions combine in a painting, and these multiple impressions can suggest the passage of time as well as the sweep of space. Ideas, rhythms, concepts from literature, music, or essays, often take precedence or merge with the influence of many artists on the structure or detail of my work. The final impact must, of course, be visual, but I admire both simplicity and complexity, and for my paintings to satisfy me, they must have both."

Project

"In teaching," Krieger says, "I often use a project based on my own creative method. I suggest a painting made up of experiments in paint—explorations of brushwork, pigment, medium, and blending. The aim is to create as many effects as possible without any thought to visual image or artistic merit. Just have fun and see what paint can do. This project will loosen you up, and a surprising number of habits, good and bad, may show up in these casual studies where they might not have been as clearly seen in more 'serious' efforts. Furthermore, once the power of the paint is explored for its own sake, it can be channeled to any purpose with enhanced authority and effect."

Painting Nature with a Free Spirit

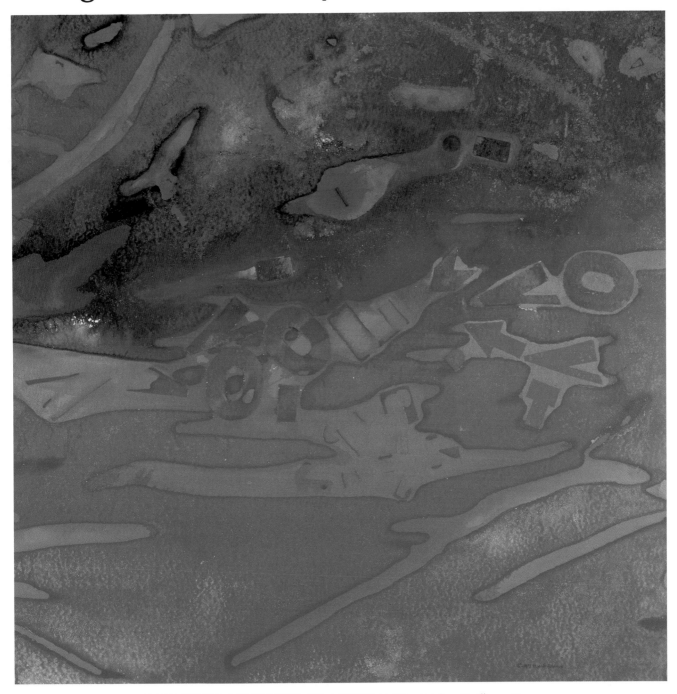

MAXINE MASTERFIELD, *A WARM BREEZE*. 40" × 40" (102 × 102 cm), ink on Morilla paper.
Courtesy of C. G. Rein Galleries.

*This painting expresses the way a warm breeze feels when it ripples water,
my hair, or blades of grass on a hill. It's a stir without a chill. A warm breeze
does not blow away anything; it does not attempt to refresh. It is just a
reminder that there is air around you that can be moved. It hints at a power
that is being saved as a trump card. It's a tease. And so within these hot,
bright colors still float shapes that are trying to form some intelligible protest.
Below, the core of cooler passion is aching to spread, with just a little more
help—contained, restrained, pent-up emotions, praying for a gust of move-
ment that will bring new sensations and a feeling of progress. This is my
need, to ever be able to seek and explore that new direction. And this is also
the frustration I feel when that freedom is not easily given by time or
opportunity. No tether, no matter how long, or how loosely tied, is tolerable
to a truly free spirit.*

Index